*Mark Jones*

# *The Art of the Medal*

Published for the Trustees of the British Museum
by British Museum Publications Limited

*Front cover* Pisanello: Don Inigo d'Avalos (detail)

*Back cover* Coudray: Orpheus (detail)

**Acknowledgements**

I should like to thank Charles Avery,
Marc Bascou, Lore Börner, Andrew Burnett,
Caroline Bugler, Ian Carradice,
Robert Carson, Jenny Chattington,
Celia Clear, Erica Davies,
Yvonne Goldenberg, John Hill,
Graham Javes, Kenneth Jenkins,
Michel Pastoureau, Graham Pollard,
Susan Robson, Klara Szegzardy-Csengery,
Gay van der Meer, and Terence Volk
for their help with this book.

Bold figures indicate colour illustrations.

© 1979 The Trustees of the British Museum

ISBN 0 7141 0850 2 cased
ISBN 0 7141 0851 0 paper

Published by British Museum
Publications Ltd,
6 Bedford Square, London WC1B 3RA

Designed by James Shurmer

Printed in England by
Jolly & Barber Ltd, Rugby

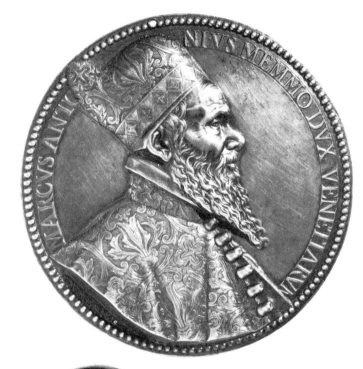

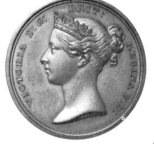

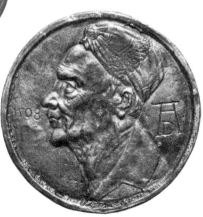

# The Art of the Medal

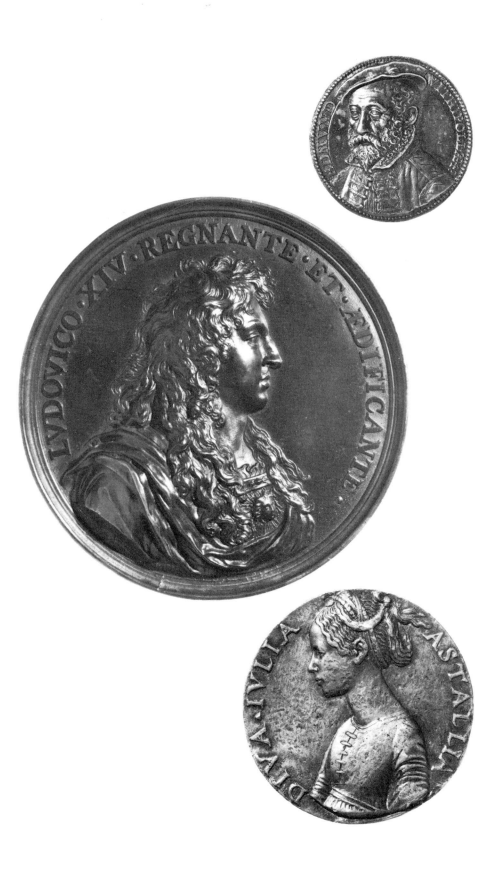

# Contents

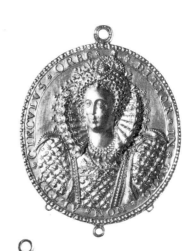

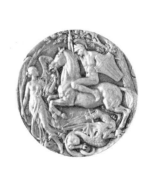

# Introduction

Medals, like coins, tend to be round, metal and two-sided but, unlike coins, they have neither monetary function nor fixed value. For this reason medal-making, unlike coining, which is a prerogative jealously guarded by government, has been able to develop as an autonomous activity practised by private individuals for their own gratification. It is with the history of this activity, 'The Art of the Medal', that this book is concerned.

The art of the medal is not, like painting or sculpture, a universal art found in cultures widely separated in space and time. It is specific to one particular civilisation, that of Renaissance and post-Renaissance Europe. It flowered in Italy with the Renaissance, and in one European country after another its birth announced the assimilation of Renaissance ideas to that country's artistic tradition.

There are various reasons for this. One of these is that medallic art is a specialised activity which can only be supported in a sophisticated society in which a number of people have enough surplus income to support activities unconnected with the primary need for survival. The richest and most sophisticated societies in existence during most of the period in which medals have been made have been European. Another reason is that medallic art, like modern European culture as a whole, was inspired by the example of ancient Rome and Greece and has been constantly renewed by continued interest in antiquity. But the most interesting reason why medals have been specific to Europe is that they are bound to it by what has, historically, been their utter dependence on the cult of the individual. Almost every medal bears a portrait, and though the features, achievements or memory of an individual have been commemorated in every medium, only in medals are they the point from which all else flows. Medallic art, in this sense, can be seen as the ultimate celebration of the individual. As such it could have been produced in no other society and at no other time, for it is a belief in the overriding value of the individual which has historically distinguished European civilisation from all others.

# 1. The origins of the medal

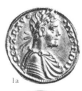

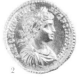

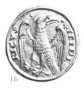

Coins were in the Middle Ages, as they are now, the most accessible of the relics of antiquity. In areas of Roman settlement they would have been found quite frequently; they were portable and durable, they bore the labelled portraits of famous men and their purpose was clear from their appearance. Consequently, when an individual or a state wished to associate him or itself with the glories of Rome it would have seemed a natural step to produce a coinage which imitated that of the Romans.

Such a coinage was produced by Frederick II, Holy Roman Emperor (1215–50) at Messina and Brindisi from 1231. These coins, called Augustales, imitate on their obverse portraits like that of Caracalla (198–217) on an aureus (2): note particularly the laurel wreath, its ties flying out behind and the drapery joined by a brooch on the shoulder (1a). On the reverse (1b) there is a version of the Roman type of eagle clutching a thunderbolt (3), which seems to have been misunderstood by the copyist as exaggeratedly large claws; the fabric of these coins is like that of gold coins of the third and fourth centuries. Both the portrait of Frederick and the technique of these coins are extraordinary in the context of their time and in comparison with the ordinary coinage of the same ruler (4a,b). This bears a portrait, stylised out of all recognition, which is typical of the period. Another isolated example of coins copying classical prototypes is provided by Ragusa in the fourteenth and fifteenth centuries. These coins (5a,7), dating from 1350 and 1436, imitate coins like those of Constantius II (AD 337–361) (6) or of an *Urbs Roma* type (8), and imitate them so closely that it is astonishing to turn them over to discover a purely medieval reverse (5b). Such rare exceptions to an otherwise uniformly unclassical coinage cannot be taken as prototypes for the Italian Renaissance medal. They do, however, demonstrate that in widely different places and times a knowledge of, and admiration for, Roman coins could express itself in imitation.

Such knowledge and admiration existed at the court of the Lords of Carrara, the home, in his declining years, of Petrarch (d.1374), the first known collector of ancient coins. In 1390 it expressed itself in a piece struck to celebrate Francesco II

**1a,b** Augustalis of Frederick II; eagle, c.1231

**2** Aureus of Caracalla

**3** Aureus of Trajan, *rev.*

**4a,b** Denaro of Frederick II, 1239

**5a,b** Follar of Ragusa, c.1350

**6** Coin of Constantius II

**7** Follar of Ragusa, c.1436

**8** Coin of Constantine I; *Urbs Roma*

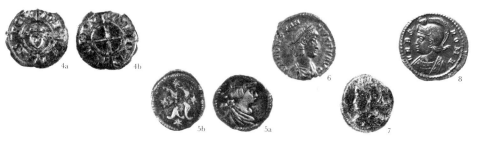

Novello's recapture of Padua on 15 June of that year (9). This, both in portrait and fabric, is copied from a Roman sestertius of the first century (10), possibly a coin of Vitellius from AD 69. It bears no relation to the contemporary coinage of the same ruler (11a,b) and had no monetary function; it is, in fact, the first modern medal. This was accompanied by another medal of Francesco II's father (12a,b) and a number of other pieces which have been discovered in and seem to have been intended specifically for burial in the foundations of buildings. These, like the reverses of the other two medals, remain purely medieval in feeling (13a,b).

At roughly the same time the Sesto family, who were employed as engravers at the Venetian mint, began to imitate and then to elaborate on ancient coins. In 1394 two brothers, Lorenzo and Marco, are mentioned as '*incisori ai conni dall' argento*' (engravers of dies for silver). By Marco we have a medal with the obverse legend '*Marcus Sesto me fecit*' and the date 1393 on the reverse (14a,b). This was the year in which Francesco II Novello was defeated, and the reverse – Venice planting her standard on the wheel of Carrara – seems to refer to this event. From about the same date there is a medal by Lorenzo which, like the previous piece, bears a portrait and in this case an obverse legend '*Imp ser Galba Ca*' (15a,b),

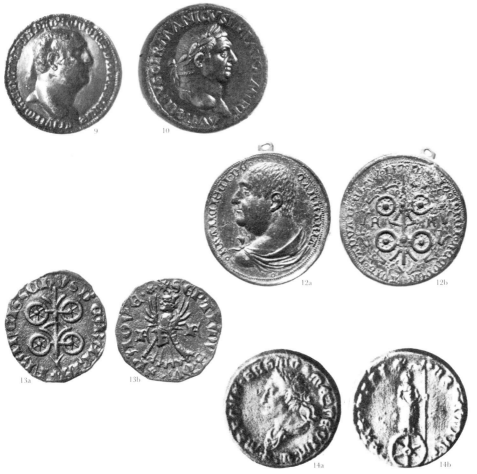

**9** Francesco II da Carrara, 1390
**10** Sestertius of Vitellius (69)
**11a,b** Carrarino of Francesco II da Carrara
**12a,b** Francesco I da Carrara; the *carro*, or cart of Carrara, 1390
**13a,b** Mural medal of Francesco I da Carrara
**14a,b** M. Sesto: Galba/Venetia, 1393
**15a,b** L. Sesto: Galba/Venetia, *c*.1393
**16** Dupondius of Galba, 68–69
**17a,b** A. Sesto: Alexander the Great, 1417
**18a,b** Constantine the Great; Old and New Churches, 1402
**19a,b** Heraclius; Heraclius at the gates of Jerusalem, 1402

copied from a Roman coin (16). Rather later, a member of the next generation called Alessandro chose to portray his namesake Alexander the Great (17a,b). Significantly, this piece, with its reverse showing Perseus delivering Andromeda, has no direct prototype among classical coins.

The congruence in time and place of the Sesto and Carrara medals makes it tempting to suppose that there may be a direct connection between them. Though differences in fabric and quality make it unlikely that the Sestos were responsible for the earlier pieces, it may well be that they knew and were inspired by examples that reached Venice. What is certain is that the Carrara medals were so widely known that even in France a wealthy and enlightened patron like Jean, duc de Berry, obtained a copy for his collection. Entry number 560 in his inventory, datable to about 1401–2, reads: 'An impression in lead, with, on one side, the face of François of Carrara and, on the other, the mark of Padua.'

That a humble lead cast of a medal was considered of sufficient value to merit inclusion in a formal inventory is particularly significant in this context, because the duc de Berry also owned a number of '*joyaux d'or roont*', '*petits joyaux d'or roont*' or '*tableaux d'or*' of Augustus, Tiberius, Philip the Arab, Constantine, Heraclius, the Duke himself, and the Virgin Mary. Copies of those of Constantine and Heraclius are known (18a,b, 19a,b), and show that they were not only the earliest surviving

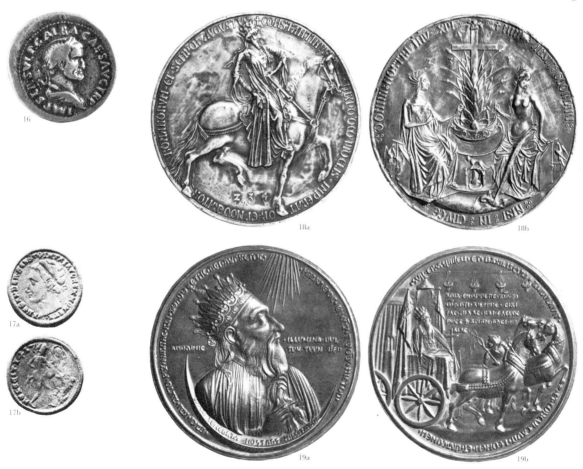

French medals, but also among the most interesting and original products of late Gothic art in France.

The Constantine medal shows on the obverse Constantine the Great on a horse and on the reverse the Old (Jewish) and New (Christian) Churches on either side of the Cross, Tree and Fountain of Life. The reverse legend '*Mihi absit gloriari nisi in cruce domini nostri Ihu Xpi*' (Far be it from me to boast of anything but the Cross of our Lord Jesus Christ) is a quotation from St Paul's Epistle to the Galatians (VI 14). It is clear from the Epistle that the reverse composition is based on St Paul's allegorical identification of Hagar (the young slave girl who bore a child to Abraham) with the Jewish Church and Sarah (Abraham's wife, who at the age of ninety-nine, miraculously gave birth to Isaac) with the Christian Church. The Heraclius medal shows, on the obverse, the Emperor making a vow to heaven 'O God, cause thy face to shine upon our darkness; [and] I will make war among the heathen' and, on the reverse, a dramatic moment in his return of the true Cross to Jerusalem. As he is about to enter the city its gates close in front of his horses and the emperor looks up as an angel informs him that since Jesus rode this way on an ass it is not for him to enter in royal state.

Who made these medals and why remains something of a mystery. They may show some knowledge of ancient coins – for example in the similarity of Heraclius' conveyance to a Roman funeral waggon (20) – but in size they are closer to the great Byzantine medallions like that shown by King Chilperic to Gregory of Tours, which weighed a Roman pound (327.45gr), or the medallion of Justinian, with its equestrian portrait (21). Some memory of the latter had certainly been preserved by Byzantine authors of the twelfth and thirteenth centuries (Cedrenus, Glycas and Manasses) and it is the influence of Byzantium which can most definitely be seen in these pieces. The legends of both ('Constantine faithful in

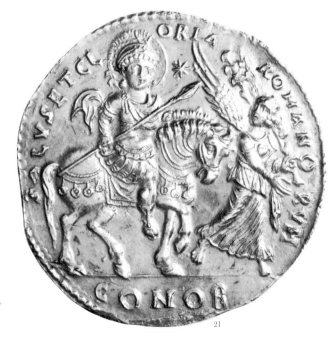

**20** Sestertius of Tiberius (14–37), *rev.*
**21** Medallion of Justinian (527–565), *rev.*

Christ our God, Emperor and Ruler of the Romans, Emperor forever' and 'Heraclius faithful in Christ our God, Emperor and Ruler of the Romans, victorious and triumphant, Emperor forever') correspond to the official Latin and Greek formulae for the imperial style used in the imperial chancery at Constantinople during the later Middle Ages. The implication that the medallist had direct contact with somebody who was familiar with the Byzantine court is easy to believe since Manuel II Palaeologus and his court were in Paris from 1400–02. In fact, from comparison with contemporary descriptions and Byzantine portraits of Manuel it seems not unlikely that the portrait of Constantine is based upon what must have seemed the natural source – his lineal descendant, the living Roman Emperor.

But, although we can date these medals quite securely to the first two years of the century (the Constantine medal certainly and the Heraclius medal probably entered the duc de Berry's collection on 2 November 1402), it is far from clear who made them. One possible attribution, to the Limbourg brothers, gains a certain plausibility from the extremely close relationship between some of their work and the medals. In the *Belles Heures* and the *Très Riches Heures* painted in about 1408 and 1411–16 for the duc de Berry they seem not only to copy but also to complete the original intention of the medallist – providing the closed door that explains the rearing horses (22) and the man holding the reins that explains the peculiar harness on Constantine's horse (23). An attribution to the Limbourgs would also be interesting because it would go some way to explaining the undeniable parallels between the next known medal, Pisanello's 'John VIII Palaeologus' (26a,b) and the pieces which have just been discussed. It is with this medal, the first of a series of masterpieces produced by Pisanello in the decade following 1438 that the history of medallic art as a continuous and autonomous tradition begins.

**22** The Limbourg brothers: Heraclius taking the True Cross to Jerusalem, *c*.1408
**23** The Limbourg brothers: Meeting of the Three Magi, *c*.1411–16

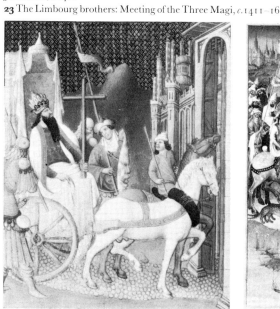

22

23

# 2. Pisanello

The first record of Antonio Pisano known as Pisanello (24) occurs in his father's will of 22 November 1395. Since his mother was then thirty-two and Pisanello was considered by Vasari to be 'very old' when he died in 1455, it seems likely that he was born in the 1380s. Soon after his mother's remarriage in the late 1390s and their move to Verona in the following decade, Pisanello may have become a pupil of Gentile da Fabriano and it was probably with Gentile from about 1409–15 that he worked in Venice on the decoration of the Sala Nuova in the Doge's Palace. After this he seems to have moved to Mantua, since a document of 1422 mentions that he was resident there. In 1424–25 documents refer to him as a court painter in Mantua, and this connection with the Gonzagas, rulers of Mantua, continued for the rest of his life. In 1425–26 he was working on the Brenzoni Monument in S. Fermo Maggiore in Verona, and after that it is likely that he went to Rome to help Gentile da Fabriano paint 'Scenes from the life of St John the Baptist' in the Basilica of St John Lateran. Gentile died in 1427 leaving his tools to Pisanello who completed the work in 1432. In that year he left Rome and went via Ferrara to Verona, where from 1433–38 he worked on the Pellegrini Chapel in the Church of St Anastasia.

The traditional title of one of the frescoes painted there is 'St George freeing the Princess of Trebizond' (25). The oriental features of two of the figures below the hanged men may link the subject matter of this fresco to the visit of the Byzantine Emperor, John VIII Palaeologus (who was himself married to a Princess of Trebizond) and to Pisanello's first medal (26a,b). The occasion for this visit and

**25** Pisanello: St George and the Princess (detail), 1433–8

25

**24** Marescotti (?):
Pisanello, *c*.1440–3
**26a,b** Pisanello: John VIII
Palaeologus; John VIII on
horseback with a page,
1438–9

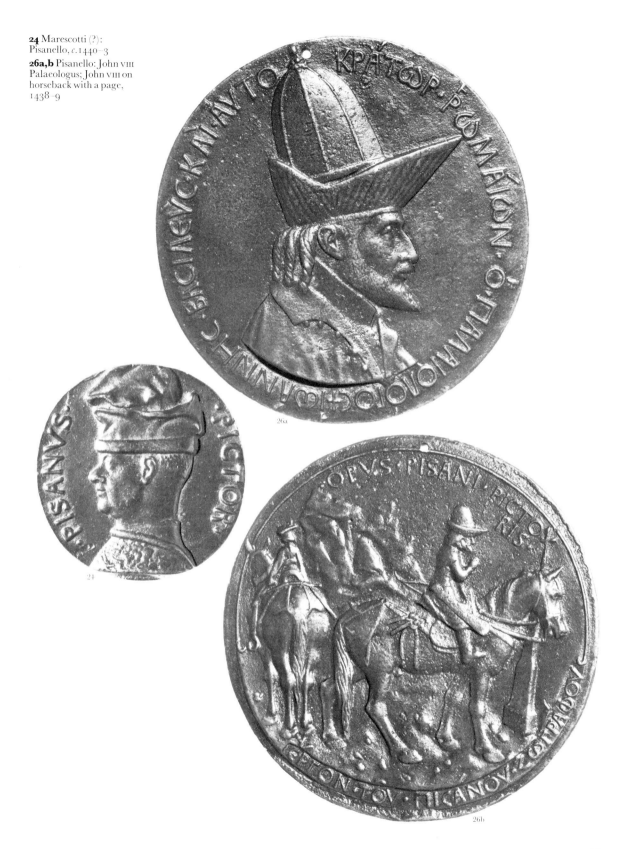

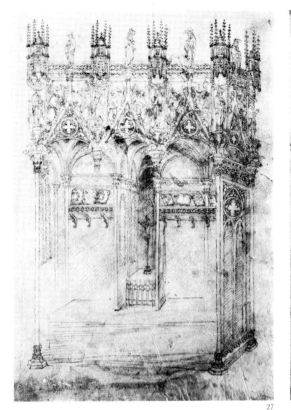

27
28

so for the manufacture of the medal, was the penultimate Byzantine Emperor's attempt to gain western support for his tottering throne by uniting the Greek and Latin Churches. The date of the medal is not clear, though most writers have held that it is more likely to have been made at Ferrara, where the Emperor resided for most of 1438, than at more distant Florence, where he stayed for the first half of 1439. The first view is slightly strengthened by a letter dated 12 May 1439 which refers to a promise of payment to Pisanello by the rector of a church in Mantua (which is near Ferrara).

Why Pisanello should have turned to medal-making so late in life is a mystery. Though he was interested in antiquity his medals are not directly influenced by classical coins, by the Carrara medals or the work of the Sestos. Their size alone sets them quite apart from such pieces. There are, however, certain suggestive parallels with the Constantine and Heraclius medals. Like these, Pisanello's medal is inspired by the visit of a Byzantine Emperor and bears legends in Latin and Greek. Like these, it is concerned with the Cross, as is a lost medal by Pisanello described by Paulo Giovo as made in Florence and showing the Cross held by hands representing the Latin and Greek Churches. It follows the Constantine medal in showing the Emperor on horseback, and follows the Heraclius medal in giving the Emperor's official title in Greek. Such similarities are not in themselves sufficient to establish any connection, but the known influence of Franco-Flemish painting, and in particular that of the Limbourgs, on Pisanello's work makes one quite possible.

**27** Pisanello (?): Architectural Study
**28** After the Limbourgs: St Jerome in his study

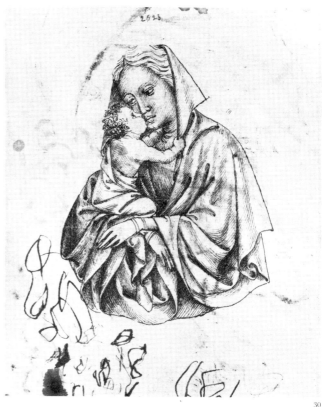

**29** Pisanello:
Madonna and Child
with Saints Anthony
and George
**30** After the
Limbourgs:
Madonna and Child

This influence seems to have been present throughout Pisanello's life. It is seen in specific instances, like a drawing of St Jerome, an architectural study (27) and architectural details in the Brenzoni Monument which all derive from a drawing by the Limbourgs of 'St Jerome in his Study', of which a copy survives in Paris (28), and again in the derivation of the Madonna in Pisanello's 'Madonna and Child with Saints Anthony and George' (29) from a composition by the Limbourgs (30). It is seen in more general terms in the tendency to use flowery backgrounds – as on the Brenzoni Monument and in a portrait of Ginevra d'Este – gold and silver, stars, and imaginary mountainous landscapes – as on the medal of Don Inigo d'Avalos (53) – and a soft all-pervasive light that led a recent writer like Paccagnini to compare the 'Annunciation' which forms part of the background in the Brenzoni Monument to a page from a book of hours or the landscapes in the Pellegrini Chapel to those of the Limbourgs. Whether Pisanello learnt of the Constantine and Heraclius medals from the Limbourgs on one of their visits to Italy or from Flemish artists resident at the Mantuan court is unclear, but it is easy to understand how, knowing of them, the visit of John VIII should have inspired him to follow their example. Even the famous hat must have aroused memories of that worn by Augustus and by one of the Three Kings in the Limbourgs' work.

The technique and style of Pisanello's medals however, differ very considerably from those of the Constantine and Heraclius medals. The refined workmanship of the goldsmith is replaced by simple casting in lead or bronze, the

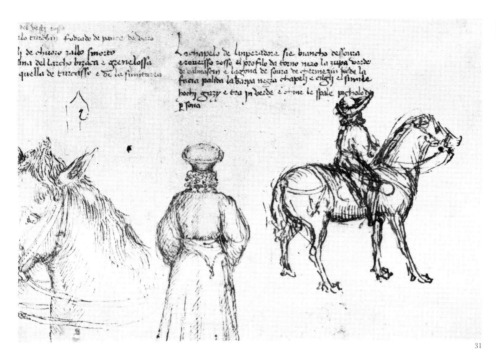

intricacy of high Gothic art by the bold modelling and composition of the
Renaissance. Some credit for the latter must go to Ghiberti, the panels for whose
second door could be seen from 1437 in his workshop in Florence. Pisanello's
admiration for Ghiberti's work is reflected in the writings of Bartolomeo Faccio
who, writing under Pisanello's influence in Naples in 1455, listed Ghiberti as the
greatest sculptor, and Pisanello, Gentile da Fabriano, Jan van Eyck and Rogier
van der Weyden as the greatest painters of their time.

For the medal itself we have two preparatory drawings. One, a small sketch
with a number of other drawings on a larger sheet shows the Emperor riding (31),
the other is a profile portrait similar to that on the medal but facing left. On the
reverse of the medal itself John VIII is seen ambling to the right on his rather
peculiar looking Danubian horse while the figure usually described as his page is
riding off in the opposite direction. The explanation for the odd behaviour of the
page may lie in the artist's fascination with foreshortened views of horses, which
is also evident in his medals of Filippo Maria Visconti (35b), Gianfrancesco
Gonzaga (44b), Domenico Novello Malatesta (43b), and a series of drawings
related to them (32,33,34) in the Réceuil Vallardi in the Louvre.

The next medals by Pisanello, of Visconti (35a,b), Niccolò Piccinino (36) and
Francesco I Sforza are datable to about 1441. The reverse of that of Piccinino
(36b) shows him and Braccio da Montone, two great *condottieri*, suckled by the
griffin of Perugia as Romulus and Remus had been by the wolf of Rome. In 1443
and 1444 he made a series of medals of Leonello d'Este, Marquess of Ferrara (37a).
The arcane symbolism of their reverses is typical of a strand of Renaissance
humanism which, like Leonello himself, was bound up with alchemy and occult
knowledge. It enabled a select few to communicate ideas in a form at once visible
and incomprehensible to those outside the charmed circle. It is among these that

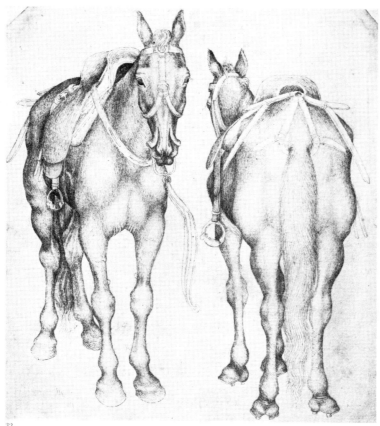

32

33

34

17

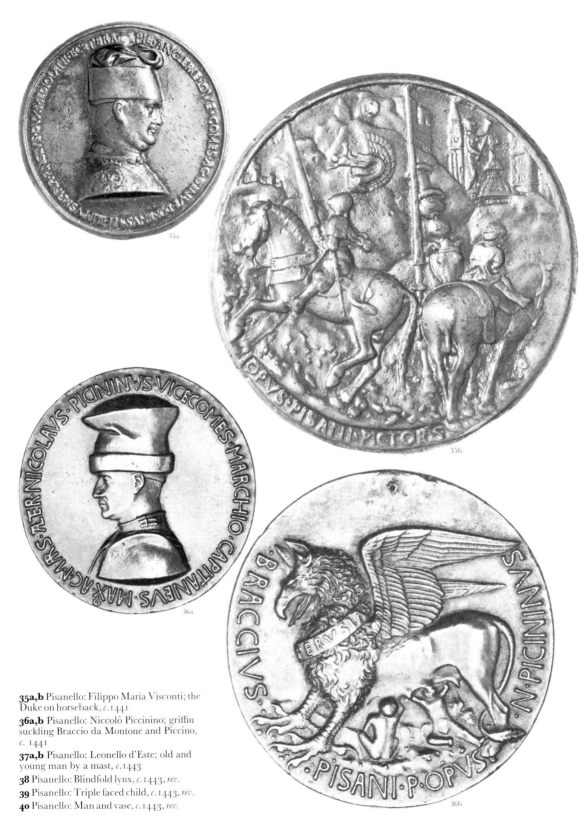

**35a,b** Pisanello: Filippo Maria Visconti; the
Duke on horseback, *c.*1441

**36a,b** Pisanello: Niccolò Piccinino; griffin
suckling Braccio da Montone and Piccino,
*c.* 1441

**37a,b** Pisanello: Leonello d'Este; old and
young man by a mast, *c.*1443

**38** Pisanello: Blindfold lynx, *c.*1443, *rev.*

**39** Pisanello: Triple faced child, *c.*1443, *rev.*

**40** Pisanello: Man and vase, *c.*1443, *rev.*

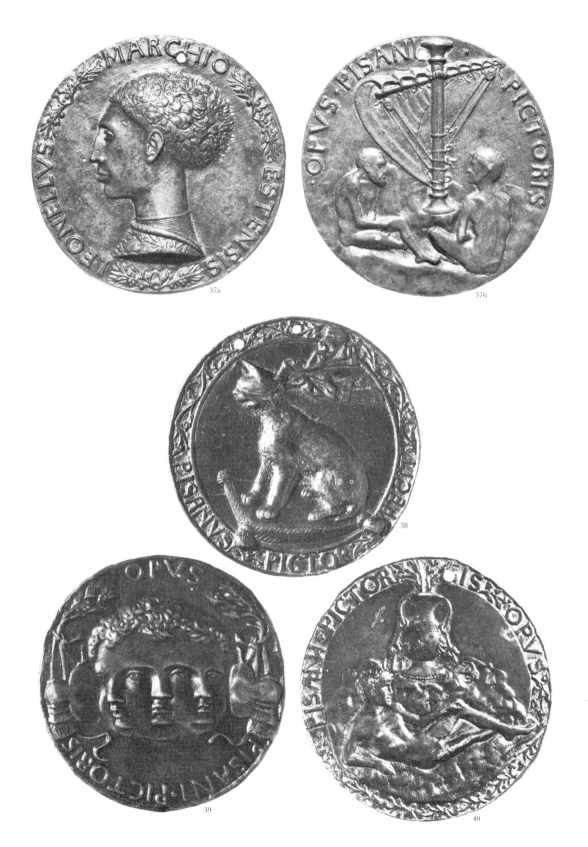

37a

37b

38

39

40

we must usually number ourselves, although we know that the blindfold lynx (38) represents statecraft, which must be blind to much of what it sees, and can guess that the triple-faced child (39) between pieces of armour (knee pieces) suspended from olive branches indicates that eternal vigilance and self protection are the price of peace. The others in the group are more mysterious. Do the old and young man (37b) sitting by a sail attached to a mast set in rock represent the qualities needed to remain steadfast amid the storms of life, and the whole and broken anchors (40) represent the combination of firmness and flexibility needed to maintain peace, symbolised by the vase containing olive branches? In any case the addition of a half-understood message from a lost world of esoteric reference to the medals' visual and plastic beauty endows them with particular fascination. The series of medals of Leonello d'Este culminates with a large piece (41a,**b**) celebrating his marriage to Maria of Aragon in April 1444. The reverse shows him as a lion (*leonello*) being taught to sing by love.

Pisanello's next group of medals, dating from about 1445, are of Sigismondo (42) and Domenico Malatesta. The latter is shown in a delightfully simple portrait (43a) and on his knees before a crucifix (43b). This reverse is supposed to refer to his vow during a desperate moment at the battle of Pausala in 1444 that if he escaped the clutches of Francesco Sforza he would dedicate a hospital to the Holy Crucifix.

In 1447 Ludovico Gonzaga, to whom Pisanello was already well known, was appointed Captain of the Florentine troops. This seems to have given him the idea of emphasising the military prowess of his family by commissioning medals and a

**41a** Pisanello: Leonello d'Este: Marriage medal, 1444

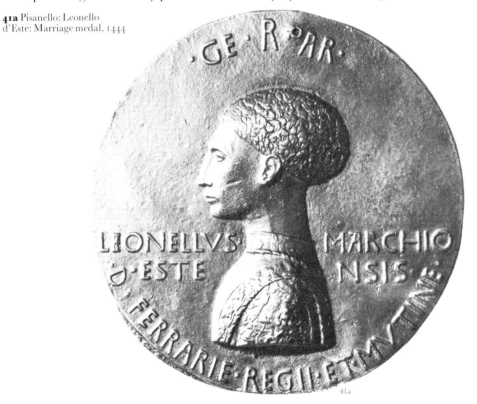

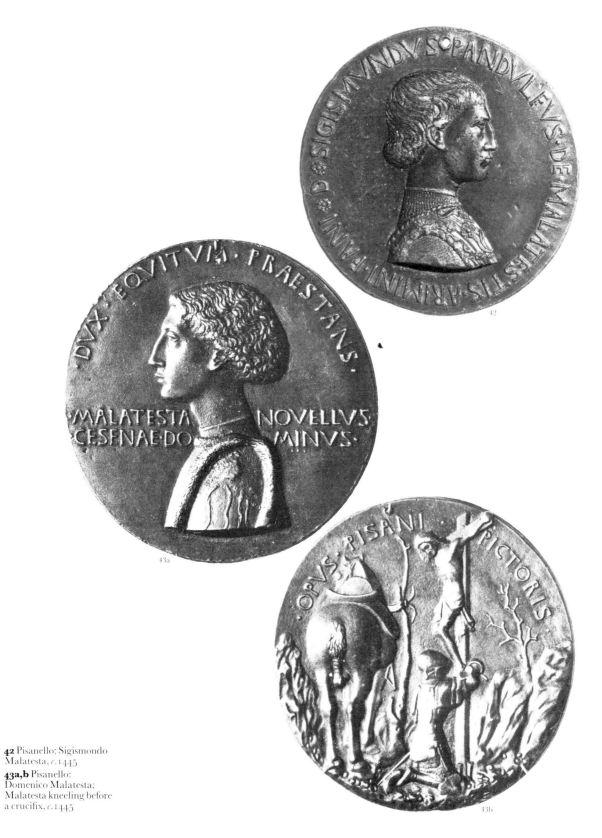

**42** Pisanello: Sigismondo
Malatesta, *c*.1445
**43a,b** Pisanello:
Domenico Malatesta;
Malatesta kneeling before
a crucifix, *c*.1445

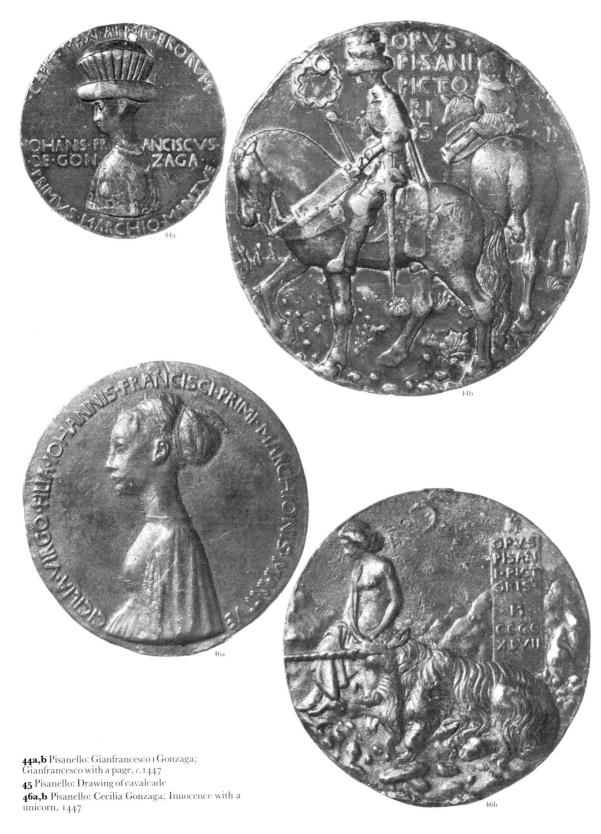

**44a,b** Pisanello: Gianfrancesco I Gonzaga;
Gianfrancesco with a page, *c.*1447
**45** Pisanello: Drawing of cavalcade
**46a,b** Pisanello: Cecilia Gonzaga; Innocence with a
unicorn, 1447

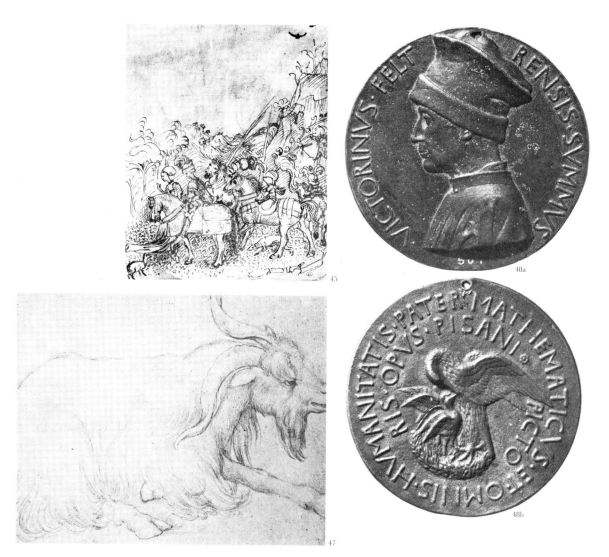

**47** Pisanello: Goat
**48a,b** Pisanello: Vittorino da Feltre; pelican drawing blood from her breast to feed her young, *c.*1447

vast cycle of Arthurian frescoes starring himself as Tristram. The first of the stern medallic portraits (44a,b) is related to a drawing for the frescoes which shows Gianfrancesco, Ludovico's father (45), riding through the mountains accompanied by his daughter Cecilia. Her weirdly beautiful medallic portrait (46a) is scarcely less unearthly than the accompanying reverse, which symbolizes her rejection of the world and in particular of the hand of Oddantonio di Montefeltro when she took the veil in 1444. It shows a unicorn tamed, as it could only be by the touch of a virgin, against a rocky landscape lit by a crescent moon. Even the discovery that the mythical beast is based on a study of a goat (47) can hardly bring us back to reality.

It must have been at about this time that Pisanello executed a portrait of Vittorino da Feltre (48a), Cecilia's tutor. The reverse is typical of Pisanello's work in its intention to complement the naturalism of the obverse portrait, representing the objective appearance of the sitter with some kind of insight into his personality – a portrait of his soul (48b). This is one of a group of portraits of humanist

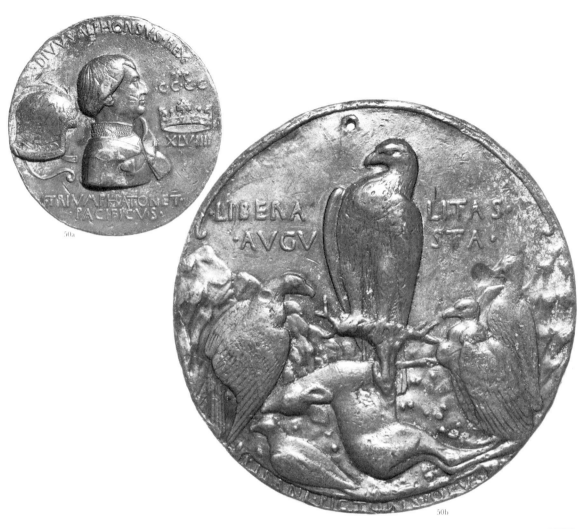

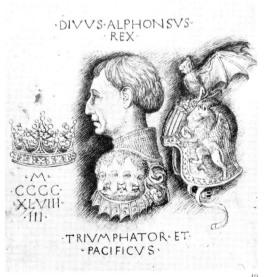

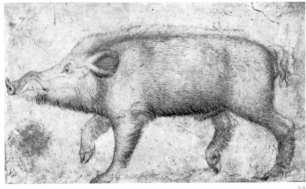

**49** Pisanello: Study for '*Liberalitas*' medal
**50a,b** Pisanello: Alfonso v of Aragon and Sicily; eagle, 1449
**52** Pisanello: Boar

scholars. In August 1448 Leonello d'Este wrote to another scholar, Pier Candido Decembrio: 'At last we have wrested from the hands of Pisano the Painter the coin with your likeness, and send it to you herewith, keeping a copy thereof, in order that you may understand how highly we esteem you and all that concerns you'. These medals and this letter are interesting because they show that although no linguistic distinction was made between coins and medals, the absolute ban on producing coins other than at the official mint or with a portrait other than of a member of the ruling family was in no way felt to apply to medals. These were regarded simply as one among a number of forms of portraiture.

We know from a drawing (49) that in 1448 Pisanello was at the Court of Alfonso the Magnanimous at Naples, centre of Gothic art in Italy and home of admiring humanists like Faccio. On 14 February 1449 he was granted a regular salary by the King and in that year he produced a number of medals. The helmet on the obverse of that taken from the drawing of the previous year has been modified to show one of Alfonso's devices – an open book on which are inscribed the words '*Vir sapiens dominabitur astris*' – a reference to the King's achievements in astronomy (50a). The reverse (50b) refers to his magnanimity by comparing him to the eagle. (It was believed that eagles always leave some of their prey to the other birds which for that reason follow and court them.) Among the other medals made by Pisanello at Naples the most dramatic shows Alfonso as a naked boy who has leaped on to the back of a great hairy boar and raises his knife, ready to strike it dead (51). It is fascinating to see how his drawing of a boar (52) has been subtly yet completely transformed for this composition. Perhaps the last and certainly one of the most beautiful of his medals portrays Don Inigo d'Avalos,

**51** Pisanello: Alfonso V boar hunting, 1449, *rev.*

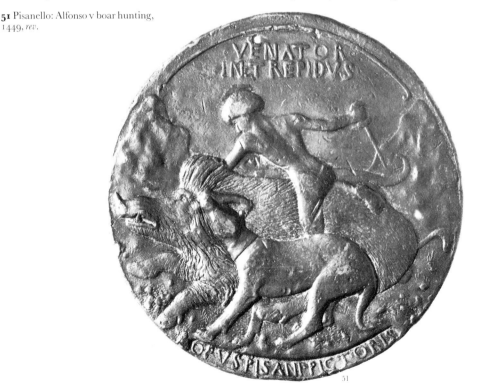

51

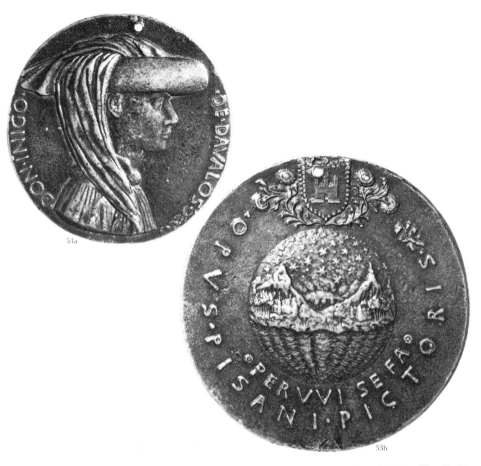

53a

53b

54

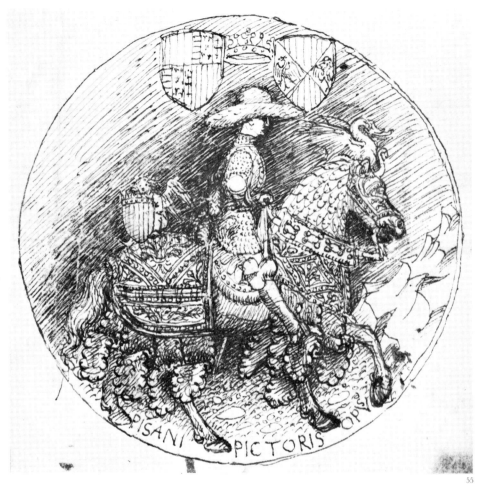

55

second Marquess of Pescara. The obverse portrait (53a), in perfect proportion and harmony with the area and circumference of the medal, is reminiscent of the finest Flemish portraits. Equally northern in feeling is a drawing (54) related to the terrestrial sphere on the reverse with its forests of Gothic spires (53b). Another drawing, for a medal of Alfonso v on horseback, seems never to have been realised in metal (55). Why this should be, and why we should have no further record of Pisanello or his work before his death (probably 1455) remains mysterious.

What is certain is that, in just over a decade, he had created a new art form, the medal. He had indicated both its possibilities and the limitations that its narrow range of scale and circular format imposed. He had shown the popularity that its informality, portability and durability could give it as a portrait medium. Above all he had demonstrated the unique advantage of the medal – the relationship that could be developed between obverse and reverse – and exploited it to produce a number of masterpieces that set standards that later medallists found hard to equal.

# 3. The Italian Renaissance

The history of the medal in Renaissance Italy is inextricably bound up with that of portraiture in general. In the fourteenth century the idea, dormant since antiquity, that a representation of a man should attempt to convey information about his physical appearance rather than the significance of his office, began to gain ground. Beginning with Giotto's portraits of Dante and himself, frescoes were increasingly populated with recognisable individuals. As artists became increasingly skilful at representing individuals' features, demand for portraits blossomed.

On the most general level this demand was a reflection of the cult of the individual – the period's greatest single distinguishing feature. On a more specific level it met a number of different though complementary desires. The first of these was for commemoration, for immortality. This was met by frescoes like Massacio's 'Raising of the Son of Theophilus' or Botticelli's 'Adoration of the Magi' in which portraits of the living and the dead are combined in compositions that were intended to preserve their memory for future generations. Frescoes, however, had the drawback, as a commemorative medium, that they were extremely vulnerable to neglect and decay. As far as the Renaissance humanists knew hardly a single painting had survived from antiquity. Coins, on the other hand, had survived in large numbers, and it was their obvious durability, their secure promise of immortality, that gave medals much of their popularity.

The initial desire to be remembered was soon complemented by the wish to be understood, to be flattered, to be the centre of attention while still alive. Fresco portraits had the disadvantage that they recorded personal features in a rather summary manner and, more important, that they subordinated the individual to the higher purpose of the composition as a whole. Early panel paintings, even those by Pisanello, were often taken from portraits in frescoes and it was not until Antonello da Messina (1430?–79) came under the influence of Flemish painting in the latter part of the fifteenth century that Italy had its 'first painter for whom the independent portrait was an art form in its own right' (as Sir John Pope-Hennessy has pointed out in *The Portrait in the Renaissance*). For those who wanted a portrait it was therefore natural to turn to medallists, for whom the portrayal of the individual had from the beginning been their primary purpose.

The Renaissance patron asked for more than the indestructibility of the portrait or even the attention of a professional portraitist. If he were a prince he, like the modern statesman, would have been eager to exchange likenesses with his equals and bestow them on his inferiors. If he were a humanist scholar, influenced by Cicero's *De Amicitia*, he believed in exchanging portraits for the sake of friendship. Before the use of oil paint and canvas (oil paints were not used in Italy

until the late fifteenth century), it was difficult and inconvenient to transport paintings. Medals, on the other hand, were easily portable. Even in the north, where the use of oil paint originated, a scholar like Erasmus found it advantageous to distribute not only paintings but also a medal by Quentin Matsys. This was because a medal, unlike a painting, was easily reproduced and Erasmus could keep going back to Matsys when he wanted more casts made.

The final reason for the popularity of the medal in the Renaissance lies in the fact that it has two sides. Renaissance man had a strong belief in the didactic properties of the portrait. He believed that the features of a great man could provide inspiration to those that beheld them. But it was very often felt that the character, intention or situation of an individual could best be conveyed by the addition of a motto or an emblem and, as has already been pointed out in the previous chapter, the combination of obverse portrait and reverse provided the ideal way in which to do this.

Yet the very popularity of medallic art at this time contributed to its decay. Among the mass of medallists in the fifteenth century there were many with meagre talent and others, like Sperandio and Niccolò Fiorentino, who were tempted by the demand for their work into producing careless and hurried portraits and combining them with almost any reverse that came to hand. Although many were influenced by Pisanello, not one came near to equalling his mastery of the art.

One of the earliest and best of these followers was Matteo de' Pasti, whose medals date from around 1446–50. His portrait of Sigismondo Malatesta (56a) is extremely close to the almost contemporary work by Pisanello (42) as is the lettering and fabric of all his medals. The architectural reverse (56b), a lively representation of the Rocca Malatestiana which had been finished in 1446, is unusual among the figure compositions normally found on reverses of this period. It is, however, not unexpected from de' Pasti who had a considerable reputation as an architect as well as a sculptor, painter, illuminator and medallist. He built the Tempio Malatestiano under the supervision of Leon Battista Alberti, whose medallic portrait he modelled in the late 1440s (57). Alberti himself dabbled in sculpture and produced two medallic self-portraits. A letter about the temple project written by Alberti to de' Pasti in 1454 reads: 'As for what you tell me Manetto says about cupolas having to be twice as high as they are wide I for my part have more faith in those who built the Terme and the Pantheon ... than in him.' This is interesting both because it illustrates the habit of reference to antiquity in such circles, and because it refers to Alberti's plans for the Tempio Malatestiano which were never realised, but which are recorded as a medal by de' Pasti dated 1450 (58). This curious church, though dedicated to St Francis, is in reality a monument to the illicit passion of Sigismondo for Isotta degli Atti, his mistress for many years and, after his previous spouse had been strangled, his wife (59a). The perhaps rather unsuitable reverse that de' Pasti chose for his portrait of this remarkable woman shows an elephant, symbol of magnanimity, stomping its way through the spring flowers (**59b**).

Although most of his work was done for the Malatestas, de' Pasti also produced medals of private individuals. Among the most endearing of these is one of his

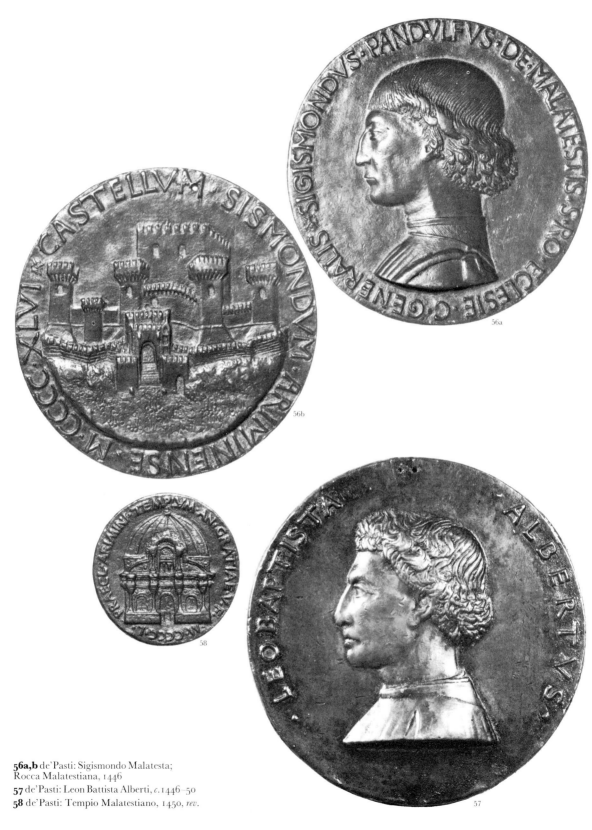

**56a,b** de'Pasti: Sigismondo Malatesta;
Rocca Malatestiana, 1446
**57** de'Pasti: Leon Battista Alberti, *c.*1446–50
**58** de'Pasti: Tempio Malatestiano, 1450, *rev.*

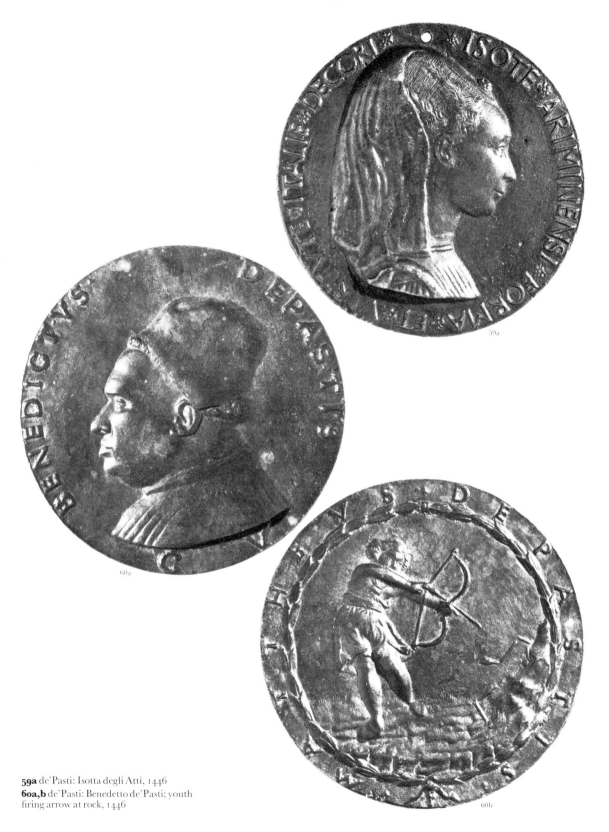

**59a** de'Pasti: Isotta degli Atti, 1446
**60a,b** de'Pasti: Benedetto de'Pasti; youth firing arrow at rock, 1446

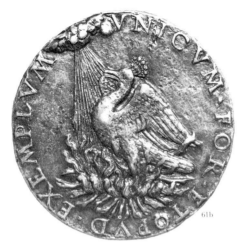

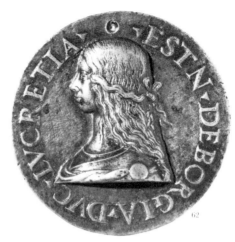

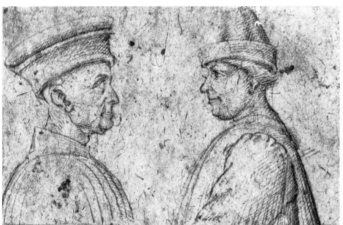

brother, Benedetto, Canon of Verona (60a), whose double chin and flabby neck
are reproduced with brotherly affection. That this unlikely exterior conceals a
character of adamantine resolve is revealed by the reverse on which a chubby
incarnation of outrageous fortune wastes his arrows on the unyielding rock (60b).

As the fashion for medal-making became widespread in Italy groups or schools
of medallists grew up in all the main urban centres. In Mantua for example
Melioli (*c*.1448–1514), L'Antico and Giancristoforo were among those working
at the court of the Gonzagas. To Pier Jacopo di Antonio Alari Bonacolsi, called
L'Antico (1460–1528), is attributed a medal of Giulia Astallia (**61a**). The in-
nocence and modesty of her pose and expression lend credibility to the theory that
she is to be identified with the Giulia of Gazzuolo who achieved immortality by
drowning herself after being raped by a servant of Bishop Ludovico of Mantua.
The reverse bears a legend referring to her outstanding courage and modesty and
portrays her soul as a phoenix speeding to heaven from the furnace of her violated
body (61b).

From Giancristoforo Romano (*c*.1465–1512), whose enormous contemporary
reputation as a sculptor and medallist is scarcely explicable in terms of the fifteen
or so rather undistinguished medals by him that survive, we have a portrait of

Lucrezia Borgia. This is a surprisingly girlish image (62) of a woman whose name became a legend for wickedness and who, when this medal was cast, had already embarked on her fourth marriage (her third husband having been murdered by her brother Cesare).

Another medallist, Sperandio (c.1425–c.1504), though born in Mantua and always associated with that town, travelled so widely that it is impossible to tie him to any particular school. He was one of the most prolific medallists of the Renaissance and one of those most influenced by Pisanello – later in life he simply copied his work. From his hand we have one of the very few surviving drawings (63) connected with a Renaissance medal (other than those by Pisanello); comparison with a signed medal (64) indicates that the gentleman on the left engaged in a curious ocular dialogue with a contemporary is Antonio di Sarzanella, a diplomat in the service of the Estes. Neither the drawing nor the medal are very impressive and even though certain of his portraits, like that of Federigo da Montefeltro (65a) have a certain power, most of them and even more so his reverses (65b) are badly executed: Goethe's opinion that he was the greatest Italian medallist can only be regarded as astonishing.

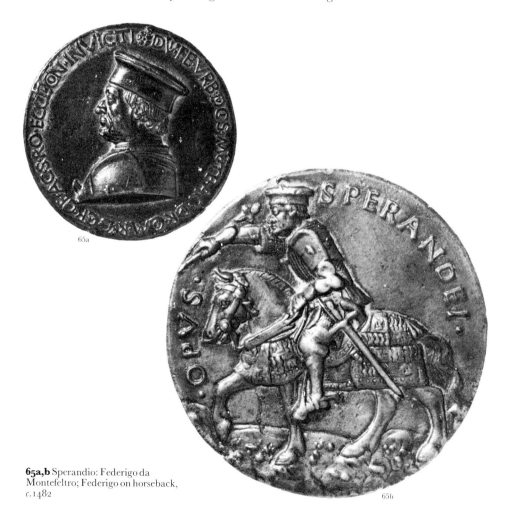

65a

**65a,b** Sperandio: Federigo da Montefeltro; Federigo on horseback, c.1482

65b

33

**66a,b** Boldù: Caracalla; the artist with Death, 1446
**67** Fra Antonio; Dea Contarina, after 1500
**68a,b** Giulio della Torre: Antonio de Giulio della Torre; Antonio with a dragon

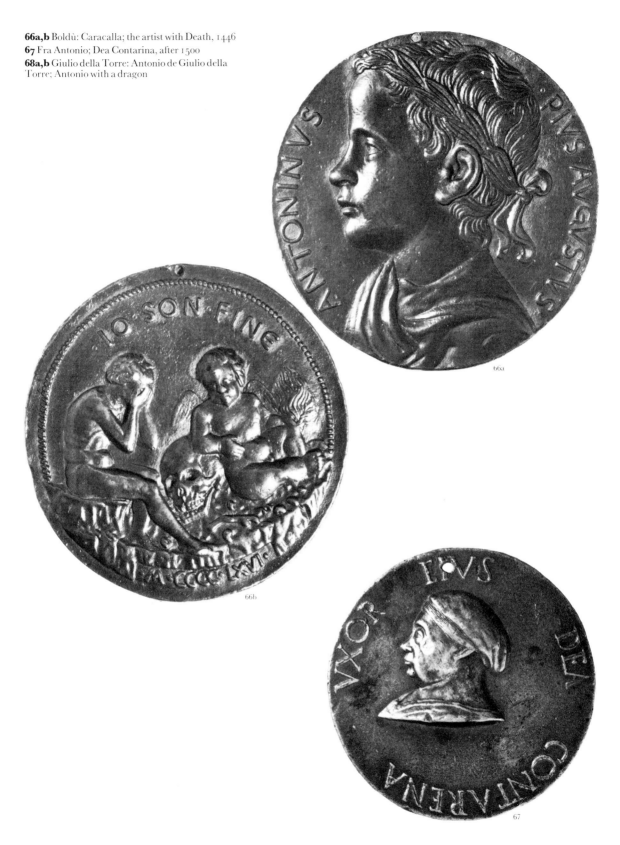

66a

66b

67

68a       68b

Despite the overwhelming importance of the idea of antiquity in the genesis of medallic art, direct borrowings from ancient coins occur surprisingly seldom in the fifteenth century, becoming really common only in the mid sixteenth century. An exception to this rule is provided by a portrait of the Emperor Caracalla as a boy (66a), attributed to the Venetian medallist Giovanni Boldù, which is based on a Roman aureus. The reverse, dated 1466, shows the artist seated naked on a rock, appalled by his own mortality in the presence of a bored and indifferent putto personifying death (66b). A medal by another member of the Venetian School, Fra Antonio da Brescia, demonstrates what one might call the democratisation of portraiture by the medal (67). For the middle ranks of the church, the law or commerce, medals often acted as a portrait medium that was less expensive and less formal than a full-size painted portrait, but nevertheless provided a permanent record of the sitter's features. Dea Contarina, wife of Niccolò Michiel, is depicted quite without flattery or pretension in her rather unbecoming coif and plain dress. Yet her strongly individual features convey to us a great deal more about her character than many flashier portraits and leave us five hundred years later with a lively idea of her personality.

Giulio della Torre, though a servant of the Venetian state, spent his life in his native towns of Verona and Padua. He was one of a number of gifted amateurs who tried their hand at medal-making during the Renaissance. In a society in which it was considered natural to appoint artists (such as Rubens) to conduct embassies and other important affairs of state, it is perhaps not surprising that a judge and high official like della Torre, an ambassador and councillor of state like Candida, or a member of a ruling family like Bassaldare d'Este, returned the compliment by turning to art. Della Torre's work benefits from the freshness and unconventionality of an amateur approach and his portraits of members of his family are particularly sympathetic. The reverse of that of his son Antonio (68a,b) shows him having his toe licked by a dragon under the appropriate legend '*Via Incerta*'.

Giovanni Candida (*c.*1450–after 1495), the finest of dilettante medallists, was

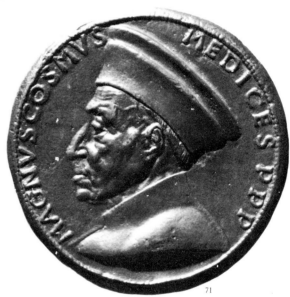

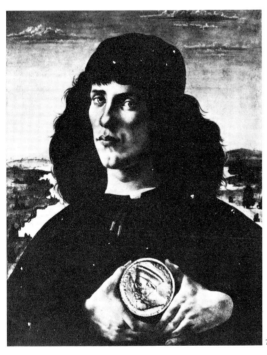

priest and soldier and secretary to the greatest men in Europe – Charles the Bold of Burgundy, Maximilian, later Holy Roman Emperor, Louis XI and Charles VIII of France. On his travels from one court to the next, he made medals which, though much affected by local taste, were influential in spreading Italian ideas to northern medallists. His fresh and charming portraits of Maximilian and Maria make it easy to understand why his work had such an effect (69a,b).

In Florence which, as the cradle of the Renaissance, one would expect to have produced a thriving school of medallists, we can identify yet another dilettante medallist, Bertoldo di Giovanni (*c.*1440–91). Ulrich Middledorf has suggested that Bertoldo, whose fame rests largely on Vasari's description of him as pupil of Donatello and teacher of Michelangelo, was in fact the illegitimate son of Giovanni de Medici and that he is to be identified as the subject of Botticelli's 'Young man with a Medal' (70). If this is the case it may also be that he is the author of the medal (71) of his grandfather which he holds in the painting.

If this medal makes it clear that Bertoldo has only a peripheral place in the history of the medal, the same cannot be said of his fellow citizen, Niccolò di Forzore Spinelli, known as Niccolò Fiorentino, who was the central figure in the Florentine school of medallists. Fiorentino was born on 23 April 1430. His immediate family were goldsmiths while his great uncle – Spinello Aretino – was a painter. On the rather slender basis of the five medals which actually bear his signature a massive oeuvre containing some 160 pieces has been assembled under his name. Despite the considerable ability evident in some of the portraits in this group, Fiorentino never achieved the synthesis between obverse and reverse, between the physical reality of the subject's features, and the expression of their character that Pisanello had shown to constitute the full potential of the medal. His medal of Giovanna Albizzi (72a) comes nearest with its reverse of 'Three Graces' which, though they have been copied from the antique, bear an unmistakable facial resemblance to the sitter (72b). When the same reverse is combined with a portrait of Pico della Mirandola (73) this compliment rather loses its point. It is generally true that, though Fiorentino was responsible for a number of fine portraits, particularly of women like Nonnina Strozzi and Caterina Sforza-Riario, his tendency to combine obverse and reverse almost at random, very often leaving the combination of the two halves and the casting of the medal to pupils, does indicate a decline in appreciation of the proper merits of medallic art.

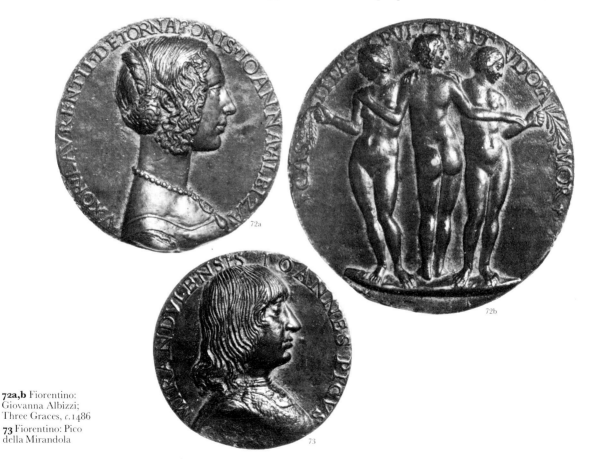

**72a,b** Fiorentino: Giovanna Albizzi; Three Graces, c.1486
**73** Fiorentino: Pico della Mirandola

This tendency was also evident in Rome which, though a brilliant centre for the other arts, has never fared well where medallists are concerned. The works of Andrea Guacialoti (1435–95), Canon of Prato, are lively if not particularly fine. His portrait of Alfonso of Aragon (74a) appears on a medal commemorating his triumphal entry into Otranto (74b). The procession, which is shown in frantic detail, has just reached the point at which his Turkish prisoners are being driven into the city.

A contemporary Mantuan working in Rome, Cristoforo di Geremia (d.1476) produced some carefully delineated portraits which display a delicacy which was inherited in full by his nephew, who, with true Renaissance conceit called himself 'Lysippus the Younger' after the antique sculptor 'Lysippus'. He produced a delightful gift for his lovers, which illustrates the charm and impudence of his character (75). The reverse is a mirror, the obverse his own portrait, with the legend 'Admire on one side your own beautiful face, and on the other that of your servant'. In its cheerfully unscrupulous acceptance that his affections were likely to shift too fast for it to be worth freezing the features of any particular love in bronze and in its delightfully ingenious solution to the problem, this medal epitomises the spirit of the Renaissance.

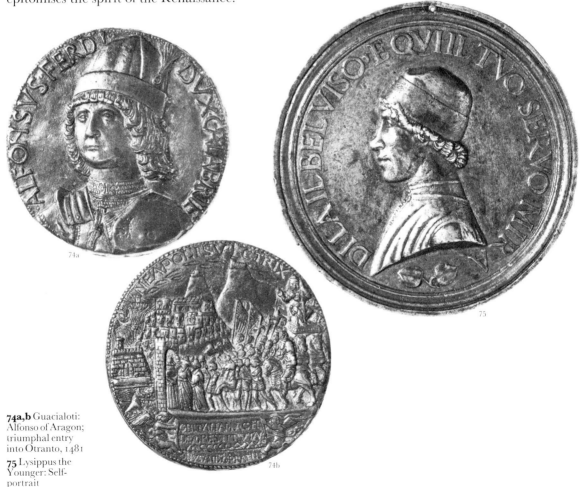

**74a,b** Guacialoti: Alfonso of Aragon; triumphal entry into Otranto, 1481

**75** Lysippus the Younger: Self-portrait

# 4. Dürer and the German Renaissance

In Germany, as in Italy, medallic art had its origin in the work of a great painter. To Albrecht Dürer (1471–1528) are attributed a number of pieces dating from 1508–14. These, though they vary in approach from the realism of 'Willibald Pirckheymer' (76) to the Italianising 'Ideal head' (77) (possibly based on Agnes Frei, Dürer's wife), are all executed in low relief and a strongly linear style. Though these, like the 'Old Man' (**78**) of 1508 or 'Young Man' (79), are extremely impressive in their combination of realism and spirituality, the conception behind them is still primarily two dimensional. For Dürer, unlike Pisanello, medals are merely a minor variant on his work as a painter and printmaker and not in any way an autonomous art form with its own particular possibilities and limitations. Perhaps for this reason Dürer, exercised little or no influence on the development of medallic art in his country.

This was to develop on its own national lines showing little or no awareness of or dependence on developments in Italy. After Dürer, German medallists were not painters or sculptors, nor were they inspired by a Renaissance ambition to revive the glories of antiquity. They sprang instead from the particularly German tradition of wood-carving which was responsible as much for innovations like woodcuts and printing as for medal-making. The different background of these medallists naturally led them to evolve different techniques. Instead of modelling in wax, like Italian medallists, they used hard woods like box, or on occasion, stone. The resulting models, again unlike those produced in Italy, were considered as works in their own right, to be preserved and perhaps decorated, while the medals cast from the model were in some ways a secondary product. Since medal-making was to a large extent simply an extension of the wood carver's art – medallists like Hans Kels and Friedrich Hagenauer, for example, also made wooden draughtsmen – it is not surprising that these medals, in the fine and precise detail of the modelling and in the absence of flowing lines or smooth curves, often recall the materials from which their models were hewn.

Of Dürer himself (80) we have a medallic portrait by Mathes Gebel (active at Nuremberg from 1523–54) dated 1527. This medal, like that of Hieronymus Holzschuher (**81a**) by the same artist, with its rather block-like representation of the head, its careful delineation of each wiry hair, its down-to-earth realism, is typical of German Renaissance medals. Equally typical is the heraldic reverse (81b). These medals were intended to convey not some mysterious and obscure message about the character or taste of the sitter, but the simple facts about his appearance on one side and about his status and family through the coat of arms on the other side.

To Joachim Deschler (1500–c.1572), one of the most productive members of

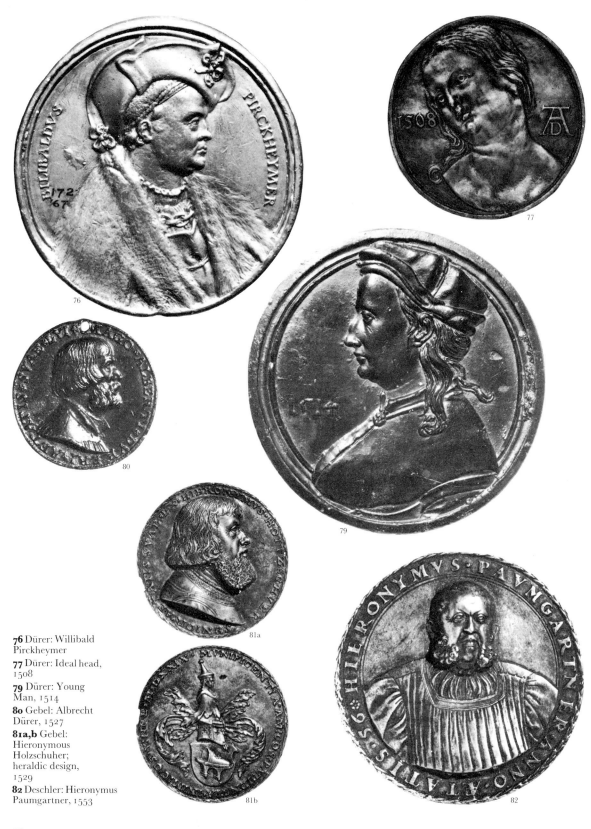

**76** Dürer: Willibald
Pirckheymer
**77** Dürer: Ideal head,
1508
**79** Dürer: Young
Man, 1514
**80** Gebel: Albrecht
Dürer, 1527
**81a,b** Gebel:
Hieronymous
Holzschuher;
heraldic design,
1529
**82** Deschler: Hieronymus
Paumgartner, 1553

the Nuremberg school, we owe one of the strangest portraits of the century. It shows a churchwarden called Hieronymus Paumgartner (82) as he was in 1553. Appalling yet fascinating in its pitiless realism, it must stand as the archetypal visage of the gross and greedy burgher, complete with pendulous double chin, slobbery lower lip and carefully cultivated sidewhiskers.

Turning to Augsburg we find in Hans Schwarz (c.1492 – after 1532) a medallist whose work has a boldness and scale which set him aside from the mainstream. A portrait like that of Lucia Doerrer (83) of 1522 seems almost to have been hacked out of the wood, although examination of his models (for example, 'A young man'; 84) shows that this impression is due more to the energy of his modelling than to any crudeness of technique. Christoph Weiditz (active 1523–36) has a far gentler way with his materials in his suave portrait of Lienhard Meringer (85) dating from 1526. The sinuous lines of cap and coat are complemented by carefully designed lettering. This is unusual in German medals of the period, as legends were normally simply punched into the mould with printing-type rather than, as in this case, being carved on the model and integrated into the com-

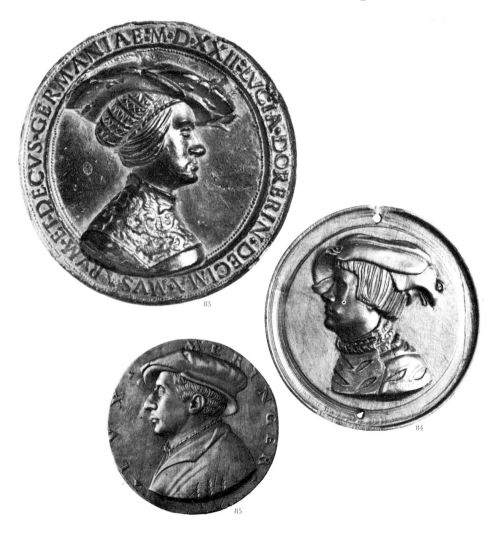

83 Schwarz: Lucia Doerrer, 1522
84 Schwarz: Young Man, 1514
85 Weiditz: Lienhard Meringer, 1526

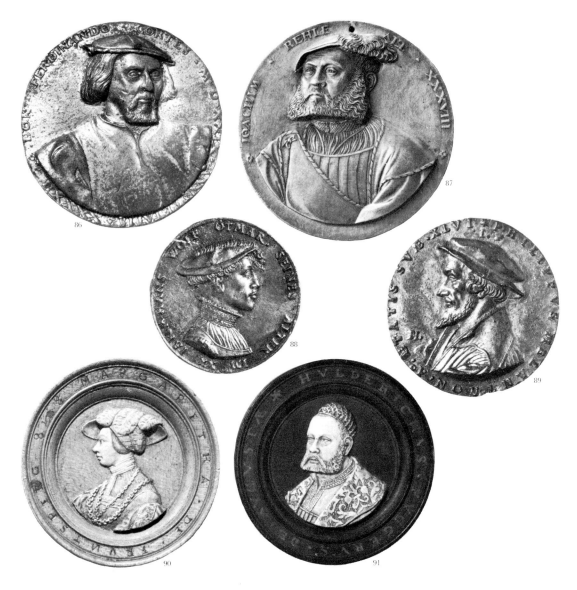

position as a whole. Curiously enough, Weiditz seems to have acquired these qualities before his travels abroad which, in 1529, led him to Spain where he produced a vigorous portrait of Fernando Cortez (86). The adventurer's fierce and even slightly manic stare is satisfactorily in accord with his incredible bravery and brutality during the conquest of Mexico. More typical of the subject matter of German medallic art of the period, which was essentially an activity carried out by and for rich and settled townsmen, is Weiditz's portrait of Joachim Rehle from 1529 (87). The wooden model for this manages, in its strict retailing of detail, to convey the absolutely down-to-earth existence of a German burgher, while at the same time giving a glimpse, in the subject's distant gaze, of the northern potential for mysticism and fanaticism that lay behind the bitter religious conflict of the Thirty Years' War.

Friedrich Hagenauer, a Strasburger who moved to Augsburg in 1527, pro-

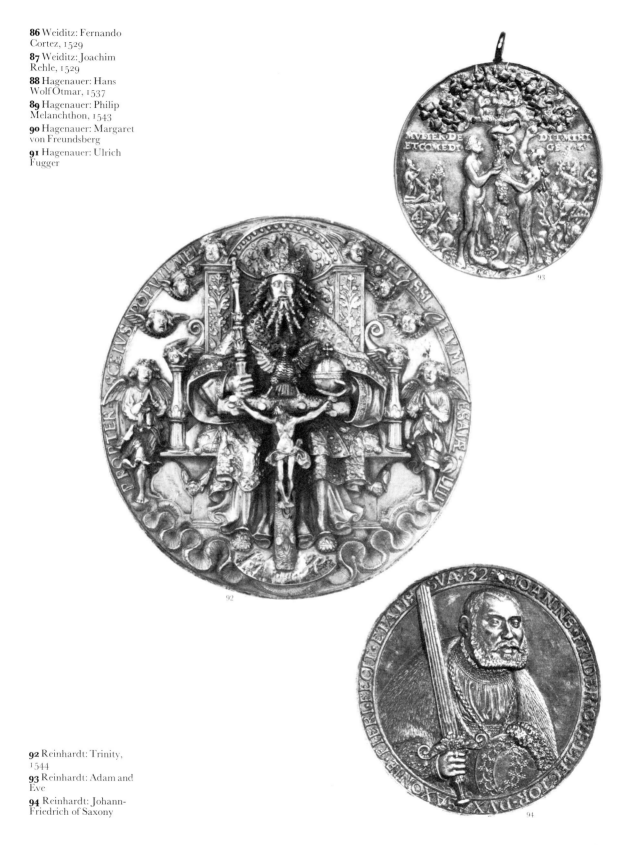

**86** Weiditz: Fernando
Cortez, 1529

**87** Weiditz: Joachim
Rehle, 1529

**88** Hagenauer: Hans
Wolf Otmar, 1537

**89** Hagenauer: Philip
Melanchthon, 1543

**90** Hagenauer: Margaret
von Freundsberg

**91** Hagenauer: Ulrich
Fugger

**92** Reinhardt: Trinity,
1544

**93** Reinhardt: Adam and
Eve

**94** Reinhardt: Johann-
Friedrich of Saxony

duced concise and popular portraits. His success there led him into conflict with the Guild system, which so restricted the activity of artists in Germany. The Guild of Painters and Sculptors claimed that medal-making was a branch of their arts and forced him to move to Strasburg and later Cologne. Hagenauer was a professional portraitist who could be relied upon for an accurate representation of the physical facts and who occasionally, as with Hans Wolf Otmar in 1537 (88), or the famous German reformer and theologian Philip Melanchthon in 1543 (89), showed sympathetic insight as well. The influence of his activity as a woodcarver on his medals is evident, if they are compared with his wood and coloured gesso draughtsmen, like those of Margaret von Freundsberg (90) and Ulrich Fugger, from the great banking family of Augsburg (91).

Hans Reinhardt, of the Saxon school, stands apart from the majority of German medallists in his training as a goldsmith rather than as a woodcarver. His mastery of the goldsmith's techniques allowed him to produce, in the 'Trinity' medal (92) dated 1544, one of the most amazing medals of the century. Its incredible detail and elaboration was so much admired that Reinhardt produced a second edition in 1561 for Elector Augustus of Saxony. His other religious works, like the 'Adam and Eve/Calvary' medal (93), are complemented by a series of portraits of rulers. These are fascinating in their absolute lack of flattery or indeed of any apparent consciousness of the possibility of idealisation. Johann-Friedrich of Saxony (94) presents his large, square, rather brutish face to us in a way which makes it clear that majesty is expressed in the trappings – the sword and hat – rather than the appearance of rulers.

The German School, though lively and original, did not contribute a great deal to the central tradition of medallic art which can be traced from Italy to France and thence to the rest of Europe. It gradually lost its independence under the influence of Italian medallists in the south during the late sixteenth century, and Dutch medallists in the north during the seventeenth century. The decline of the great imperial free cities like Nuremberg and Augsburg, accelerated by the ravages of the Thirty Years' War, removed the self-confident patronage that had been dispensed by their wealthier citizens. This was only partially replaced by that of the various German princely houses who, conscious of their cultural inferiority in relation to the glories of Versailles, readily capitulated to the cultural imperialism of Louis XIV. German medallists, condemned to imitate others, lost importance both in relation to their own society and to medallic art as a whole. They were to make no further substantial contribution to the history of the medal until the beginning of the twentieth century.

# 5. Quentin Matsys and the Renaissance in the Netherlands

The origins of medallic art in the Low Countries and in Germany are very similar. In both countries, a great painter made a few medals which were widely admired. In the period which followed there seemed to be a complete lack of interest in medals, and then a national school of medallists appeared who seemed to owe nothing to the originator of the art in their country.

In the Low Countries the painter in question was Quentin Matsys (1460–1530), a great artist and a central figure in the circle of Northern European humanists which included Erasmus and More, Dürer and Holbein. One group of medals attributed to him dates from the early 1490s and includes a self-portrait, a portrait of Matsys' sister, Christine, and another of William Schevez, Archbishop of St Andrews dated 1491 (95). The last of these was presumably made when Schevez was staying in Louvain on his way to Rome in the early part of that year. These medals are attributed to Matsys on the basis of their subject matter. Another, later medal of Erasmus dated 1519 (96a,b) can be attributed to Matsys on the evidence of a letter (dated 29 March 1528) in which Erasmus writes: 'I am at a loss to imagine where that sculptor got my likeness unless he has the one Quentin cast in bronze at Antwerp. Dürer painted my portrait but it was nothing like'. That this is the medal to which he refers is confirmed by the fact that there are two casts of it in Erasmus's own collection (96 is of one of them). It is interesting to note that these are of rather poor quality, which indicates that it is unwise to assume, as people generally do, that badly made casts are necessarily later copies. The differences in style between the earlier and later medals has led many art historians to deny that they could be from the same hand, although the Schevez medal was also in Erasmus's collection and therefore likely to have been made by someone in his circle. They can, I think, largely be explained by the fact that when, after an interval of twenty-four years, Matsys came back to medal-making, he abandoned the Germanic technique of carving wood in favour of modelling in wax and found that a different material dictated a different treatment of relief, line and lettering.

Another precursor of the Netherlandish medal, Jean Second (1511–36) was, like Candida, a gifted amateur, better known as poet-author of *Kisses*, as secretary to Charles v and as an indefatigable lover. His medals, which include portraits of his mistress, Julia, and of Nicholas Perrenot (97), though clearly influenced by contemporary German work show a freedom in the modelling, a sympathy with his subjects, and a consciousness of the ideal which are all his own.

It was not until 1549, with the arrival of Leone and Pompeo Leoni, recruited to the service of Charles v by Cardinal Granvelle, and that of Jacopo da Trezzo, at the request of Philip ii, that Netherlandish society received the impetus to develop

**95** Matsys: William Schevez, 1491
**96a,b** Matsys: Erasmus; Terminus, the Roman god
of boundaries, 1519

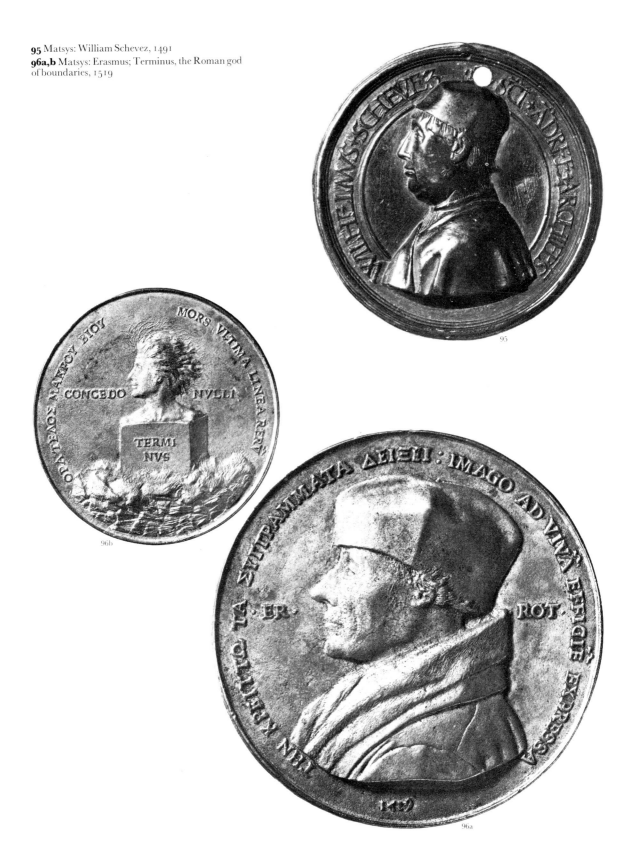

95

96b

96a

46

**97** Second: Nicholas Perrenot
**98a,b** Jonghelinck: Antonis van Stralen;
Fortune, 1565
**100a,b** van Herwijck: Maria Dimock; hart
and water, 1562
**101** van Herwijck: Engelken Tols, 1558

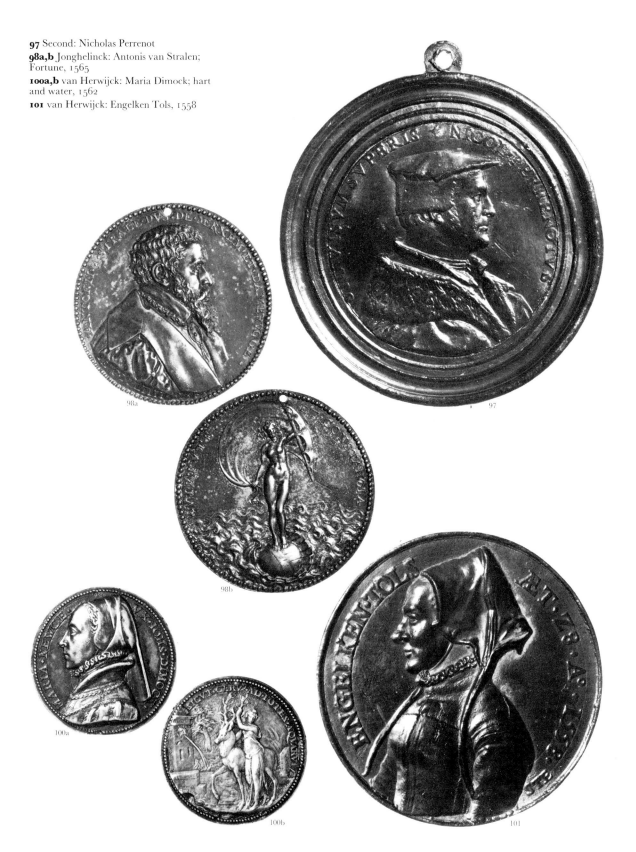

98a

97

98b

100a

100b

101

its own school of medallists. Their presence in Holland gave native artists the opportunity to develop a new synthesis between the German and Italian approaches to the medal. The brutally realistic approach to portraiture favoured by the former was softened by the delicacy and grace typical of the latter, while the technical skill and love of detail characteristic of northern artists was retained.

Jacob Jonghelinck (1530–1606), who actually visited Italy in 1552 and worked for Leone Leoni there, was a central figure in the development of this new synthesis. His portrait of Antonis van Stralen of 1565 (98a), though exquisitely worked in the northern style, shows an appreciation of the possibilities of the reverse which is distinctly Italian (98b). From Jonghelinck's hand we have a large number of portraits among the most elegant of which are those of Philippe de Croy, 1567, and Walbourg de Neunar, 1566. A coloured lead impression of the latter (**99**), is one of the very few painted medals that survive.

The other great figure in Netherlandish medal-making in the sixteenth century, Steven van Herwijck (*c.*1530–*c.*1567), was born at Utrecht and worked in England as well as in the Low Countries. His portraits, whether of an English mercer's wife like Maria Dimock made in 1562 (100a), a Dutch woman like Engelken Tols (101) with her wonderfully lively headgear, or a Polish king like John Sigismund, have a sincere, kindly and homely appeal which is very similar to that of Dutch genre painting. The reverse of the Maria Dimock medal (100b) shows a complete absorption of the lessons of contemporary Italian medal-making and proves that it is possible to develop even quite elaborate and ambitious landscape compositions on a very small medal.

Italian influence is even more evident in the work of Jan Symons whose portrait of Margarita de Calslagen of 1567 (102) is almost indistinguishable in style from the work of an Italian contemporary like Pastorino. Medallic art in the Netherlands, however, unlike that in Germany, was saved from losing its individuality by the revolt of the 1570s, the subsequent establishment of an independent, republican and Protestant state, and the emergence of rich merchant patrons who were at loggerheads with the Catholic monarchies and whose demands on medallists were quite different from those of the royal patrons.

This is not to say that Dutch medallists worked entirely in isolation. Coenrad Bloc (active 1572–1602) worked in Germany and France as well as in the Netherlands. His portrait of Pomponne de Bellièvre of 1598 (103) was obviously in Nicholas-Gabriel Jacquet's mind when he did a portrait of the same sitter (104) in 1601 and influenced the Danfries when they produced a scene surrounded by the same legend for a medal of Henry IV (122). From the very beginning, however, with the satirical badges produced for the nobles who adopted as their title their enemies' taunt that they were *Geux*, or beggars, the Dutch Protestants demanded of their medallists that they act as medallic pamphleteers. A typical example of such work, a medal celebrating the defeat of the Spanish Armada in 1588 (105a,b), shows the Dutch medallist's skill in fulfilling this role. The reverse records the event – the Spanish fleet being driven on to the rocks – and claims God's intervention in the legend 'Thou, God, art great and doest wondrous things; thou art God alone'. The obverse pours scorn on their Catholic opponents, the blindfold kings and bishops – 'Oh! the blind minds, the blind hearts of men' –

**Plate 1**

*Top*
**41b** Pisanello: Leonello being taught to sing by love; *rev.* of Marriage Medal of Leonello d'Este 1444.

*Right*
**61a** L'Antico: Giulia Astallia.

*Bottom*
**59b** de'Pasti: Elephant; *rev.* of medal of Isotta degli Atti, 1446.

48

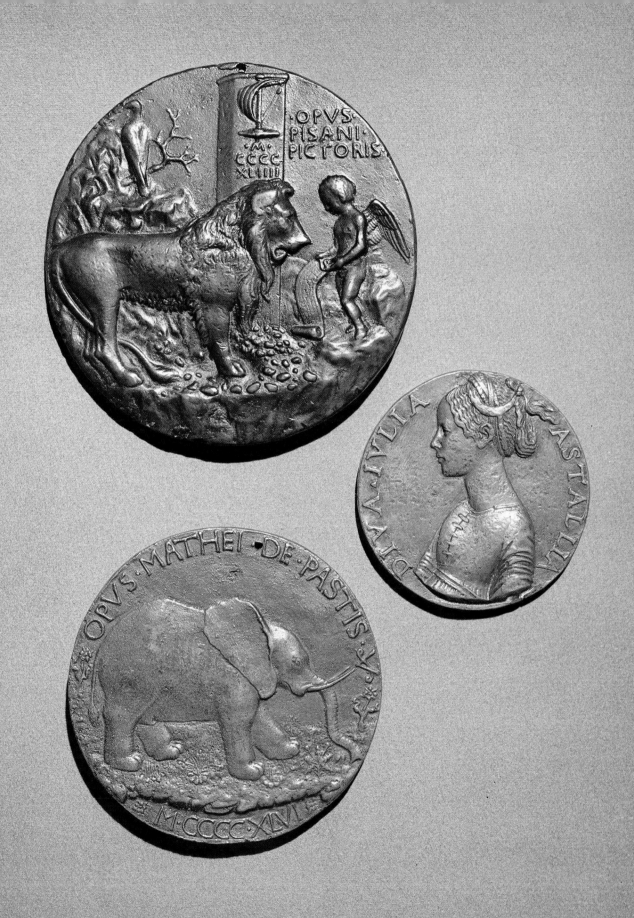

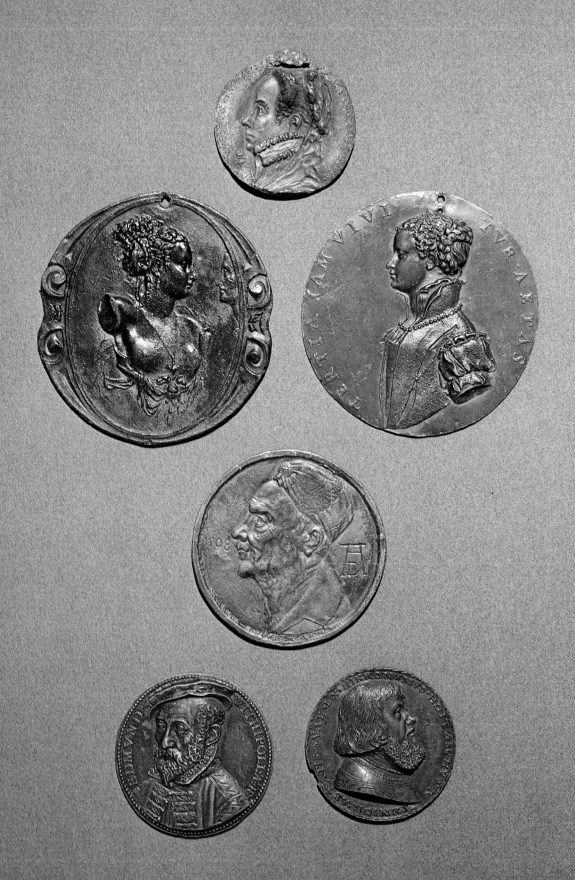

**102** Symons: Margarita de
Calslagen, 1567
**103** Bloc: Pomponne de Bellièvre,
1598
**104** Jacquet: Pomponne de
Bellièvre, 1601
**105a,b** Defeat of the Spanish
Armada, 1588

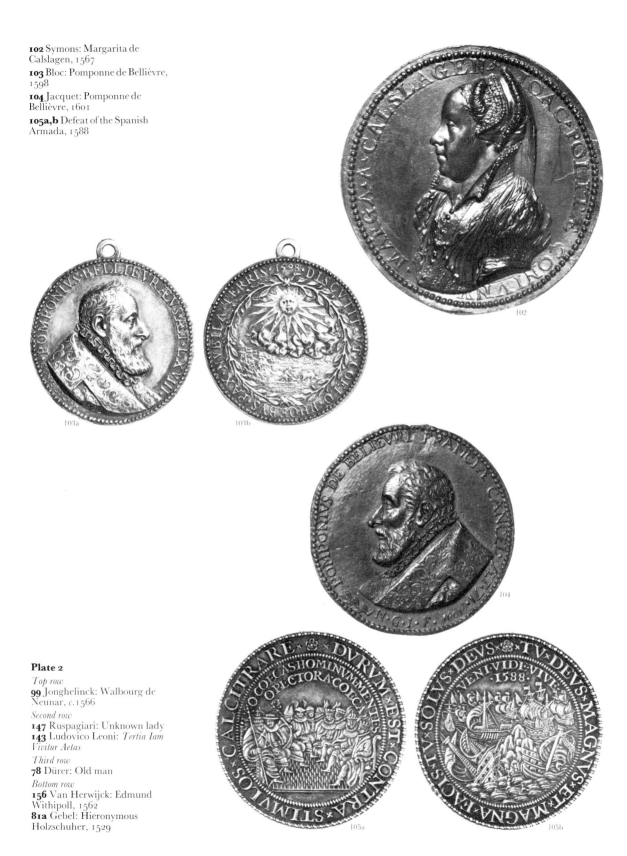

103a

103b

102

104

**Plate 2**

*Top row*
**99** Jonghelinck: Walbourg de
Neunar, *c.*1566

*Second row*
**147** Ruspagiari: Unknown lady
**143** Ludovico Leoni: *Tertia Iam
Vivitur Aetas*

*Third row*
**78** Dürer: Old man

*Bottom row*
**156** Van Herwijck: Edmund
Withipoll, 1562
**81a** Gebel: Hieronymous
Holzschuher, 1529

105a

105b

and both sides make fun of them – 'It is hard to kick against the [vividly represented] pricks' and '*Veni Vidi Vive*' (Come, See, Live) instead of '*Veni, Vidi, Vici*'. This desire to convey the maximum amount of information and entertainment naturally had an effect on the standard of design and modelling. Even when, as for the medal celebrating the battle of Nieuport (106), a distinguished artist like Jacob II de Gheyn provided the design (107) the result tended to be almost baffling in its accumulation of detail. It was not until the middle of the century that medallists like Pool, Müller and van Abeele developed a new and more sculptured style. These artists tended to use the technique of joining two thin repoussé plates of silver, leaving a hollow centre, to produce elaborate portraits in very high relief. The most graceful and appealing of these are by Peter van Abeele (active 1622–77). Particularly charming are his medals of William II of Orange, produced in 1650 (108), of Princess Mary (his wife and the daughter of Charles I) and, from 1654, of their son, later William III of England, as a child, wearing an elaborate hat and surrounded by a wreath of oranges (109). More typical of the genre both in their ugliness and in their virtuosity are O. Müller's portraits of Cromwell (110a) and Masaniello (110b). This piece is also typical of the Dutch medal of the period in making a political comment – on the fortunes of two men who had succeeded, by rebellion against their kings, in becoming supreme in Britain and in Naples.

Their continuing fascination with the medal as a medium for the transmission of political ideas led the Dutch, in their titanic struggle with the French during the late seventeenth and early eighteenth century, to make increasing use of it as a propaganda weapon. The resulting development of the Dutch medal at first led it to flourish as never before. However, as Dutch medallists produced increasingly sophisticated take-offs of French medals, their work gradually became stylistically indistinguishable from the originals that they mocked and so committed slow suicide as a distinct national school.

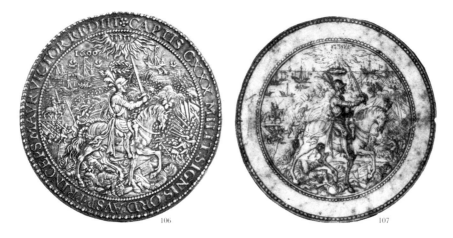

106 Battle of Nieuport, 1600
107 Jacob de Gheyn: design for no. 106

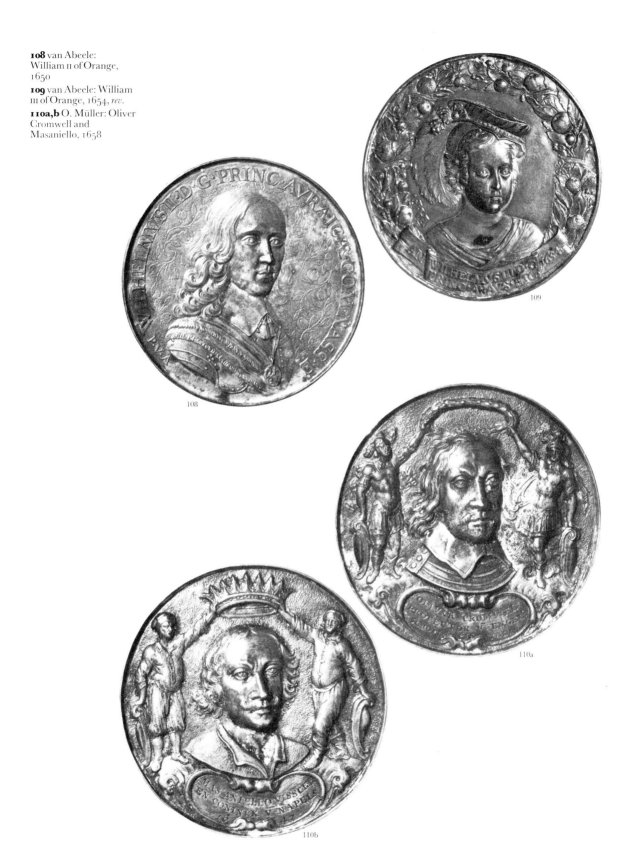

**108** van Abeele:
William II of Orange,
1650

**109** van Abeele: William
III of Orange, 1654, *rev.*

**110a,b** O. Müller: Oliver
Cromwell and
Masaniello, 1658

108

109

110a

110b

# 6. The medal in sixteenth-century France

The medals of Constantine and Heraclius proved to be the false dawn of French medallic art. The next group of French medals, the pieces dating from about 1454 commemorating the expulsion of the English from France at the end of the Hundred Years' War (111) are similar both in technique and in appearance to large coins of the period. They owe nothing to medallic art as the Italians understood it. Soon after they were made, however, the Italian conception began to make itself known in France. Pietro da Milano and Francesco Laurana both worked at the court of René d'Anjou, at Bar-le-Duc and elsewhere, and the latter is known to have lived in France from 1477 until the end of the century. By Pietro we have a portrait of Margaret of Anjou, Queen of England, dating from around 1461–3, and by Laurana one of Louis XII of about 1465 (112). Then, towards the end of the century, Charles VIII's expedition to Italy resulted in another group of Italian portraits of Frenchmen. These are in the style of Niccolò Fiorentino and include likenesses of the King himself and of seven other prominent members of his entourage. The medal of Matharon de Salignac from about 1494 (113) is typical of the group in its high relief and frank treatment of the sitter's features.

At about the same time, in 1494, the Consulate of Lyons, the most Italian of French cities, decided to present Charles VIII and Anne of Brittany with a cup of medals (114a,b). These were executed by Louis Lepère, Nicholas de Florence and Jean Lepère from a drawing by Jean Perréal. Coin-like in fabric and technique (they were struck), and Gothic in lettering and heraldic backgrounds, they are still the first French medals which show awareness of Italian Renaissance portraiture. They were followed by a number of other medals, of Anne and the Dauphin, of Louis XII by Michel Colombe, of Louis XII and Anne by Nicholas Le Clerc, Jean de Saint-Priest and Jean Lepère in 1500 (115a,b) and of Philibert of Savoy and Margaret of Austria by Jean Marende, dated 1502, which seemed to confirm that a specifically French assimilation of the Renaissance portrait to their Gothic and heraldic tradition had been achieved.

But in admitting the possible superiority of the Italian medal this nascent style signed its own death warrant. François I, not content with French imitations, went straight to Italy for the real thing. His taste for Italian medals may have been inculcated by Giovanni Candida (see chapter 3) who was in France from 1480. To him or his followers have been attributed medals of François himself, as duc de Valois (116), Louise de Valois and Marguerite de Valois. From Italy direct, François attracted Benvenuto Cellini whose portrait of the King (117a), shown on the reverse about to club fortune into submission (117b), indicates that his talent for self-advertisement (in his famous autobiography) was greater than that as a medallist. Only outside the court, in Regnault Danet's portraits of

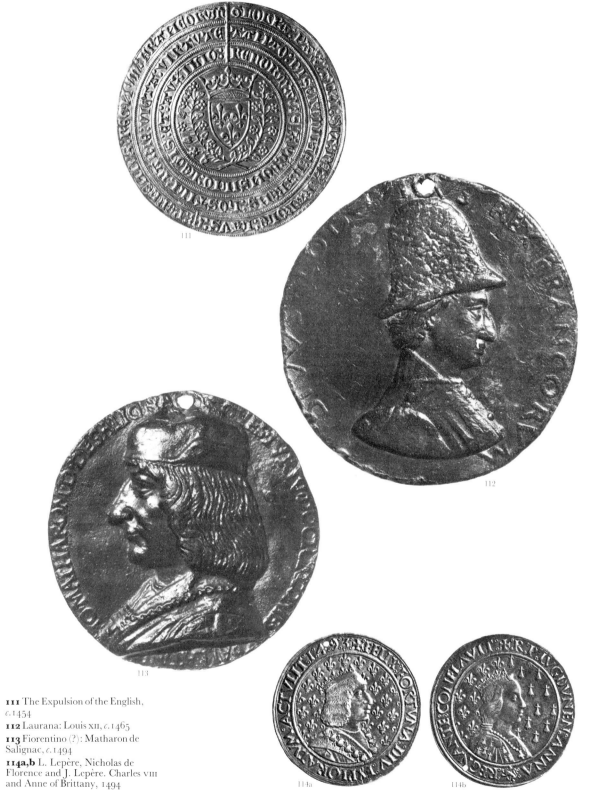

**111** The Expulsion of the English,
*c.*1454

**112** Laurana: Louis XII, *c.*1465

**113** Fiorentino (?): Matharon de
Salignac, *c.*1494

**114a,b** L. Lepère, Nicholas de
Florence and J. Lepère. Charles VIII
and Anne of Brittany, 1494

53

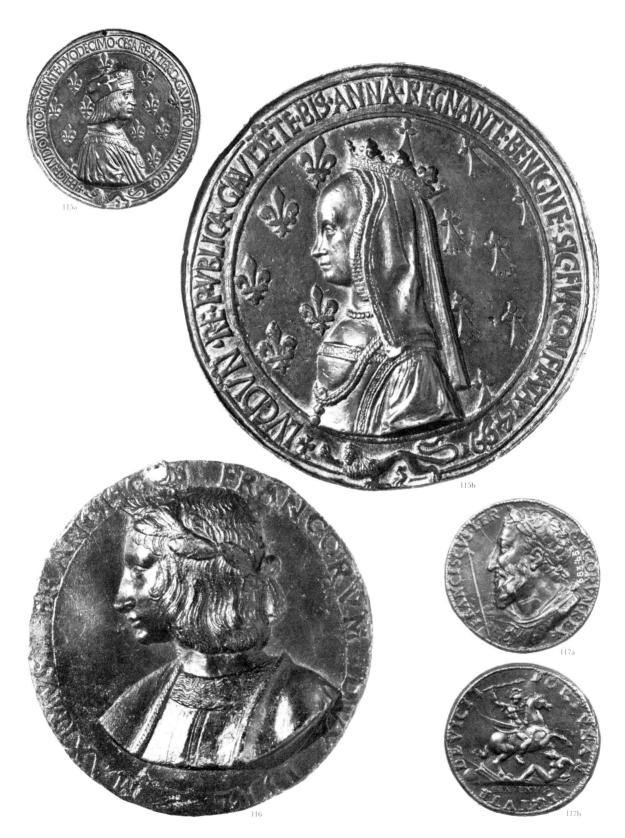

115a

115b

116

117a

117b

himself and his wife (118a,b) and particularly in Lyons where artists like Jacques Gauvain (119) and Jérônyme Henry found a living, could some trace of a native tradition still be found.

Two events brought fresh life to medallic art in France. One was the establishment in 1550 of a new mechanical press in Paris, the other was the appointment of Germain Pillon, one of the greatest of French sculptors, to the new post of *Contrôleur Général des Effigies*, in 1572. The new press was intended to produce perfectly round money which would be impossible to imitate by the old methods and so defeat forgers. Unfortunately it also threatened the position of the established body of moneyers. These managed to confine the new press to the manufacture of medals and jettons and in doing so conferred a monopoly of the new techniques on the medallists who worked there. Among these was Étienne de Laune (1516–83), one of the original assistants of Aubin Olivier who had set up the press with knowledge and machinery obtained from Augsburg. His medal of Antoine, King of Navarre (120a,b) shows his skill as a portraitist and designer of decorative reverses. Medals by other artists working at the Monnaie de Moulin, like Alexandre Olivier's piece for Charles IX's entry into Paris, or Claude de Hery's 'Creation of the Order of the Holy Ghost' (121), tend to display skill

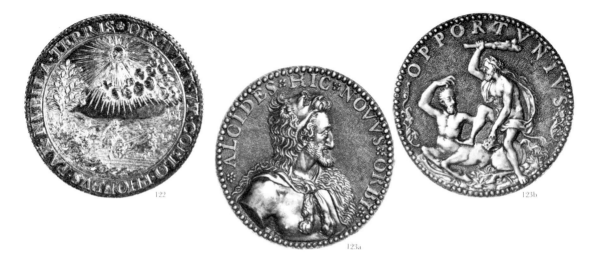

122

123a

123b

without feeling. The production of struck medals was continued until after the
end of the century by the Danfries, father and son. One example of their work
shows a happy peasant ploughing in the peaceful landscape created by Henry IV's
benign rule (122). Another, by Philippe II Danfrie (the son), refers to Henry IV's
conquest of Bresse and Savoy (123a,b). It replies to a medal which the Duke of
Savoy had struck in 1588 celebrating his capture of the Marquisate of Saluces
with the legend '*Opportune*' (opportunely), by showing the Duke, who had
represented himself as a centaur on the earlier medal, losing his marquisate to
Henry IV as Hercules under the legend '*Opportunius*' (more opportune).

In the field of cast medal-making, too, the dominance of the Italians in France
was ended. Though Primavera, who was presumably of Italian origin, was
undoubtedly the most popular medallist of the second half of the century among
the French aristocracy, France could claim, in Germain Pillon (1535–90) one of
the greatest medallists in the history of the art. As *Contrôller Général des Effigies* it was
he who was responsible for providing the models from which coin and some
medallic portraits were taken. He also produced in his Valois medals – of Henri II,
Catherine de Médicis (124), Charles IX (125), Elizabeth of Austria and Henri III –
a series of portraits at once devastating in their psychological insight and en-
ormously attractive in their wealth of decorative detail. The rest of Pillon's
medallic work consists largely of struck pieces executed after his models by
engravers at the Mint who have lost the power of the original in the process of
transcription and reduction in size. But there is one other medal on the scale of
those of the Valois. This is one of Pillon's greatest works, the portrait of René de
Birague (**126**) for whom he also produced the funerary statues that surmount his
tomb.

Pillon was a medallist without either direct antecedents or pupils. But his work
presented to later medallists an example of the possible advantages of pursuing a
more sculptural approach to the medal. A fusion between his inspiration and the
technical virtuosity of engravers at the Medal Mint was to produce a standard
and style of medal-making in the next century which swept across Europe and
dominated the art for a hundred years.

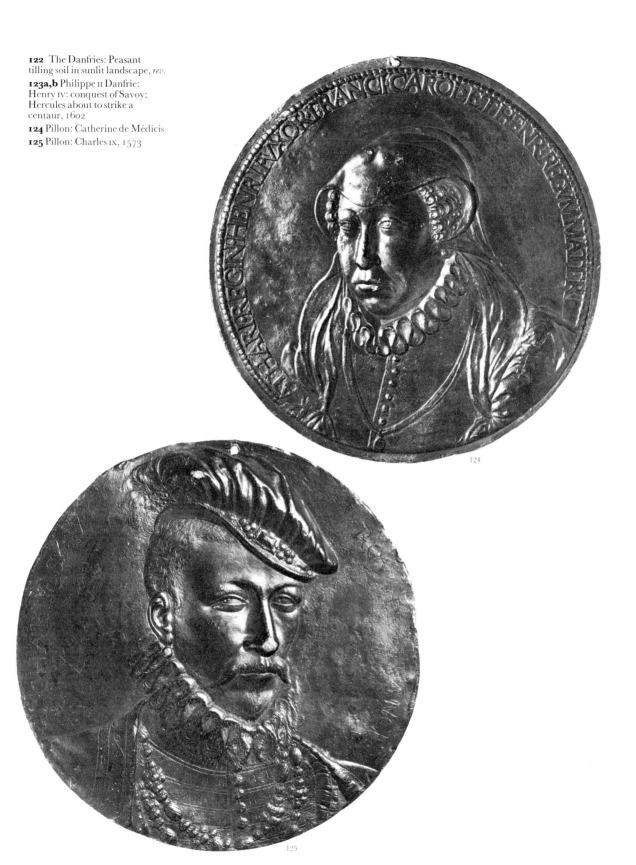

**122** The Danfries: Peasant
tilling soil in sunlit landscape, *rev.*
**123a,b** Philippe II Danfrie:
Henry IV: conquest of Savoy;
Hercules about to strike a
centaur, 1602
**124** Pillon: Catherine de Médicis
**125** Pillon: Charles IX, 1573

124

125

# 7. The pursuit of elegance– Italian Mannerist medals

The shadow cast by Pisanello over the development of Italian medallic art was finally lifted only toward the middle of the sixteenth century. Two major advances contributed to this breakthrough. First, a group of medallists working at the Papal Mint developed increasingly sophisticated techniques for striking medals. Second, another group, possibly influenced by the fineness of the detail obtainable on struck medals, abandoned the stylistic conservatism characteristic of the Italian medal at the end of the fifteenth century and enthusiastically pursued the development of the mannerist medal.

Benvenuto Cellini (1500–71) must rank as the most famous exponent of the struck medal. His medallic work (see, for example, his medal of Clement VII; 127a,b) is generally rather uninspired, and though his portrait of François I is more interesting, it was his spirited advocacy of the process and his glowing description of his medals in his famous *Memoirs* that contributed most to a wider understanding of its possibilities. From this period onwards medallists tend to be divided between those who specialise in casting medals (that is, pouring molten metal into a mould made from a model, which is usually in wax) and those who prefer striking (that is, producing an impression on a metal blank by a blow from a steel die, engraved in intaglio).

Probably more influential in the development of the technique of striking medals than Cellini's much advertised experiments was the increasing demand for ancient coins among Italian connoisseurs. No longer satisfied with imaginary portraits like those produced by Valerio Belli in the early part of the sixteenth century, they demanded the real thing – a demand successfully met by Cavino's extremely convincing copies of first and second century Roman sestertii. His skill in engraving and striking such pieces is equally demonstrated in his self-portrait with Bassiano (128). Among his other medals of contemporary subjects there is one celebrating the restoration of England to the Roman Catholic Church (129). It is typical of Cavino's rather pedantic classicism that even this is an adaptation of a classical coin type – *Roma Resurges* (130).

One of the most gifted makers of struck medals, Alessandro Cesati, called Grechetto, also worked at the Papal Mint and was also a skilled counterfeiter of ancient coins. The reverse of a medal of Paul III struck in about 1545 (131) shows both his outstanding skill as an engraver, partly the result of his experience of working in gems, and the great technical advances which had been made at the Mint. Michelangelo, when shown some of his medals, said that the death of the art was imminent since nobody could do better. This was evidence, if not of Michelangelo's discrimination as a critic, of the extent to which contemporaries appreciated these accomplishments. It has to be admitted, however, that Cesati's

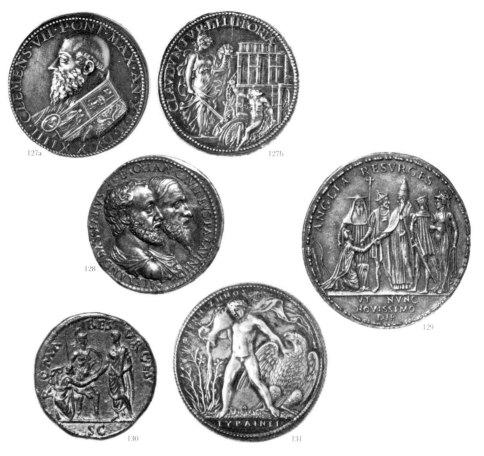

successors at the Papal Mint – medallists like Bonzagna and Fragni – were isolated from the mainstream of medallic art in Italy and distinguished largely by their lack not only of originality, but also of any real sense of design.

The distinction between the makers of struck and cast medals was by no means complete. Cellini made cast medals and Leone Leoni (1505–90), one of the greatest exponents of the art of casting medals, had in the late 1530s seemed firmly set on a career at the Papal Mint. These two violent and colourful personalities were enemies and colleagues there from 1537–40. Cellini accused Leoni of trying to poison him, but Leoni went one better by having Cellini imprisoned on the pretext that he had stolen the Pontifical jewels. He then overreached himself by attacking and injuring a Papal goldsmith and was sentenced to the galleys. He thanked Andrea Doria, who secured his release, by making medals showing the Genoese admiral on the obverse (133a; 132 is the drawing for the medal) and himself, either surrounded by his leg irons (133b) or rowing gratefully away from his galley (134) on the reverse. Of Michelangelo, one of the few artists with whom Leoni did not quarrel (he nearly killed Titian's son), he made what are perhaps the most sympathetic surviving portraits (135,136).

Leoni's portrait of Ippolita Gonzaga is a good example of the mannerist approach to portraying women, with its emphasis on elaborate coiffure, splendid jewellery and flowing drapery and its strange combination of a profile head and a

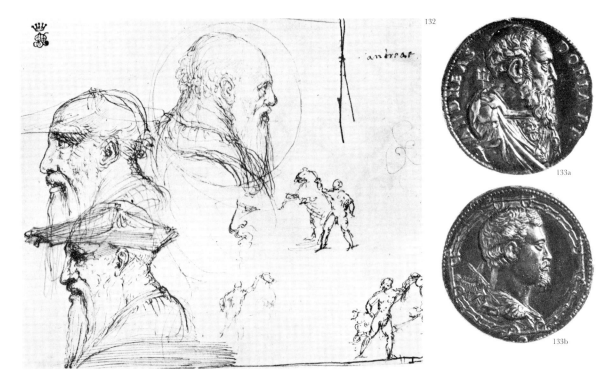

132

133a

133b

three-quarters facing bust (137). His reverses are immensely ambitious and admirable in their energy. In two of them Charles v is shown first as Jupiter engaged in his epic struggle with the giants (138), and then as Hercules, who is also disposing of a couple of giants before turning to deal with the Hydra of Lerna (139). In the latter Leoni has managed to convey the impressive physical bulk and energy of the hero in the tiny space provided by the medal by bringing him forward so that his foot is poised on the rim of the medal and his club is about to escape from its circumference and come hurtling towards us.

Among the artists with whom Leoni came into contact during his long period at the Milanese Mint (1550–90) we must mention Jacopo Nizolla da Trezzo. His portrait style is very close to Leoni's and his reverses, though somewhat less frenetic are, as his 'Fountain of the Sciences' (140) shows, exceptionally elegant. His work had considerable influence throughout Europe partly because, in service of the Emperor, he travelled to the Netherlands in 1555, produced marvellous portraits of Mary Tudor (**153a**) and Philip II and then went on to Spain in 1559, where he worked with Pompeo Leoni (son of Leone) at the Escorial. Among the other members of this school were Pier Paolo Galeotti, called Il Romano (d.1584), who came from Rome and settled in Florence, Ludovico Leoni, nephew of Leone who worked at the Papal Mint and then at Padua, and Antonio Abondio.

Like da Trezzo, Abondio was a successful proselytiser of this north Italian mannerist style, though in his case not only in Spain and the Netherlands but also in Austria. Here his wax models (141) and medals aroused such admiration that they partially undermined German self-confidence in their approach to the art and so contributed to its demise. When we see the elegance of Abondio's 'Cat-

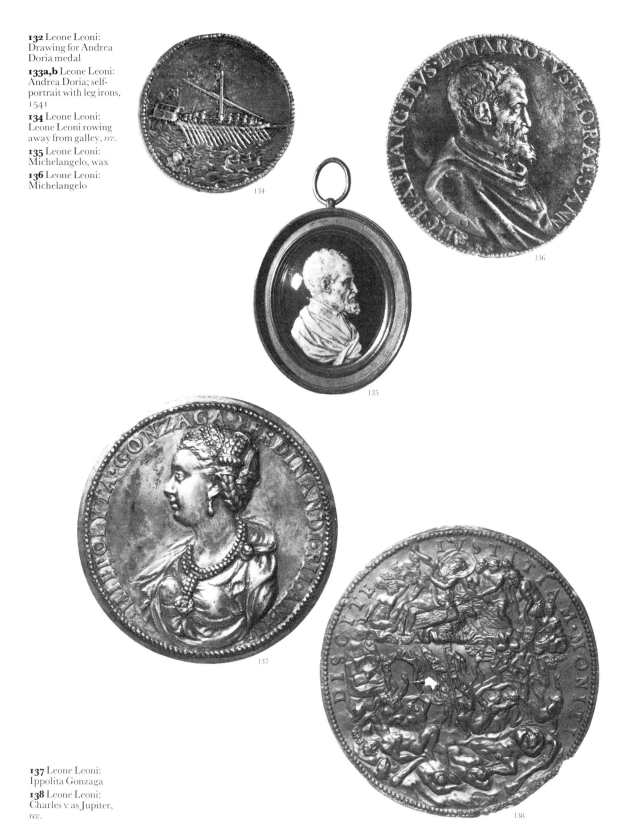

**132** Leone Leoni:
Drawing for Andrea
Doria medal

**133a,b** Leone Leoni:
Andrea Doria; self-
portrait with leg irons,
1541

**134** Leone Leoni:
Leone Leoni rowing
away from galley, *rev.*

**135** Leone Leoni:
Michelangelo, wax

**136** Leone Leoni:
Michelangelo

**137** Leone Leoni:
Ippolita Gonzaga

**138** Leone Leoni:
Charles v as Jupiter,
*rev.*

134

136

135

137

138

**139** Leone Leoni: Charles V as Hercules, *rev.*
**140** da Trezzo: Fountain of the Sciences, *rev.*
**141** Abondio: Archduke Ernest of Austria
**142** Abondio: Caterina Riva

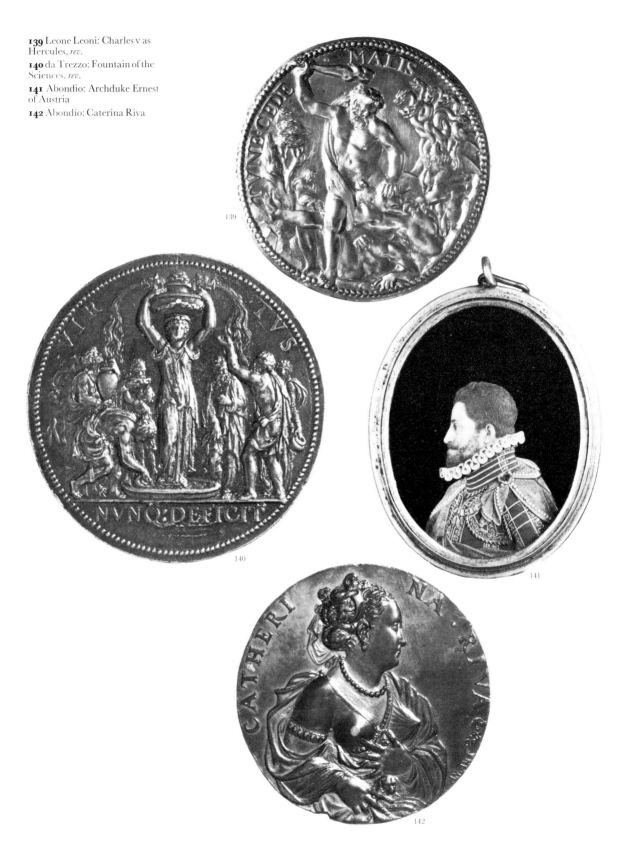

erina Riva' (142) or still more so that of '*Tertia Iam Vivitur Aetas*' (**143**), attributed to Ludovico Leoni, we can hardly be surprised at Mannerism's success.

More fashionable even than Leone as a portraitist was a contemporary Sienese medallist, Pastorino de' Pastorini (1508–92) who worked in his native town, in Ferrara, and later in Florence. Less ambitious than the members of the Milanese school he made little attempt to make use of the reverse, but he excelled in the production of unilateral portraits of members of fashionable society such as, for example, Edward Courtenay (155). His medal of 1556 of Cassan Ciaussi, or Hassan the Envoy (144), who was in Italy in connection with negotiations for an alliance with the Sultan, stands out from the ordinary run of nobles and priests. That of Isabella Manfro de' Pepoli from 1551 (145) shows an early use of the pearled border, which he made popular. It also illustrates that ability to make the most of the decorative qualities of clothing, hair and jewellery which made him such a successful portraitist.

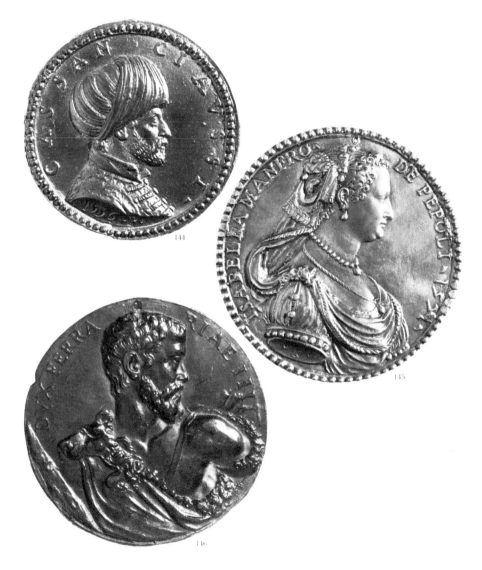

**144** Pastorini: Cassan Ciaussi, 1556
**145** Pastorini: Isabella Manfro de' Pepoli, 1551
**146** Ruspagiari: Ercole II d'Este

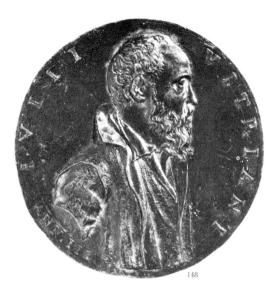 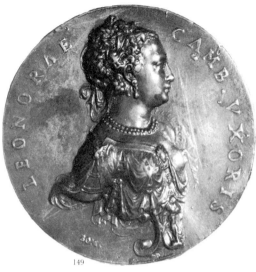

This emphasis on the exquisitely decorative, already developed to a high point in such works, was carried to its ultimate conclusion by a small group of medallists that developed around Alfonso Ruspagiari (1521–76). Ruspagiari was primarily a public servant, superintendent of the Mint in his native town of Reggio d'Emilia, but he must have delighted his contemporaries by his ability to produce portraits which are so lightly modelled that they seem almost to hover on the surface of the medal. Where the subject is a man like Ercole II d'Este (146), dressed in his heroic namesake's lionskin, there is a slightly uneasy relation between the delicate treatment of the portrait and the assumed virility of the subject. In his portraits of women, particularly that of an unknown Lady (**147**), eyes locked with her lover who peers out from behind a scrolled frame, the effect is extraordinarily seductive.

Close to Ruspagiari in style are G. A. Signoretti and Andrea Cambi of Cremona, known as Bombarda. The latter's portrait of Giulio Vitriani (148) again demonstrates the exceptional mastery of texture achieved by these artists – one can almost feel the texture of the jacket and shirt. Bombarda's portrait of his wife (149), who displays her bosom with the sangfroid characteristic of the ladies of the period, shows how far the tendency toward artificiality had been taken. The decorative has triumphed over reality to the extent that even the artist's portrait of his own wife turns out to be a portrait of a portrait – a medal of a bust supported on a scrolled stand.

But before the Italian mannerist medal expired on a death-bed of silk and roses, overcome by its own tendency toward the effete, it had not only sounded the death-knell of the German school and profoundly modified that of the Netherlands but had also provided the basis on which the French seventeenth century medallists, founders of the next dominant school, were to build.

**Plate 3: 126** Pillon: René de Birague, *c*.1576

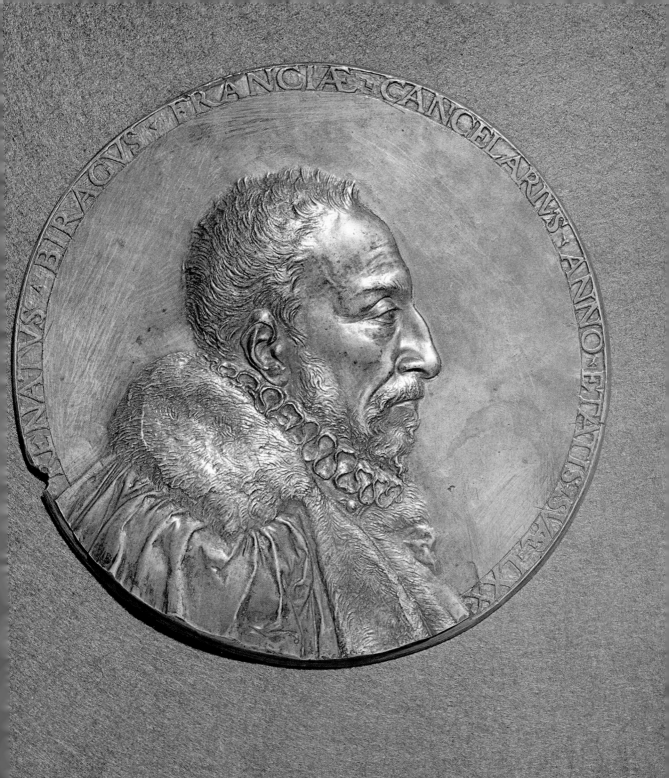

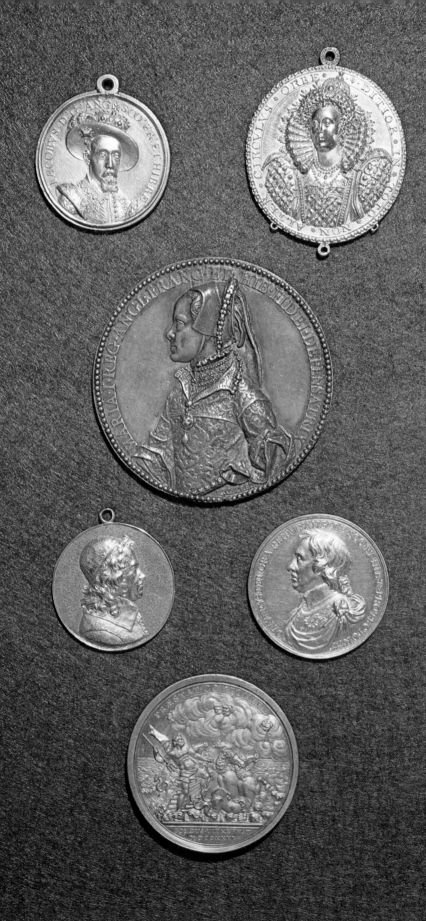

# 8. From the Armada to the Civil War – Nicholas Hilliard and the Simons

The Renaissance in England was late and largely literary in orientation. Medal-making, like the visual arts in general, was affected by it slowly and uncertainly and remained mainly in the hands of imported talent. The lack of native interest was not due to ignorance, for a number of Britons were portrayed by foreign medallists. Among these were John Kendal, of whom there is a medal made in 1480 (150) by a member of the school of Fiorentino, Archbishop Schevez of St Andrews whose medal by Quentin Matsys has already been noted (95), and Henry VIII, the best of whose medallic portraits is attributed to Hans Schwarz (151).

The first English medals to which any maker's name can be attached are those of Henry VIII proclaiming his supremacy over the Church and dated 1545, and of Edward VI for his coronation in 1547 (152). It seems likely that these were done by Henry Basse, chief engraver at the Mint. They exhibit a marked contrast between the scholarship of the reverse inscriptions, which are in Hebrew, Greek and Latin, and the relative crudity of the portraiture. Though these pieces did not, unfortunately, presage the development of an English school of medallists, the medallic portrait gradually became more popular. Mary Tudor, as wife of a great European monarch, Philip II of Spain, was naturally the subject of a number of medals. The finest of these by Jacopo da Trezzo, shows Mary's determined features and splendid dress on the obverse and the happy state of England under her rule on the reverse (**153a**,b).

**150** School of Fiorentino: John Kendal, 1480
**151** Schwarz: Henry VIII

**Plate 4**

*Top row*
**162a** Hilliard(?): James I, 1604
**161a** Hilliard(?): Elizabeth I: Dangers Averted, c.1588

*Second row*
**153a** da Trezzo: Mary Tudor, 1555

*Third row*
**170** T. Simon: John Thurloe
**181a** T. Simon: Oliver Cromwell, 1653

*Bottom row*
**221** Croker: Second Treaty of Vienna, 1731, *rev.*

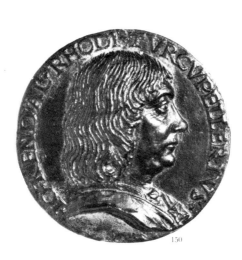

150

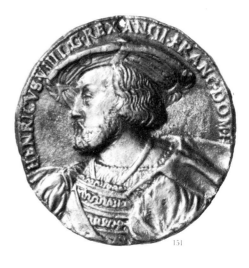

151

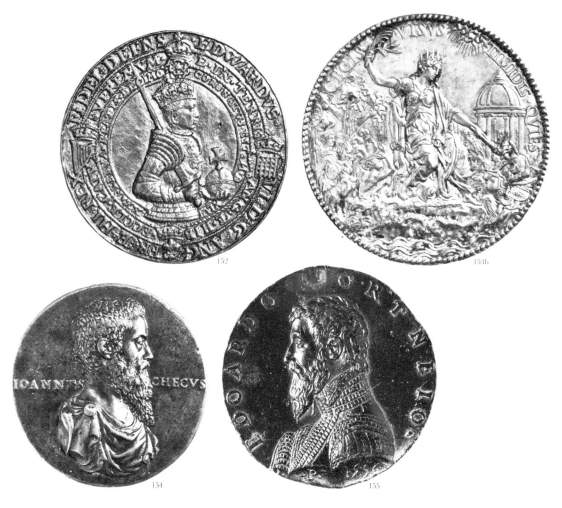

152

153b

154

155

Most medals of English people of the period, like those of John Cheke attributed to Ludovico Leoni (154) and Edward Courtenay made by Pastorino in 1556 (155), were produced abroad, and it was not until the visit of Steven van Herwijck in 1562 that an outstanding group of medals was actually made on English soil. Besides the Dimock medal, which we have already seen (100), the group includes exceptionally attractive portraits of Edmund Withipoll (**156**) and Richard Martin with his wife Dorcas Eglestone (157). Withipoll looks far more comfortable and secure in his fine doublet with its slashed sleeves than Cheke does in his classical drapery, while the Martin/Eglestone medal must rank among the most immediate and intimate portraits of a successful couple from the rising middle classes in Elizabethan England. Although Richard Martin was a gold-smith and Master of the Mint, he does not seem to have been inspired by van Herwijck to encourage local talent. In the absence of such encouragement even the most famous Elizabethan feats were recorded only by foreigners. Drake's circumnavigation of the globe was mapped out by Michael Mercator on an engraved silver plaque (158) which is a fascinating record not only of the voyage but also of the extent of the known world at that time. The defeat of the Spanish

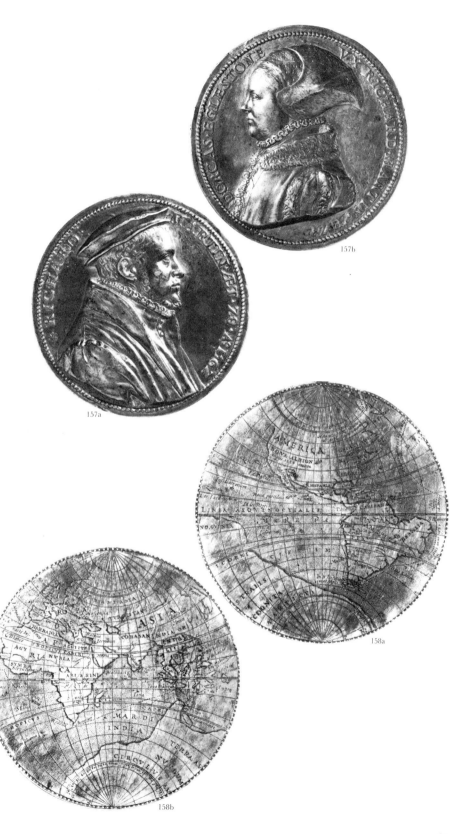

157b

157a

158a

158b

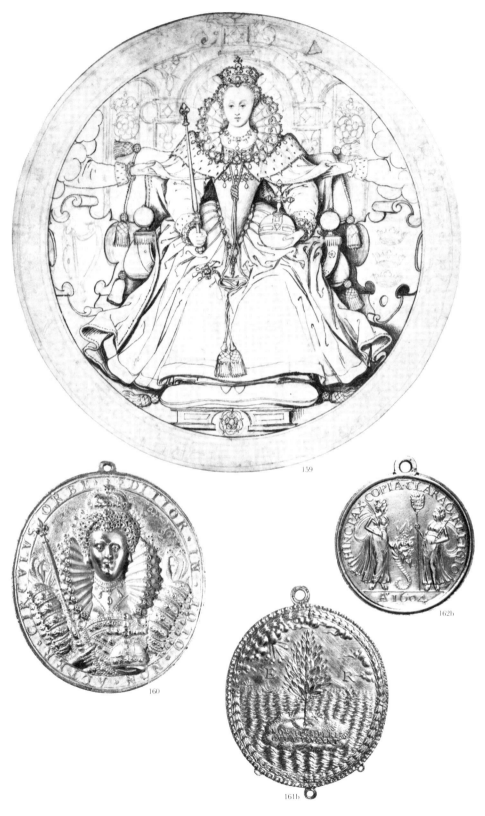

**159** Hilliard:
Drawing for Elizabeth's
Great Seal of Ireland
**160** Hilliard (?):
Elizabeth I; Dangers
Averted, *c.*1588
**161b** Hilliard (?): Bay
tree on an island; *rev.*
of medal of Elizabeth
I, *c.*1588
**162b** Hilliard (?):
Peace with Spain; *rev.*
of medal of James I,
1604

159

160

162b

161b

Armada was celebrated by quite a large group of medals made in Holland which included some of the finest early satirical pieces (105).

The first man who can properly be called an English medallist was, in accordance with the pattern which has by now become strangely familiar, one of the greatest painters of his time. Nicholas Hilliard (1547–1619), who was a goldsmith as well as a painter, is known to have designed and engraved great seals for Elizabeth I (159) and, under James I, to have held a patent as principal drawer of small portraits and embosser of the King's medals of gold. It is very probable that it was he who produced two medals showing the Queen in all her finery on the obverse and a bay tree, supposed to be immune to lightning, on the reverse (160, **161a**,b). It is likely that the lightning, visible in the distance, represents the wrath of heaven. It is deflected from the island (Britain) by the bay tree (Elizabeth), and instead threatens the ships of the Spanish Armada which can be seen in the distance. The loop for suspension and the chain, preserved with a silver example of the medal in the British Museum, leads one to believe that these were certainly worn, and they may possibly have been awarded to those who had played a distinguished part in the battle. It would certainly be typical of the place of the medal in England that one of its first and greatest medals should have been produced for this purpose.

The technique used to produce these medals is very much that which one would expect of a goldsmith. It relies on direct chasing of the metal for its effect – the obverse of the large gold version in the British Museum (160) has even been decorated by hand with a design that has been punched into the field after the medal was cast. The medal of James I (**162a**,b), struck to celebrate the peace with Spain in 1604, probably also by Hilliard, shows in its detailed rendering of the King's doublet the same love of splendid clothing that is evident in the medals of Elizabeth. The fine and bold, if somewhat unlikely-looking hat, however, contributes to a much livelier and less hieratic overall effect. No other medals can be firmly attributed to Hilliard although it is possible that he made some engraved counters after being given a patent for their production by James I in 1617, and his influence can be seen in a number of coin-like medallets in low relief of, among others Elizabeth, Anne of Denmark and one of Henry, Prince of Wales from about 1612 (163a,b) which were probably made by Charles Anthony, chief engraver at the Mint from 1599–1615.

Hilliard, again following the pattern to which we have become accustomed, had little or no influence on later British medallists. But he did have a profound effect on the development of medallic art in Britain. Despite being the pioneer of the art, he nevertheless effectively stifled it at birth through his exquisite and

**163a,b** Anthony (?): Henry, Prince of Wales; coat of arms, 1612

163a

163b

**164a,b** van de Passe:
Counter: James I; Charles I as
Prince of Wales

**165** Hendrick Goltzius: The
Earl of Leicester, 1586

**166a,b** van de Passe: James I;
coat of arms

164a

164b

165

166a

166b

167a

167b

168

169

masterly contribution to the English tradition of the miniature painted portrait. In other countries the initial *raison d'être* of the medal had been the provision of small-scale, portable and wearable portraits. In England this role had already been filled by the miniature, and the resulting lack of patronage inhibited the development of a healthy and continuous native school of medallists. Deprived of a tradition to which they could refer, British medallists and patrons frequently failed to respond to the different functions and possibilities that later opened up to medallic art. For this reason, as the introduction to the great work on British medals, *Medallic Illustrations of British History*, points out, the history of English medallists is to a great degree the history of the medallists of other countries.

Among the more important of these foreigners was Simon van de Passe who came to England in about 1615–16 and produced engraved portraits, probably initially under licence from Nicholas Hilliard. The majority of the pieces produced in his workshop fulfilled a function, as gaming and reckoning counters, which miniatures could not. These counters came in sets, some of which contained real or imaginary portraits of the Kings and Queens of England from Edward the Confessor onwards (164). De Passe also produced larger portraits, a taste for which had already been introduced into England by Hendrick Goltzius' portrait of the Earl of Leicester, dated 1586 (165), and Jacob II de Gheyn's 'George Clifford, Earl of Cumberland' of 1594. These included portraits of members of the Royal Family, among which is one of James I (166a) which has a fine heraldic reverse (166b), and of a number of private individuals.

Another foreign medallist, Nicholas Briot, fled to England in 1625, leaving behind in France a number of angry creditors and a reputation as a charlatan, gained by specious claims of technical advances made during his tenure of office as *Tailler Général*. He brought with him coin-presses of a type which had been used in France since the mid-sixteenth century. After having demonstrated that these produced results superior to those obtained by the old method of striking with a hammer, he became Chief Graver at the Mint in 1633. At their best, his cast medals are rather fine, like the medal proclaiming English dominion over the seas produced in 1630 (167a,b). His struck pieces may be amusing, as, for example, the reverse of the medal commemorating Charles I's return to London in 1637 (168) showing the old St Paul's, London Bridge and a river filled with swans and rowing boats, but they would win no prizes for design.

The Civil War stimulated a demand for portrait badges that demonstrated the loyalty of partisans of both sides, and could be used to reward them. These needed to be readily reproducible in large numbers, which portrait miniatures are not, so medals enjoyed a brief vogue. The Royalists were served by Thomas Rawlins who provided models for badges which, partly due to the sheer number which were required, tend to be rather shoddily made. Parliament and the Commonwealth were better served by the only outstanding medallists that Britain was to produce until the nineteenth century – Thomas and Abraham Simon – who between them produced a regular gallery of portraits of contemporary notables.

From a statement by George Vertue in his book on Thomas published in 1753, it appears that most of them were cast from models in wax by Abraham although none of the surviving models by him (for example, 'Self-portrait', 169) seem to

**167a,b** Briot: Charles I; dominion over the seas, 1630
**168** Briot: Charles I's return to London, 1637, *rev.*
**169** A. Simon: Self-portrait in wax

have been used for medals. Once cast they were usually chased and signed by Thomas. The beautiful gold medal of John Thurloe (**170**), which is signed TS on the truncation, is probably a result of this collaboration. The gold example of the medal of General Monk (171), on the other hand, seems to have been chased by someone else. Not only are there errors in the reverse legend and details omitted on the obverse, but the signature, which is clearly visible on a silver specimen from the Bank of England Collection, is missing.

This division of labour in no way implies that Thomas was the inferior artist. The latitude of interpretation open to a chaser working in soft metal is demonstrated by the two versions of the medal of the Earl of Southampton (172, 173). The cap which he is wearing in one version has been transformed into hair in the other. More important in establishing Thomas's originality is his sketch book which contains, among other portraits of contemporaries, one of Lord Strafford (174), and some preparatory drawings for medals (175). The Simons also used other sources for their medals – both Thomas's medal of Cromwell (**181a**,b) and Abraham's of Elizabeth Cleypole (176) are taken from miniatures said to be by Samuel Cooper (177).

Thomas Simon's struck medals, in whose production Abraham seems to have played no part, show his complete mastery of the engraver's art. His 'Dunbar medal' (178a,b), which was ordered by Parliament to be distributed among officers and soldiers, moved even Cromwell to describe him as 'ingenious and worthy of encouragement'. The reverse which shows Parliament assembled, is based on his design made in 1649, for the Great Seal (179). In 1653 Parliament

**174** T. Simon: Drawing for portrait of the Earl of Strafford

**175** T. Simon: Drawing for a medal

174

175

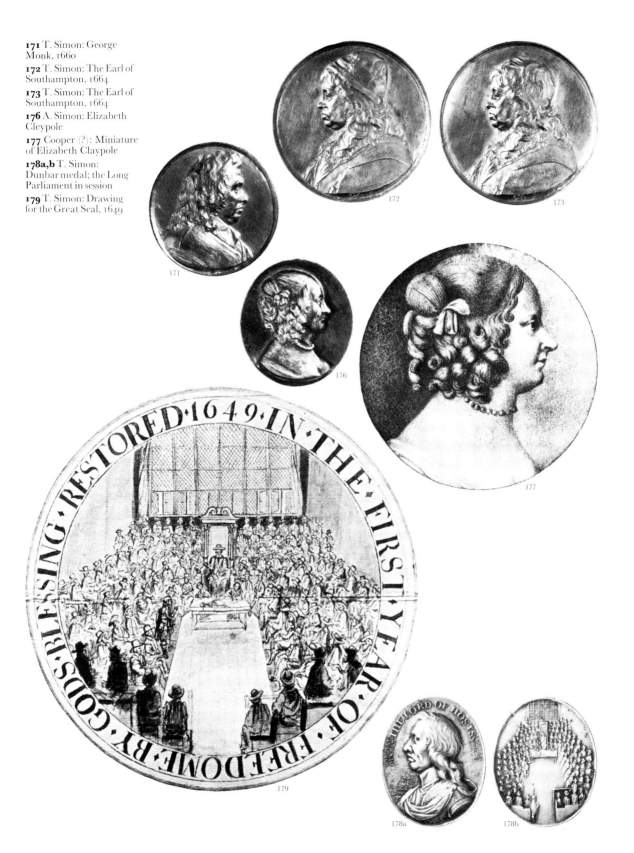

**171** T. Simon: George Monk, 1660

**172** T. Simon: The Earl of Southampton, 1664

**173** T. Simon: The Earl of Southampton, 1664

**176** A. Simon: Elizabeth Cleypole

**177** Cooper (?): Miniature of Elizabeth Claypole

**178a,b** T. Simon: Dunbar medal; the Long Parliament in session

**179** T. Simon: Drawing for the Great Seal, 1649

ordered another medal, a 'Naval Reward' for senior officers who had taken part in victories over the Dutch, and this is another triumph of minute skill and careful design (180a,b: the example given to Admiral Penn). The medal celebrating Cromwell's elevation to the Protectorate (**181a**,b), also of 1653, is not only one of the finest portraits of the subject but also a demonstration of Thomas's ability to make a rather boring subject – the arms of the Protectorate – attractive.

Even in the relative disfavour that he experienced under the Restoration Thomas Simon continued to produce fine work – the medal of Clarendon for example, or the Petition Crown of 1663. But even before his death in 1665 and his brother's retreat into obscurity, English medal-making reverted to type with the importation of a series of foreign engravers and the abandonment of any attempt to build its own tradition.

180a 180b

181b

**180a,b** T. Simon: Naval Reward; naval battle, 1653
**181b** T. Simon: Arms of the Protectorate, *rev.* of medal of Oliver Cromwell, 1653

# 9. Dupré and Warin – the Sun King and his enemies

The history of medallic art in France in the first half of the seventeenth century is to a great extent that of two medallists, Guillaume Dupré and Jean Warin.

Dupré (*c*.1576–1643) was born at Sissonne near to Laon. His master was probably the sculptor Barthélemy Prieur, whose daughter he married in about 1600. In 1597 he successfully launched his career with a medal of Henry IV and his mistress, Gabriel d'Estrées. This so pleased the King that he made Dupré 'Sculptor in Ordinary to His Majesty'. Seven years later, following on a number of successful medals, including that of Henry IV and Marie de Médicis, he reached the peak of his profession when he was appointed *Contrôleur Général des Effigies* – the position which had been created for Germain Pillon. Dupré's early style shows, though to a lesser extent than that of Jacquet or the Danfries, traces of Netherlandish influence in the firmness of his portraits, like that, for example, of Lavallette, made in 1607 (182a) and in the fascination with intricate detail evident in his reverses (182b). Perhaps even more important is the influence of the school of Leoni and da Trezzo, which was to persist into Dupré's later work, as can be seen by comparing his reverse for a medal of Brulart de Sillery (183) with that of a medal by da Trezzo of Philip II of Spain (184). Dupré, however, rejected the excesses of Mannerism and by 1611, in his medal of Louis XIII and his mother, Marie de Médicis (185a,b), he had developed a stately portrait style and an unfussy yet delicate handling of reverse compositions which were entirely his own.

In the following year Dupré travelled to Italy. There he was able to produce a series of medallic portraits on a much grander scale than he, or indeed any contemporary medallist, had used so far. He also experimented with other media, like coloured wax, as in, for example, his portrait of Cosimo II (186). His portraits of Marcantonio Memmo, Doge of Venice (**187**), of the fat and unlovely Francesco IV of Mantua (188), or of Francesco de'Medici show the effect that he was able to achieve and the influence on his work of Italian medallists like Gaspare Mola, with whom he came into contact (222).

On his return to France Dupré made, in 1618, the finest of his great medallions, a portrait of Pierre Jeannin, Superintendent of Finances (189). After this he settled down to produce a series of medals of Louis XIII and his Queen, Anne of Austria, and of great statesmen or generals, like the Maréschal de Toyras (190a,b), which in their dignity and restraint laid the foundations of an approach to medals that was to be universally adopted as the ideal by the end of the century.

The work of Guillaume Dupré did not, of course, come into being in complete isolation. Nicholas Briot, whose work in England has already been described, and Pierre Regnier engraved medals at the Mint. Other medallists like Claude Frémy, Jacob Richier and Claude Warin made quite ambitious cast medals in the

 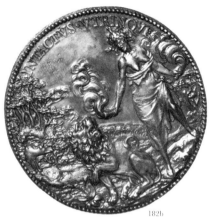

182a 182b

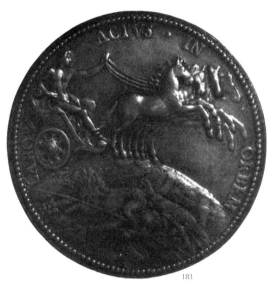 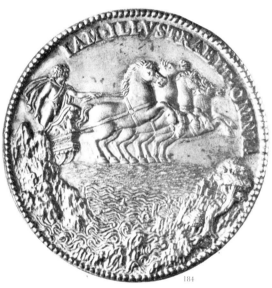

183 184

**182a,b** Guillaume Dupré:
Lavallette; Lion, fox and Fury, 1607

**183** Guillaume Dupré: Apollo; *rev.* of
medal of Brulart de Sillery, 1613

**184** da Trezzo: Apollo; *rev.* of medal
of Philip II of Spain, 1555

**185a,b** Guillaume Dupré: Louis XIII
and Marie de Médicis; Louis as
Apollo and Marie as Minerva, 1611

185a 185b

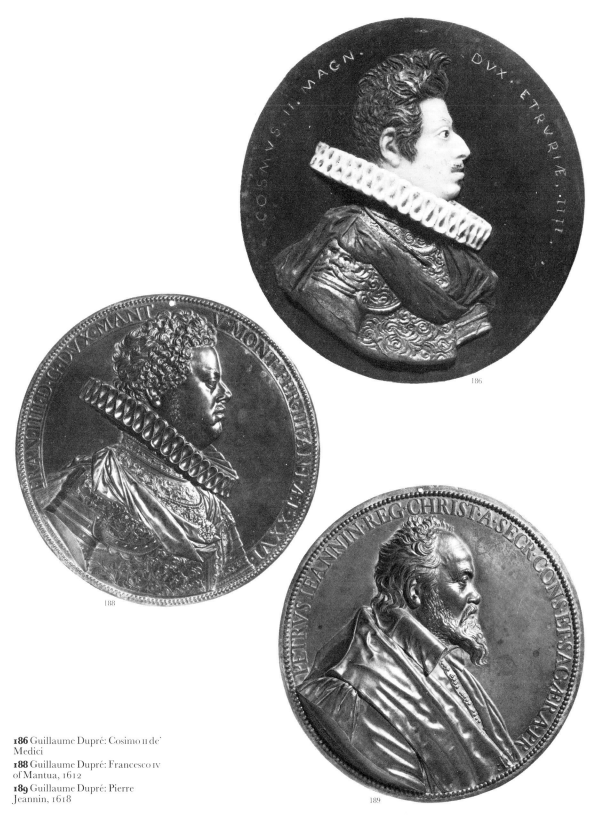

**186** Guillaume Dupré: Cosimo II de'
Medici
**188** Guillaume Dupré: Francesco IV
of Mantua, 1612
**189** Guillaume Dupré: Pierre
Jeannin, 1618

first half of the century. Claude Warin in particular was quite prolific – some seventy medals by him are known. During a visit to England from about 1631–36 he produced a number of portraits of English people. Some of these, for example his medals of Thomas Carey (191) and William and Anne Blake, are very attractive, though his later work, his portrait for example of Alphonse de Richelieu (192), tends to be rather heavy.

Interest in cast medals was, however, gradually waning. Dupré's works, though in fact always cast, became, towards the end of his career, so sharp in detail and smooth in the field that they look as though they have been struck (190). In relying increasingly on striking, Jean Warin, who succeeded Dupré's son as Controller General in 1647, only carried to its logical conclusion the tendency inherent in Dupré's approach.

Jean Warin (1596–1672) was born at Sedan. His family were probably engravers who worked in the mints of the petty princes in the area around Sedan and Liège. These princes made a profit from producing coinage of inferior alloys which was intended to pass at par with the coins of neighbouring countries. If Jean learned his skill as an engraver in one of these dubious mints before he came to France in 1625, it would explain his later condemnation for forgery.

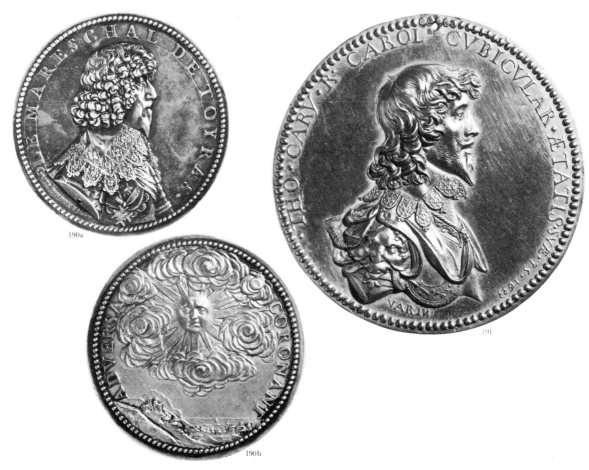

190a

190b

191

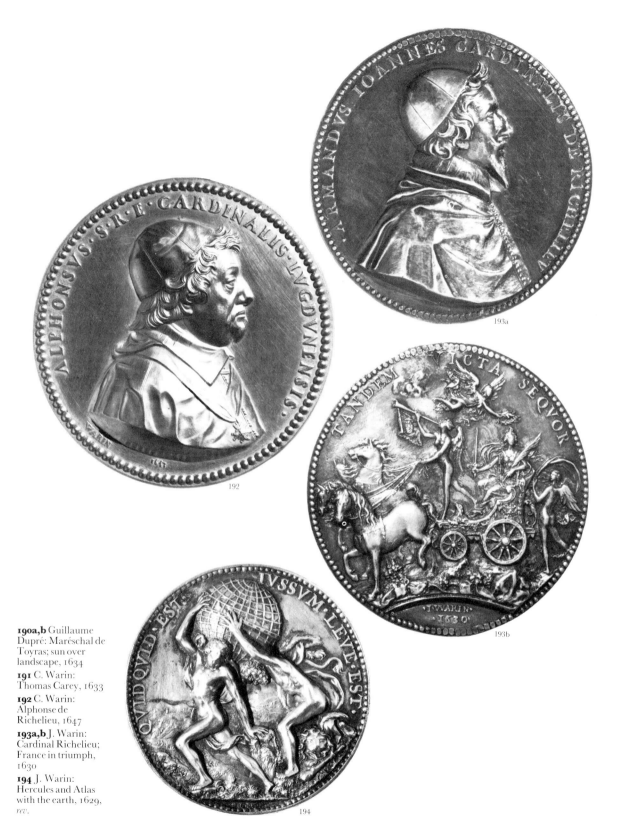

193a

192

193b

190a,b Guillaume
Dupré: Maréschal de
Toyras; sun over
landscape, 1634
191 C. Warin:
Thomas Carey, 1633
192 C. Warin:
Alphonse de
Richelieu, 1647
193a,b J. Warin:
Cardinal Richelieu;
France in triumph,
1630
194 J. Warin:
Hercules and Atlas
with the earth, 1629,
*rev.*

194

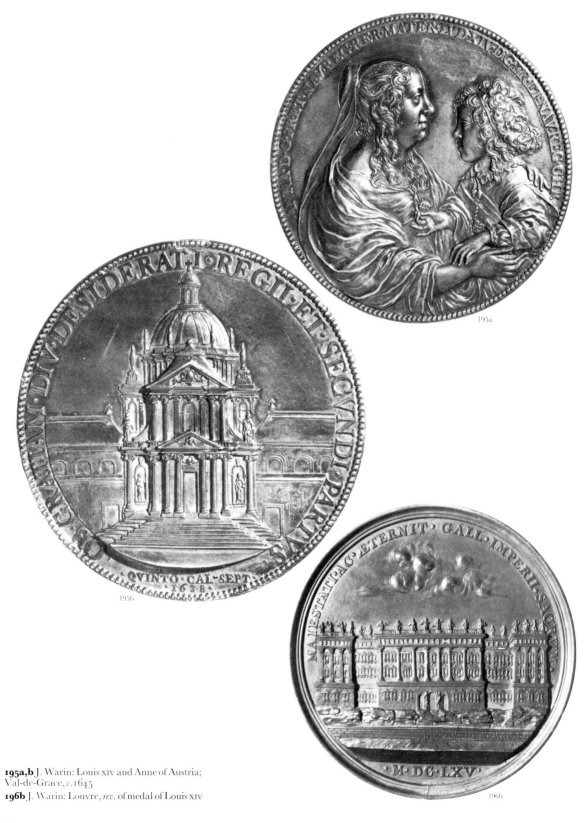

195a

195b

196b

**195a,b** J. Warin: Louis XIV and Anne of Austria; Val-de-Grace, c.1645
**196b** J. Warin: Louvre, *rev.* of medal of Louis XIV

Warin's early work in France was stylistically conservative. The reverse of his portrait of Richelieu 1630 showing France crowned by Victory, heralded by Fame and followed by Fortune, who is chained to her triumphal car (193a,b), shows more than a vestige of mannerist exuberance, as does the reverse of a medal of Antoine de Ruzé (194) of the previous year. (This has generally been attributed to G. Dupré, but the version in the British Museum is signed Warin and its style is much closer to that of the Richelieu medal than Dupré's contemporary work.) Gradually, however, the prevailing trend toward classicism had its effect. When in the 1640s Warin produced a medal to celebrate the laying of the foundation stone of the Val-de-Grâce (195a,b), it reflected the sobriety and restraint of the church which was one of François Mansard's most classical works.

Warin's most ambitious medal produced in 1665 shows Bernini's projected design for the Louvre (**196a**,b). The obverse portrait of Louis XIV is a magnificent evocation of the absolute monarch in the early years of his personal rule. In its heroic idealisation of the subject it has come a long way from the simple and direct approach to portraiture adopted by Renaissance medallists in Italy or Germany. This change in approach reflects a more profound change in attitude towards the function of art in relation to the state. Experience of the chronic tendency of French society to drift into civil war when central government was weak led a line of French statesmen, from Henry IV through Richelieu and Mazarin to Louis XIV, to place the greatest importance on increasing the power of government. One way of doing this was to impose central control on the arts.

This was precisely the purpose of the 'Little Academy', which was set up in 1663 by Colbert. To its members Louis said: 'You can, Messieurs, judge my esteem for you, since I confide to you the thing which is most precious to me in the world, my *gloire*.' Initially the Academy exercised dictatorial powers over all the arts, but increasingly it was directed to concentrate upon the production of great 'Medallic Histories' which would preserve the memory of the victories of the Sun King in the same way that coins had preserved that of the Roman Emperors.

These histories appeared in four main stages. The first consisted of the pioneering efforts of Jean Warin and his contemporaries in the 1660s and 1670s. Most of their medals, for example, Warin's celebration of the completion of a canal system stretching from the Atlantic to the Mediterranean (197), record contemporary events. This, like so many of Warin's medals of the period, provided the basic composition which was reused in the later Medallic Histories. Another example is Warin's composition for a medal commemorating the 'incredible speed' with which the Franche-Comté was conquered in 1668 (198). This was reused in the first serious attempt at a Medallic History in the 1680s (199), in the elaborate and complete history which appeared with an accompanying folio volume in 1702 (200), and in the revised version of 1723 (201).

It is ironic that, by providing the talent and expertise necessary for the initiation of such an enterprise, Warin had unwittingly signed the death-warrant of medal-making as an autonomous art. The galaxy of talented medallists who worked in France in the late seventeenth century – Thomas Bernard, Jean Dollin, Michel Molart, Jean Mauger and Jérôme Roussel to name only a few – had almost no freedom to execute their own ideas. Instead they had slavishly to copy

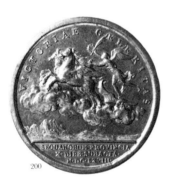

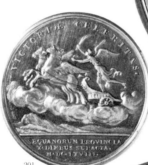

**197** J. Warin: Completion of canal system, 1667, *rev.*

**198** J. Warin: Conquest of the Franche-Comté, 1668, *rev.*

**199** Conquest of the Franche-Comté, *c.*1688, *rev.*

**200** Mauger: Conquest of the Franche-Comté, *c.*1695, *rev.*

**201** Conquest of the Franche-Comté, *c.*1705, *rev.*

**202** van Abeele: Charles II, 1660

**203** J. Warin: Louis XIV, 1660

**204** Höhn: John III Sobieski, 1683

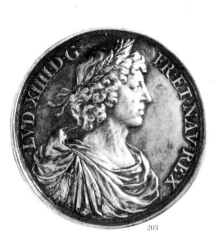

203                                                     204

drawings by draughtsmen (Sebastian le Clerc, Antoine Coypel), who interpreted the ideas and tidied up the sketches of academicians (writers like Racine), who were directly subservient to a Secretary of State and whose work was corrected by the King himself.

Yet the Medallic Histories of Louis XIV had enormous prestige and influence throughout Europe. Their prestige was due partly to their scale (the 1702 and 1723 versions contained some three hundred medals of uniform size), partly to their technical accomplishment (the French Medal Mint was the most advanced in Europe), and partly to their strictly homogenous style and presentation. Their influence was exercised partly through the numerous foreign medallists drawn to Paris to work on the scheme and partly through organised propagation of the Medallic Histories and their message. Foreign artists, like their French counterparts, had to submit completely to the technical and stylistic discipline imposed by the literary classicists who composed the Little Academy. When they left, even those, like Raymond Faltz, who were disgusted by the lack of artistic freedom available to them in France, continued to apply what they had learned there. The result was that medallists like Faltz, Meybusch, Smeltzing and the Roettiers gradually pulled other national schools into the French orbit. The organised propagation of the Histories took the form of widespread publication (in Germany, Holland and Switzerland), of the exhibition of dies and medals in the Louvre and of the gift by Louis of sets of medals to fellow monarchs and their ambassadors.

One of the most remarkable effects of this activity can be seen in changes of approach to royal portraiture. In the first half of the seventeenth century medallists in different countries adopted widely different approaches – compare, for example medals, of Charles II by P. van Abeele (202) and of Louis XIV by Jean Warin (203) both dated 1660. Variations of the former style, characterised by large and unflattering frontal portraits, were at that time dominant throughout northern and eastern Europe. But by 1683 even so provincial a medallist as Johann Höhn was directly imitating a French prototype in his portrait of John III Sobieski (204). John Sobieski was in some ways unpromising material – it is difficult to make a fat middle-aged man with a walrus moustache look very like a

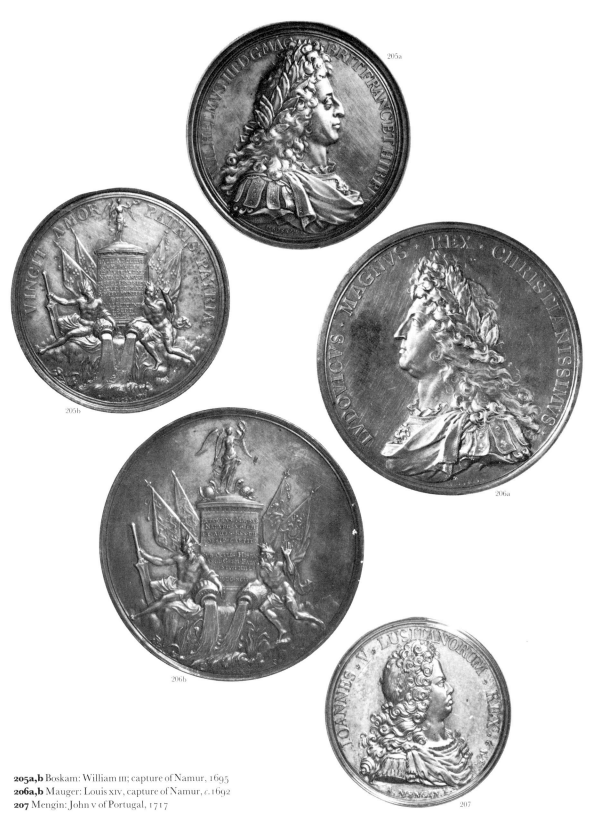

**205a,b** Boskam: William III; capture of Namur, 1695
**206a,b** Mauger: Louis XIV, capture of Namur, *c.*1692
**207** Mengin: John V of Portugal, 1717

clean shaven seventeen-year-old. By contrast William III has been turned by Jan Boskam into something like a twin of the Sun King (205a). Not only his clothing, wig and laurel wreath, but even his features have been modelled in imitation of Louis, as represented by Jean Mauger (206a) in about 1692. The debt owed by court medallists to the French example is equally evident in almost every European country from Russia, Sweden and Denmark to Spain and even Portugal, as a medal by A. Mengin of John v of Portugal (207), demonstrates.

A particularly interesting reaction to the massively successful use of medallic propaganda by France can be seen in the output of one of its most consistent enemies, Holland. In the earlier part of their struggle with the French the Dutch were content to continue with their well-established tradition of using the medal as a metallic pamphlet. In a piece dated 1691 we see Louis XIV described as the 'decrepit oppressor' leaning on a sword made of coins resting on a bomb (208a) – for it is only by bribery and bombardment that he could have captured Mons. In the background we see ladies from his court whom Louis, to his disgrace, was supposed to find more interesting than the delights of battle. On the other side we have William III, the 'successful liberator' who has taken three kingdoms (three crowned shields) by force of arms (208b). His banner represents the Cap of Liberty and the Symbol of Christ which he defends against the horrible harpies who flee away to the right. One of the most extreme examples of this unsubtle kind of frontal attack ridicules Louis' concessions to the Pope at Avignon and to the Infidel at Algiers (209). It humiliates him in the most obvious way by showing him responding to the enemas of the one and the chamberpot kindly preferred by the other. But a more subtle approach was also possible. Another medallist took an

**208a,b** Louis XIV; William III, 1691

**209** Louis XIV's concessions to the Pope and to the Moors, 1689

official French piece by Chéron (210), commemorating the bombardment of Algiers in 1684, turned '*Africa Supplex*' into '*Gallia Supplex*' and showed the relative positions of the participants ludicrously reversed (211b). By combining it with an obverse that pretends to be part of an official series (211a) he managed to make the French look very silly.

This approach became popular throughout the countries opposed to France. A medallist like P. H. Müller, faced with the necessity to comment on an Anglo-Dutch victory like that at La Hogue would simply take a French original, in this case Jean Dollin's piece for the French victory off Palermo (212), alter it a little and put in a reference to Louis, in this case a sinking sun with the legend '*Se condet in undas*' (it shall hide itself in the waves). This left him with a medal that not only celebrated the victory but also turned the knife in the French wound (213). The same formula could also be used to make more general points. As late as 1709 we find Martin Brunner, another German, taking Louis in his incarnation as Apollo, and turning him into Phaethon under the legend 'he is a lying sun whom the stars terrify', doomed to disaster by the zodiacal signs representing Holland (Leo), Queen Anne (Virgo), Justice (Libra) and Defeat (Scorpio) (214).

In Holland itself the game had by this time been taken a stage further. In 1695 Namur was taken from the French. Hostile medallists naturally turned with glee to Mauger's medal of 1692 (206b), which had particularly annoyed the allies by boasting that Louis had captured Namur under the eyes of an army of Spanish, English, German and Dutch troops one hundred thousand strong. Jan Luder adopted the traditional approach – a medal broadly based on the French piece on which an obelisk representing the French monarchy is overturned (215). Jan Boskam adopted a different tactic. He copied Mauger's work almost exactly, though replacing the Allied standards by French ones (205b), complemented it with a portrait (205a) close to Mauger's original (206a), and allowed himself only

**210** Chéron: Bombardment of Algiers, *c*.1684, *rev.*
**211a,b** Louis XIV; the French alliance with the Turks

a touch of irony in the legend: 'The French, to celebrate with great festivity the birthday of Louis XIV, bid an eternal farewell to the castle of Namur which they had occupied for three years and fortified at the greatest expense, 1 September 1695'. It was in this increasingly refined satire that the Dutch, and indeed Northern European medallists generally, paid their sincerest compliment to the French. It had come to the point where, in order to undermine their opponents, they had to abandon their individuality. France may finally have lost the war but the cultural battle had already been won.

John Croker, a German medallist who lived in England during the early eighteenth century is an interesting example of the effects of French cultural dominance. His medals are not direct copies of French pieces, though medals like those for the capture of Bonn, Huy and Limbourg in 1703 or of Lille in 1708 (216) certainly show knowledge of similar compositions – for example numbers 33 and 7 in the Medallic History of 1702 (217). More significant is the way in which he

**212** Dollin: Battle of Palermo, *c.* 1676, *rev.*

**213** P. H. Müller: Battle of La Hogue, *c.*1692, *rev.*

**214** Brunner: Louis XIV as Phaethon, 1709

**215** Luder: Capture of Namur, 1695, *rev.*

**216** Croker: Capture of Lille, 1708, *rev.*

**217** Mauger: Capture of Thionville, *c.*1695, *rev.*

20th Feb 170⁵⁄₆ Let a Medals be made of fine gold or fine silver with her Majesties Effigies & ye usual inscription on one side & her reverse above delineated on the other.
Js. Newton

20th Feb 170⁵⁄₇ The Medal above delineated may be made in fine gold or fine silver
Js. Newton

218

219

has absorbed the ethos of the French work. His medals are similar to medals of that series not only in style but also in fabric and size, and they are even produced in a uniform series. The idea behind the French Histories, that the medal should serve as an orderly record of the state's triumph, has been equally thoroughly absorbed. But Croker, unlike his French contemporaries, was allowed to be an artist in his own right as his drawings with comments by Sir Isaac Newton, then Master of the Mint, demonstrate (218, 219). His portraits of Anne (220) are unrivalled in their serene dignity and his reverses, for example for the 'Capture of Gibraltar' and the 'Battle off Malaga' in 1704, are carefully and pleasingly composed. When in later life he broke free from the shackles of French classicism and allowed himself to experiment with the freedom of the baroque he managed to commemorate the Treaty of Vienna (**221**) in wonderfully vigorous style.

**218** Croker: Drawing for medal

**219** Croker: Drawing for medal

220

**220** Croker: Queen Anne, 1707

# 10. Italian Baroque

Alone in their refusal to bow to the French example, Italian medallists pursued their exploration of the possibilities of the baroque with almost undiminished independence. Though certain artists in Rome were employed in the production of struck medals for Church and State, others continued to work as independent artists and to develop the potential of the cast medal.

Gaspare Mola, whose style was close to that of Guillaume Dupré (see for example his medal of Cosimo II, Duke of Tuscany; 222), differed in having almost all his medals struck. So too did his nephew, Gaspare Morone Mola, who also worked at the Papal Mint (1640–68). Morone Mola, though a master of the techniques of engraving and wax modelling was, like his French counterparts, reduced to copying another artist's sketches. Unlike them, however, he had the advantage that these sketches were from the hand of a great artist – Gian Lorenzo Bernini. In some cases Morone Mola's wax models have also survived, allowing us to trace the development of a medal like that celebrating the construction (by Bernini) of a Cathedra to contain St Peter's chair, from the drawing (223), through the model (224) to the finished work (225). It is unfortunate that,

**222** Gaspare Mola: Cosimo II, Duke of Tuscany

**223** Bernini: Drawing for no. 225

**224** Gaspare Morone Mola: Wax model for Cathedra, 1662

**225** Gaspare Morone Mola: Cathedra, 1662

whether because Bernini was not conversant with the limitations of the die engravers' art, or because of Morone Mola's own failings as a medallist, the vigour of the drawings is lost in the medals. Indeed a comparison between the work of uncle and nephew shows the direction, from relative breadth and freedom towards a dry concentration on technique and detail, in which the Italian struck medal was heading.

Perhaps in reaction to this tendency a new school of cast medallists grew up in northern Italy around a sculptor and medallist called Massimiliano Soldani-Benzi (1658–1740). The reverses of his earlier medals, like those of the architect Cyro Ferri and Francesco Reddi, show both the grace and the vigour of which his style was capable. The decorous if slightly deshabillé figures representing Painting and Architecture in a medal produced in 1680 (226) have loosened their drapery and joined with considerable enthusiasm in a bacchic orgy in one of 1684

**226** Soldani-Benzi: Painting and Architecture, 1680, *rev.*
**227** Soldani-Benzi: Bacchic orgy, 1684, *rev.*
**228** Soldani-Benzi: Serristori Patriti, 1711
**229** Selvi: Giuseppi Martelli, 1722, *rev.*

226

227

(227). His portraits at their best, as, for example, that of Serristori Patriti dated 1711 (228) combine strongly characterised features with the same liveliness in the flow of drapery and hair.

A group of pupils and imitators, including Antonio Selvi (1679–1755), Lorenzo Maria Weber and his brother Giovanni Zanobio, Bartolomeo Veggelli, G. Francesco Pieri, Antonio Montauti and Giovanni Pozzo produced medals in this style throughout the eighteenth century. Selvi's work is particularly close to that of his master – the reverse of his medal of Giuseppe Martelli, Archbishop of Florence, dated 1722 (229) is unchanged in style from that of Soldani forty-two years earlier (226). His portraits, though competent, derive more of their interest from the extraordinary features of his sitters than from any originality in their execution. This is even more true of a medallist like Montauti who occasionally hit upon a subject like Count Lorenzo Magalotti, whose appearance was so

228

229

extraordinary that it combined with the conventional forms of drapery and wig to produce an almost surreal image, a distillation of the cruel absurdity of the decadent Italian aristocracy (230).

Lorenzo Maria Weber (1697–1774) a German who worked in Florence from 1720–54 was the most original member of the group. He improved upon the generally rather poor casting technique used by these medallists, using a lighter coloured patina and producing finer and more finished casts. His reverse compositions, for example that for a medal of Gaietano Berenstadt (231), show an awareness of the beginning of a trend away from the confusion of the baroque toward the calm serenity of classicism. To follow the origins and development of this trend we have, once again, to turn to France.

**230** Montauti: Count Lorenzo Magalotti
**231** Weber: Gaietano Berenstadt, *rev.*

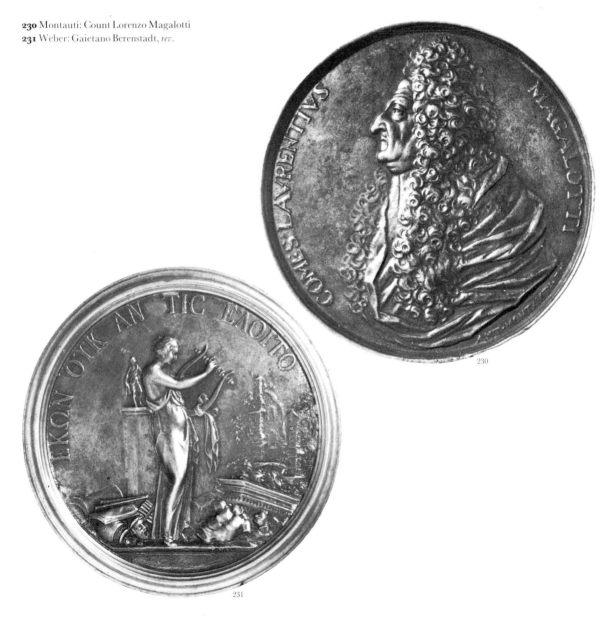

230

231

# 11. From Rococo to Revolution– the medal in eighteenth-century France

The bureaucratic and centralised control of medal-making in France did not, as one might expect, have the effect of imposing a stylistic stasis. Instead, as Louis grew old, and as the aristocracy became bored with the rigid formality of the Sun King's court, there was a generalised reaction against formality in the arts. The effect of this undercurrent of feeling on the Little Academy can be observed in the changing nature of their medallic production.

These changes are of particular interest because, as we have seen, the nature of the production process totally excluded the vagaries of individual talent. The differences between the second and third versions of the Conquest of the Franche-Comté (199, 200), or between the equivalent versions of medals commemorating the building of a pyramid in Rome (232, 233), or the opening of the *Grands Appartements* at Versailles (234, 235) can be regarded as the purest and most impersonal reflection of the evolution of the collective taste of the French ruling class. This evolution can be characterised most simply as the replacement of a desire for calm by a desire for movement. The figures in the earlier medals (199, 232, 234) are all placed horizontal to the medals' surface and give an impression, even in movement, of repose. The figures in the later medals are full of life. Victory, balanced perilously on one foot, has left the seat of her chariot to hurtle through the air (200). Roma has remained seated, but her limbs have been rearranged to form a vigorous spiral which makes her look as though she is ready, at any moment, to spring into action (233). The central figure in the '*Appartements*'

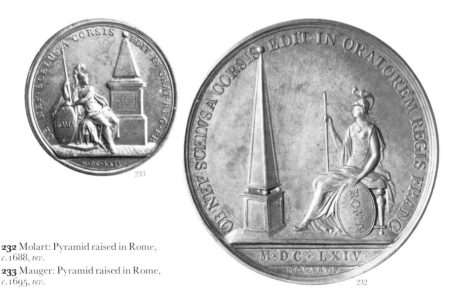

**232** Molart: Pyramid raised in Rome, *c*.1688, *rev*.

**233** Mauger: Pyramid raised in Rome, *c*.1695, *rev*.

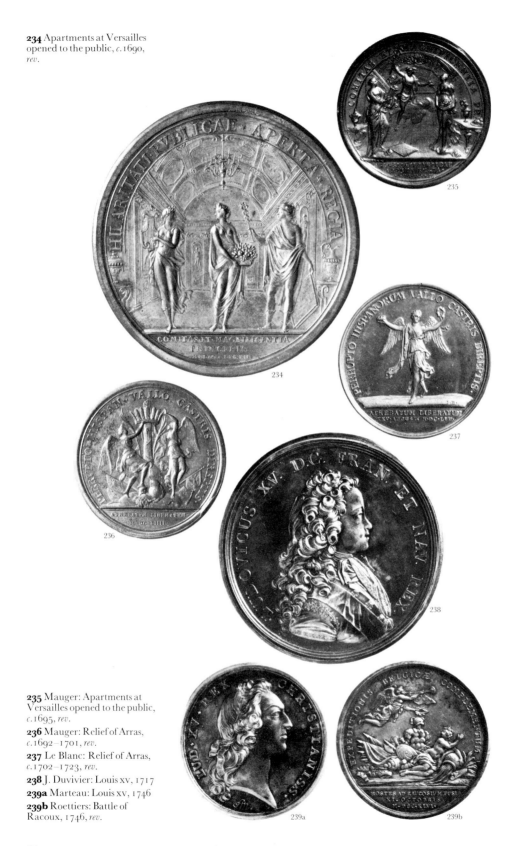

**234** Apartments at Versailles opened to the public, *c.*1690, *rev.*

**235** Mauger: Apartments at Versailles opened to the public, *c.*1695, *rev.*
**236** Mauger: Relief of Arras, *c.*1692–1701, *rev.*
**237** Le Blanc: Relief of Arras, *c.*1702–1723, *rev.*
**238** J. Duvivier: Louis XV, 1717
**239a** Marteau: Louis XV, 1746
**239b** Roettiers: Battle of Racoux, 1746, *rev.*

(235) has been transformed into Mercury who is flying towards us right out of the composition – so that his staff has already escaped from the 'picture space' and into the legend.

When the Little Academy revised the Medallic History of Louis XIV for the last time, between 1702 and 1723, they turned away from violent movement, flowing draperies and dramatic gestures toward the delicacy and refinement of the rococo. The ebullient Victories leaping around a vallary crown on the 1690s version of 'The Relief of Arras' (236) had come to seem rather vulgar and were replaced by something altogether more refined (237).

Under the regency of the Duc d'Orleans and then under Louis XV, the shift away from the strict application of classical formulae to the medal was followed by a gradual relaxation of government control. The Little Academy, now known as the Académie des Inscriptions et Belles Lettres turned increasingly to literary pursuits and sometimes left medallists the freedom to design as well as to execute official medals. One family, the Duviviers father and son, dominated French medallic art for much of the eighteenth century. Jean Duvivier arrived in Paris in 1711 and started work in the hard school of the revised Medallic History which was to be published in 1723. His portrait of the young Louis XV (238) contrasts, both in the sitter's unformed features and in his elegant contemporary dress, with those of the previous reign. In this medal, as in those by Duvivier's contemporaries like Norbert and Joseph-Charles Roettiers, the emphasis is on achieving a decorative effect. In the latter's 'Battle of Racoux' (239b) the spirit of the Meuse is represented, not by the normal bearded river god but by a chubby nymph who, instead of being frightened, as she should traditionally have been, by the appearance of Fame above her head, seems rather to be delightfully surprised. The obverse portrait (239a) is by François Marteau, rather than Duvivier, who, used to producing his own designs for medals (240), had refused the Academy's request that he copy a drawing by Edmé Bouchardon. The slavish copying to which he objected can be seen in a comparison between Bouchardon's drawing for a jetton for the *Trésor Royal* (241) and Marteau's finished work (242).

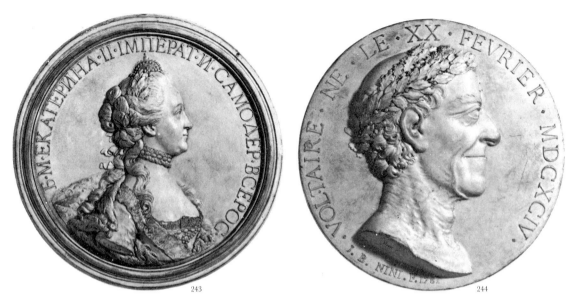

**243** Nini: Catherine the Great, 1771
**244** Nini: Voltaire, 1781

Quite outside the range of the Academy's control was Jean-Baptiste Nini (1717–86), a modeller of terracotta medallions. Among his most interesting portraits are those of Catherine the Great (243) and Voltaire (244). Catherine, though one of the greatest of Russian rulers, provides a remarkable example of the dominance of French culture. In appearance she could be an elegant member of the Court at Versailles, while intellectually she regarded herself as a disciple of Voltaire, whose bizarre profile contrasts so strangely with her own.

The next generation of medallists, of whom Benjamin Duvivier was the most prominent, went on to re-establish a more considerable degree of artistic autonomy. We have a wide range of drawings from Benjamin's hand (245) which show that it had once again become normal for a medallist to design his own work. The trend toward weaker state control was accompanied by the growth of a body of opinion, derived from the writings of the philosophers and partially inspired by the example of the British Constitution, that absolutism was of itself a bad system. In its rejection of the Court it equally rejected the rococo which was seen as a Court style. The American War of Independence provided French medallists with a unique alternative to the normal run of official commissions and the opportunity to evolve a style fit to express these new ideas. Augustin Dupré's (1748–1833) 'American Liberty' (246), with her fierce classical profile, free flowing hair and cap of liberty, seems very distant from the same artist's official medal for the subterranean junction of the Escaut and the Somme (247) of 1785 which shows the unabated frivolity of Court art.

Dupré's medal of John Paul Jones (248a,b) is equally far from the rococo in the sober realism of the naval officer's uniform and the realistic representation of the sea battle. Other medallists including N. M. Gatteaux and Duvivier himself also produced medals for the American Congress. The reverse of Duvivier's 'Washington before Boston' (249a,b) is another example of the unusual realism elicited from French medallists by the down-to-earth leaders of the new nation.

The commissions given to French medallists by the American Congress pro-

**245** B. Duvivier:
Drawing for no. 251

**246** A. Dupré: American Liberty,
1783

**247** A. Dupré: Subterranean
junction of the Escaut and the
Somme, 1785, *rev.*

**248a,b** A. Dupré: John Paul Jones:
battle between the Bon Homme
Richard and the Serapis, 1789

245

246

247

248a

248b

**249a,b** B. Duvivier: Washington before Boston, 1786–9

**250** B. Duvivier: Abandonment of Privilege, 1789

**251** B. Duvivier: Storming of the Tuilleries, 1792

249a

249b

250

251

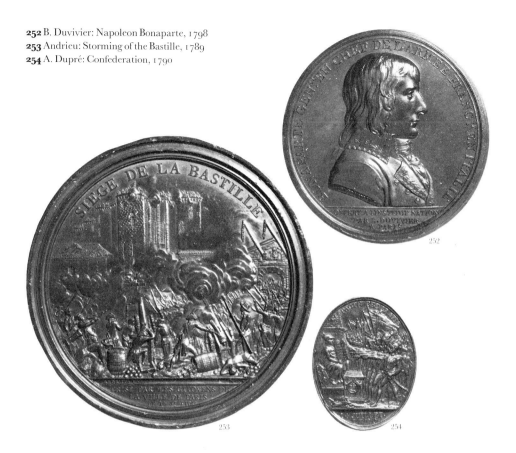

vided them with experience on which to draw when they faced the more stringent demands of their own revolution. Duvivier made valiant efforts to adapt to the new situation in his 'Abandonment of privilege' 1789 (250). But even though the King has become the 'Restorer of French Liberty' the approach is still reminiscent of the *Ancien Régime*. His medal for the storming of the Tuilleries (251), which shows Liberty revenging herself on the relics of the past has more revolutionary fervour, but by this time Duvivier had been stripped of his position at the Mint. Even his portrait of Bonaparte after the Peace of Campo Formio in 1797 (252), showing him as the revolutionary soldier, with free flowing locks scornful of the wig and powder of the past, was insufficient to regain him favour. Bertrand Andrieu (1761–1822), on the other hand, achieved considerable popular success with his 'Storming of the Bastille' (253) and 'Entry of Louis XVI to Paris', while A. Dupré, who had already shown an understanding of the possibilities of neo-classicism, made use of the example of Louis David's 'Oath of the Horatii' to identify the heroes of modern France with those of Republican Rome in his 'Confederation' of 1790 (254). Dupré's hour of glory as the medallist of the Revolution was, however, short-lived. With the establishment of Consulate and Empire a new discipline was imposed and a new group of medallists came forward to meet its demands.

# 12. The Wyons and the age of Neo-Classicism

The future for medallists under the Napoleonic Empire seemed most promising. The Prix de Rome (a prestigious award which enabled the winner to study in Rome at the Villa de' Medici for three years) was founded for them and two seats were reserved in the Academy of Fine Arts. The way for new talent was opened up not only by the removal of the medallists of the *Ancien Régime* during the Revolution, but also by the subsequent dismissal of Augustin Dupré in 1803. An *Histoire métallique de Napoleon le Grand* was undertaken and it became apparent that French medallists were to be given an opportunity to repeat the exploits of their predecessors under Louis XIV, by identifying their Emperor with the greatest rulers of Rome and establishing neo-classicism as a new orthodox style, to be adopted by their fellows throughout Europe.

The great Medallic History which was planned by the Ancient History and Literature section of the Institute (successor of the Little Academy) never came to fruition despite Napoleon's keen personal interest which led him to have medal designs submitted to him even when he was away campaigning. But in the meantime Vivant Denon, Director of the Louvre from 1804 to 1815, presided over the production of a semi-official Medallic History of his own devising, which imitated Louis' not only in format but also in the degree of control exercised over the medallists employed on it. One of the earliest works in the series records Bonaparte's arrival at Fréjus in October 1799 (255a,b). One side shows his ship arriving, with the British ships which he has eluded in the distance, the other the Roman god of good fortune. The strict neo-classicism of this medal by André Galle (1761–1844) is typical of the art of the Consulate. Dumarest's (1760–1806) medal for the National Institute of Arts and Sciences with its lovely head of Athena (256), Droz's (1746–1823) exquisite 'Peace of Amiens' (257a,b) and

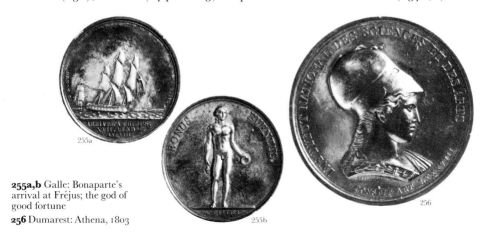

**255a,b** Galle: Bonaparte's arrival at Fréjus; the god of good fortune
**256** Dumarest: Athena, 1803

Brenet's '*A la Fortune Conservatrice*' (258) after a design by Chaudet, struck in commemoration of the preparation for the invasion of England in 1803, share its quality of absolute classical purity.

With Bonaparte's coronation as Napoleon 1, Emperor of France, in 1804 the pace of medallic production increased. Yet of all those medallists who had been active under the *Ancien Régime* and during the Revolution only Andrieu managed to make a substantial career under the Imperial regime. He capitalised on the popularity of his earlier medals (e.g. 253) by combining them with representations of Napoleon's triumphs as a young general, for instance during the Passage of the Great St Bernard (259), and what were to become almost the standard portraits of the Emperor and Empress, and selling them in sets made up to look like books. His portrait of Napoleon as a Roman hero (264a), devoid of any petty or human emotions, with his steely gaze fixed on his own path to glory, became the standard obverse of Denon's Medallic History.

Under the Empire the orthodox approach remained strictly neo-classical. Medallists and men like Chaudet and Percier, respectively sculptor and architect, who provided designs for Denon's series, were expected where possible to find and copy classical prototypes. Brenet's 'Conquest of Naples' (260) is a direct copy of an ancient coin of that city (261) as Depaulis' 'Conquest of Illyria' (262) is a copy of a coin of Illyria (263). But other medals produced under the Empire show

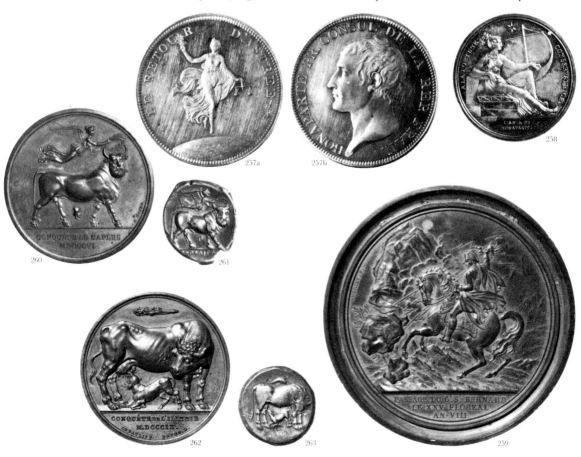

257a

257b

258

260

261

262

263

259

rather less serenity and restraint than had been characteristic of those com-
memorating events which occurred during the Consulate. The reverses are still
filled with elegant male nudes, classical deities, and classical symbolism, but the
repose inherent in a medal like Galle's 'Bonus Eventus' is transformed into electric
energy in his 'Battle of Jena' (264b) dated 1806. In this Napoleon himself is shown
naked astride his imperial eagle, hurling thunderbolts upon the impotent giants,
representing the old European powers. Galle's portrait of Elisa Bonaparte (265),
the Emperor's sister, demonstrates the elegance both of his technique and of the
fashion of the period. His 'Retreat from Moscow' (266) shows a premonition of
the collapse of the Napoleonic Empire, not only in its subject matter, an unhappy
French warrior defeated by the elements, but also in a retreat from classical
symbolism to the dreary reality of the dead horse and burning waggon in the
background.

By Nicholas Brenet, who contributed a substantial number of pieces to the
Napoleonic series, we have the extraordinary 'Mont Blanc School of Mining'
(267), one of the most original designs of the period. His 'Fortune Adverse' (268),
showing the wind spilled from the sail and the Wheel of Fortune broken, provides,
with his earlier medal (258) the brackets that enclose a surprisingly self-contained
epoch in French medallic art; self-contained because the Restoration, by robbing
French medallists of the subject matter for medals in the heroic classical mode,
deprived their style of its raison d'etre. The features of Louis XVIII (269a) defeated
even Andrieu's attempts to endow them with classical nobility, while the presence
of a Roman altar among the victorious monarchs, who are robed in the symbols of
the Ancien Régime by E. Gatteaux (269b), is ridiculously incongruous.

The approach adopted by the medallists who worked on Denon's Medallic
History naturally had its most immediate effect within the Empire. Italy was
regarded as second only in importance to France by Napoleon, who associated
Rome with Paris as the joint imperial capital, and installed his son as its King. For
this reason Italian medallists found it natural to look to France and in Milan
Ludovico Manfredini (1771–1840) produced a number of medals which are very
similar both in style and fabric to those made in Paris. Of these the most original
shows Archduke Charles of Austria, defeated at Ratisbon, as Typhon crushed by
Mount Etna (270b). H. Vassallo (1773–1819), another Milanese medallist, was
responsible for the obverse of this medal (270a) which, as comparison with a
Roman aureus (271) demonstrates, portrays Napoleon in a way calculated to
make him look as much as possible like Augustus.

In Rome itself another Italian, Benedetto Pistrucci (1784–1855), was at about
this time making his reputation as a gem engraver. In 1814 he set off for London,
stopping in Paris on the way, and there modelling Napoleon's portrait in wax, in
the French neo-classical style. Once in London he made a stir by claiming that the
'antique' cameo representing Flora which a famous collector, Richard Payne
Knight, had bought from a dealer called Bonelli was really his own work, and he
made three other versions of the piece to prove it. In 1816 he was commissioned to
make jasper cameos of George III and George and the Dragon as models for the
coinage. Since it was considered that no engraver with the ability to execute dies
from these designs was then available Pistrucci was commissioned to cut them

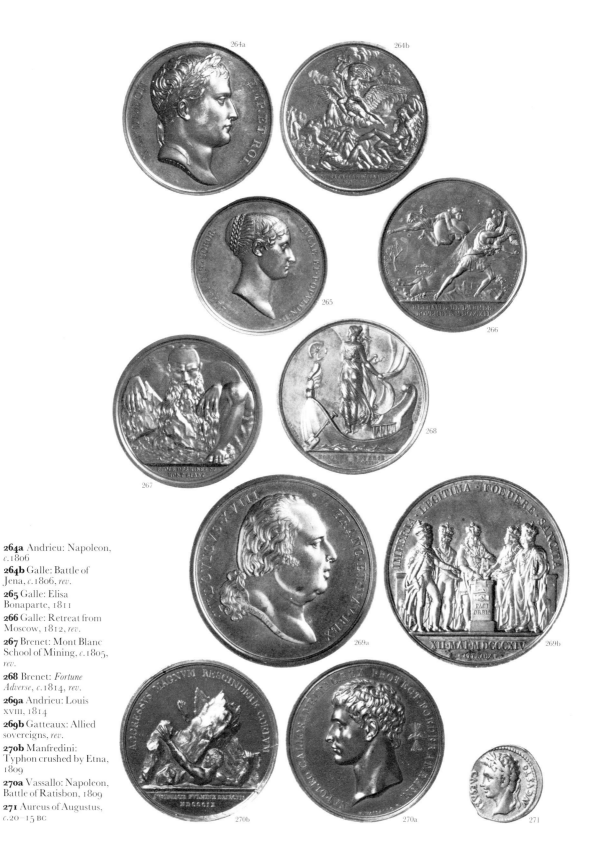

**264a** Andrieu: Napoleon, *c*.1806

**264b** Galle: Battle of Jena, *c*.1806, *rev*.

**265** Galle: Elisa Bonaparte, 1811

**266** Galle: Retreat from Moscow, 1812, *rev*.

**267** Brenet: Mont Blanc School of Mining, *c*.1805, *rev*.

**268** Brenet: *Fortune Adverse*, *c*.1814, *rev*.

**269a** Andrieu: Louis XVIII, 1814

**269b** Gatteaux: Allied sovereigns, *rev*.

**270b** Manfredini: Typhon crushed by Etna, 1809

**270a** Vassallo: Napoleon, Battle of Ratisbon, 1809

**271** Aureus of Augustus, *c*.20–15 BC

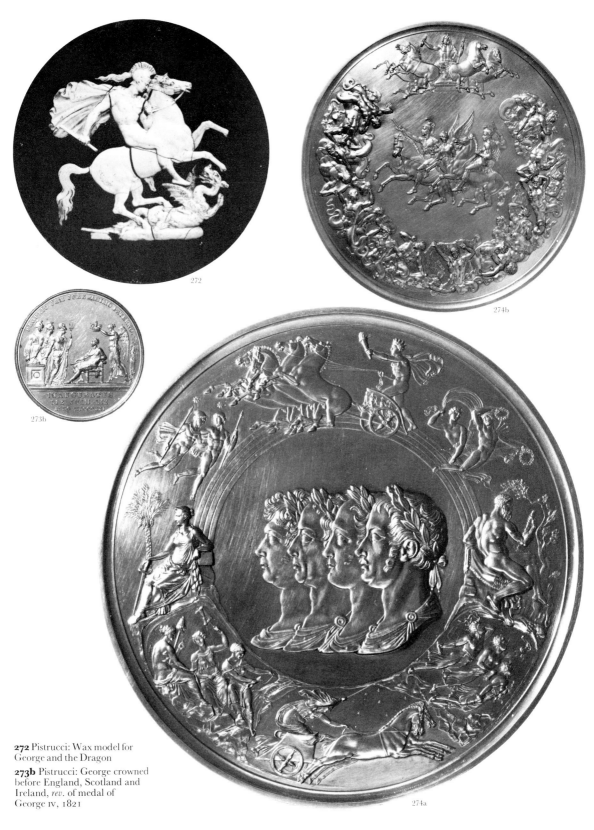

**272** Pistrucci: Wax model for
George and the Dragon

**273b** Pistrucci: George crowned
before England, Scotland and
Ireland, *rev.* of medal of
George IV, 1821

272

274b

273b

274a

himself (272) and so was launched upon a career as a medallist. His work, of which the official medals for George IV's coronation are a good example (**273a**,b), is clearly designed and exquisitely engraved, but tends to a certain hardness of line, particularly noticeable in the hair, which betrays the artist's training as a gem engraver.

Pistrucci was not a particularly prolific medallist and never quite fulfilled the promise of his marvellous early coin designs (e.g. the £5 piece, 272). His greatest achievement, the famous 'Waterloo medal' (274a,b) was also his greatest failure. This gigantic piece with its portraits of the Prince Regent (George IV), Francis II of Austria, Alexander I of Russia and Frederick William III of Prussia, the victors over Napoleon, was a white elephant whose scale defeated even its designer and which was never struck. The surviving electrotype copies of the reverse show a plethora of impressively modelled figures in a rather incoherent and unsatisfactory design.

Yet the most important neo-classical influence on the greatest British medallist, William Wyon (1795–1851), came not from Pistrucci but directly from the French engravers who worked on the Imperial Medallic History. A number of these, among them Depaulis, Droz and Brenet, came to England after the war to work on what James Mudie hoped would be a British rival to Denon's scheme. Due to the nationality and training of the artists working on it this became, paradoxically, a tribute to the culture of the Napoleonic France whose defeat it celebrated. William Wyon's work for the series, for example his designs for 'The Battle of Ushant' (275a,b) or 'The Defeat of the Pindaree and Mahratta Confederacy' (276) of 1818, is very much influenced by their example – though he obviously found it difficult to assimilate the features of an English admiral to the classical ideal.

William was also able to refer to another, specifically British, tradition. He greatly admired the work of Flaxman, on whose designs for Pidgeon's medal

**274a,b** Pistrucci: Waterloo medal; Victory, horsemen and Tritons, 1817–50

**275a,b** W. Wyon: Earl Howe; Battle of Ushant, c.1818

**276** W. Wyon: Defeat of the Pindaree and Mahratta Confederacy, 1818, *rev.*

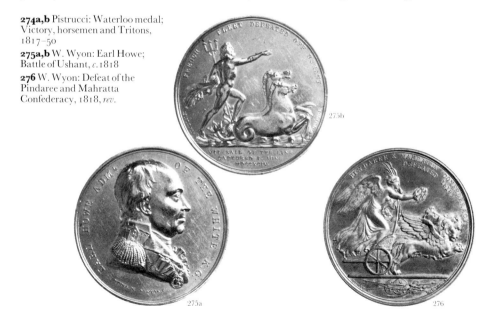

(277) for the Royal Society of Arts he based his own medal for the same organisation (278) in 1820, and was influenced by other neo-classical artists like Burch and Smith. There was also the legacy of his own family who had long been established as medallists. His great grandfather, a silver-chaser, medallist and engraver, came to England during the reign of George II; his father was a medallist, his uncle, Thomas Wyon, was Chief Engraver of His Majesty's Seals and his cousin, Thomas II Wyon, was Chief Engraver at the Royal Mint from 1815 until his death, aged 25, in 1817.

This background gave him a width of experience that allowed him to design a pattern crown (279) in 1817, the reverse of which, showing England, Ireland and Scotland in sisterly embrace, is quite different in spirit from the contemporary work that he was doing for Mudie. However, this masterpiece of coin design did not suffice to win Wyon the place of Chief Engraver on his cousin's death in 1817. Instead, the place went to Pistrucci who occupied himself with its duties until 1822, when he refused a request that he should take Chantrey's bust of the new King as a basis for the portrait to be used for coinage. From that date Wyon, as Second Engraver, was responsible for the coinage and for many years performed the function of Chief Engraver without receiving the normal salary for the job. This situation led to a bitter controversy over the relative merits of the native and the foreign medallist which lasted until Wyon's death in 1851. During these years he produced a series of coins unrivalled in the skill of their obverse portraits, the beauty of their reverse designs and the technical perfection of their execution. Wyon's designs for Victoria's first coinage, for example the reverse of the £5 piece (280) or the portrait on the 'bun' penny (281) are classics of their type. But his development as an artist, like that of most coin designers, can be traced mainly in his much more varied work as a medallist.

In his medallic work Wyon was able to experiment with different approaches to royal portraiture which were often close to and could be useful for work on the coinage – for example, portraits of George IV in 1824 (283a) and Queen Victoria in 1840 (**282**). But medallic work also gave Wyon, as shown by an early medal done for the Royal National Institution for the Preservation of Life from Shipwreck (283b), the opportunity to develop vigorous compositions and use relatively high relief which would have been quite unsuitable for the coinage. In this medal Wyon also demonstrated an ability to model the human body that was later displayed to the full in the powerful if rather macabre reverse of the Cheselden medal of 1829 (284). Wyon's sensitivity to changes in prevailing taste is evident in his reverse for the Apothecaries' Company's 'Linnaeus medal' (285), 1830, in which he softens the rigour of his neo-classicism to delight the eye with a charmingly detailed representation of 'medicinal plants'. He was as impressed by the marvels of the industrial revolution as by the glories of the ancient world and his 'Newcastle to Carlisle Railway', 1840, is one of the finest monuments to the new form of transport (286).

At various stages in his career Wyon reverted to purely neo-classicist subject matter. His medal commissioned by Lloyd's to reward 'humane and perilous exertions to save Life from Shipwreck' and dated 1839 represents the moment at which Leucothöe 'an azure sister of the main' saves Ulysses from a watery grave

**277** Pidgeon: Minerva and Mercury

**278** W. Wyon: Minerva and Mercury, 1820

**279** W. Wyon: Pattern Crown, *rev.*

**280** W. Wyon: Five pound piece: Una and the Lion, 1839, *rev.*

**281** W. Wyon: 'Bun penny', Victoria, 1839

**283a,b** W. Wyon: George IV; rescue from shipwreck, 1824

**284** W. Wyon: Cheselden medal; a body awaiting dissection, 1839, *rev.*

**285** W. Wyon: Apothecaries' Company 'Linnaeus medal', 1830, *rev.*

**286** W. Wyon: Newcastle to Carlisle Railway, 1840, *rev.*

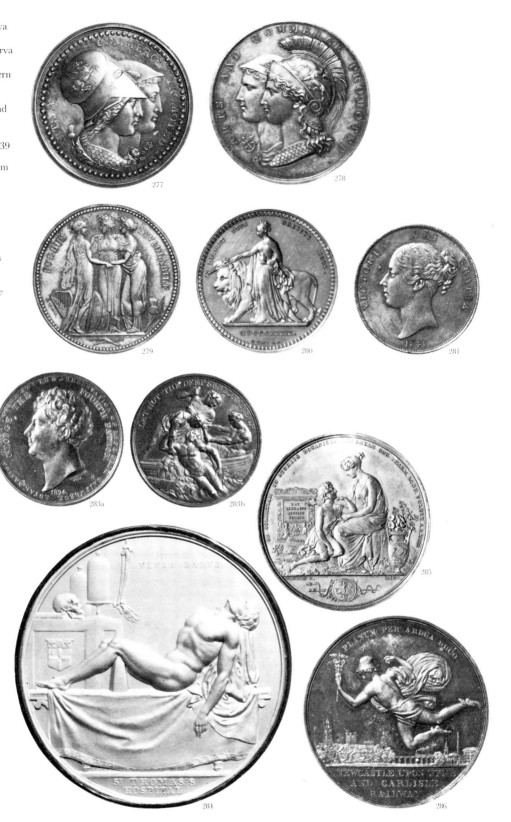

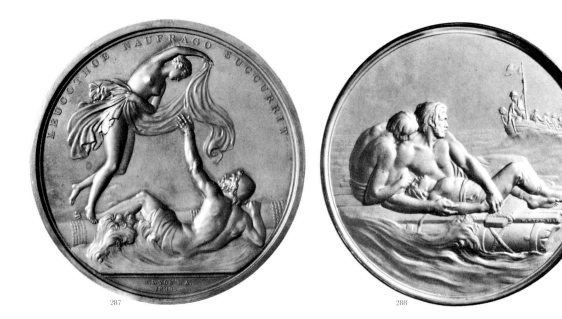

287

288

(287). As a rescuer, however, the charitable nymph, about to expose herself to us and the elements in order to wrap her sailor in a diaphanous drape, lacks conviction beside the bowler-hatted heroes on his later Royal Humane Society medal (288). This, with its contrast between the group on the raft centred round a distraught sailor in whose arms the cabin boy lies dying, and their eager rescuers, straining at the oars, ready to leap to their aid, is a masterpiece of Victorian sentiment.

Towards the end of his life Wyon became increasingly obsessed with his ancient rivalry with Pistrucci. He wrote to Edward Hawkins, then Keeper of Coins and Medals at the British Museum: 'I took the letter to Mr Gladstone he said that he perfectly agreed with every word I said and that he would as soon trust to a *Maniac* as Mr Hamilton [Pistrucci's main defender] for any judicial character wherein I was concerned or Pistrucci – so far is right but there is great necessity for watching – there will be an attempt to do something for Pistrucci . . .' In what may have been an attempt to settle the question of their relative merits once and for all Wyon confronted his rival's famous coin design (272) head on. For his medal of Prince Albert he produced a 'George and the Dragon' (**289**) which is both tighter in composition and more credible than the earlier work.

With William Wyon's death the great period of British medal-making moved towards its end. In his son, Leonard Charles (1826–91), and his cousins, Benjamin (1802–58), Alfred Benjamin (1837–84) and Joseph Shepard (1836–73), the family produced talented medallists who dominated the field until the end of the century. A series of interesting medals were commissioned by the Art Union of London, including Leonard Wyon's portrait of his father (290). Leonard also engraved what must rate as the epitome of the high Victorian medal after a drawing by Daniel Maclise (292) showing Britannia surrounded by the good things of life (291). The portrait style evolved by William Wyon became, if anything, even more influential in the rest of Europe after his death. From

**287** W. Wyon: Leucothöe rescuing Ulysses, 1839, *rev.*
**288** W. Wyon: Royal Humane Society medal, *rev.*

Germany in particular a number of medallists, including Karl Schwenzer (1843–1904) and Christian Schnitzpahn, came to England to work and train in the Wyon family firm. Yet none of the later Wyons capitalised on the prestige enjoyed by William, the first and last medallist elected to the Royal Academy, to extend the possibilities of their art. They ignored the development of the cast medal and the new school of medallists that, from 1870, produced a revival of interest in medal-making in France. Their work came to seem increasingly dull and dated, and the number of commissions given to medallists began to decline. As a result of this trend, which was duplicated throughout Europe, the initiative in the development of medallic art slipped not merely from a group of professional medallists in one country to a similar group in another, but away from the medallist altogether.

**290** L. Wyon: William Wyon, 1854

**291** L. Wyon: International Exhibition of 1862, *rev.*

**292** Maclise: Drawing for no. 291

# 13. Romanticism and the revival of the cast medallion

In France the situation deteriorated earlier and faster than in England. There, as in the rest of Europe, the official medal became increasingly conservative until under Louis Philippe and the Second Empire it reached appalling depths of banality.

An art that was born of painting was rescued from these dire straits by sculpture. The three-dimensional nature of medallic art was increasingly emphasised and the 'art medal', as opposed to the popular medal began to be regarded as a specialised form of sculpture. In the catalogues of the French Salon, for example, we find medal-making included in a section with engraving (print-making) at the start of the century and so firmly linked with the technique of cutting metal and with the paintings after which engravings were made. Through the thirties, forties and fifties, however, a shift occurs and medals are increasingly and finally almost invariably included in the sculpture section.

The man who was primarily responsible for this shift was the great, early nineteenth-century sculptor David d'Angers. Though restricted by the neo-classical orthodoxy imposed by his patrons on his sculptural work this passionate revolutionary found scope for his Romantic tendencies in the literally hundreds of medallions which formed his *Galérie des Contemporains* (begun in 1827). In producing these portraits David had a political as well as an artistic aim – to show that there were in society those whose character and achievements would bear comparison with any in the past and so justify the optimism about the potential for progress that underpinned his support for revolution. Among his most famous historical portraits are those of Napoleon (293) produced in 1838, who, given David's views, was naturally portrayed as the young republican general Bonaparte, and Juliette Récamier (294), one of the great intellectuals of the age, and who became his enemy. Of those more strictly his contemporaries David portrayed well-known figures in almost every walk of life. Among politicians he tended, naturally, to select reformers like George Canning, one of the liberators of South America, and Lamartine, poet and member of the revolutionary government of 1848. Further from the mainstream of European political life was Jean-Pierre Boyer (295), one-time president of what was then the only recognised black state, Haiti, whose refined and mournful features are recorded in a medallion of 1845. Of his portraits of writers some of the finest are of Goethe, Schiller and Victor Hugo, one of David's greatest admirers, who said 'David is to Paris what Michelangelo was to Rome'. David was equally interested in portraying men in less elevated professions, engineers like Marc Isambard Brunel, bronze founders like Richard (who cast his medals) or, and above all, any one of his numerous friends.

David's medallions are truly sketches in bronze. He shaped his models with careless vigour, hacking out his subject's features and scrawling his signature or the sitter's name across the field with a lack of restraint which would have appalled the traditional medal engraver. Among his hundreds of portraits there are some in which the unceasing striving for freshness of touch induces a sense of monotony. But there are others, like that of Blumenbach (296), professor of medicine at Göttingen, which demonstrate his ability to take an ordinary man in ordinary dress and convey through his portrait David's own Romantic belief in the limitless potential of the individual. Such medals represent a total break with the conventional approach towards medallic portraiture which recorded a subject in terms of his achievements or his position in society. They reflect a fundamental change of attitude which, totally contrary to practice in previous

**293** d'Angers: Bonaparte, 1837
**294** d'Angers: Juliette Récamier, 1838
**295** d'Angers: Jean-Pierre Boyer, 1845

111

296

**Plate 5**
*Top:* **187** Guillaume Dupré: Marcantonio Memmo, 1612
*Bottom:* **196a** J. Warin: Louis XIV, 1665

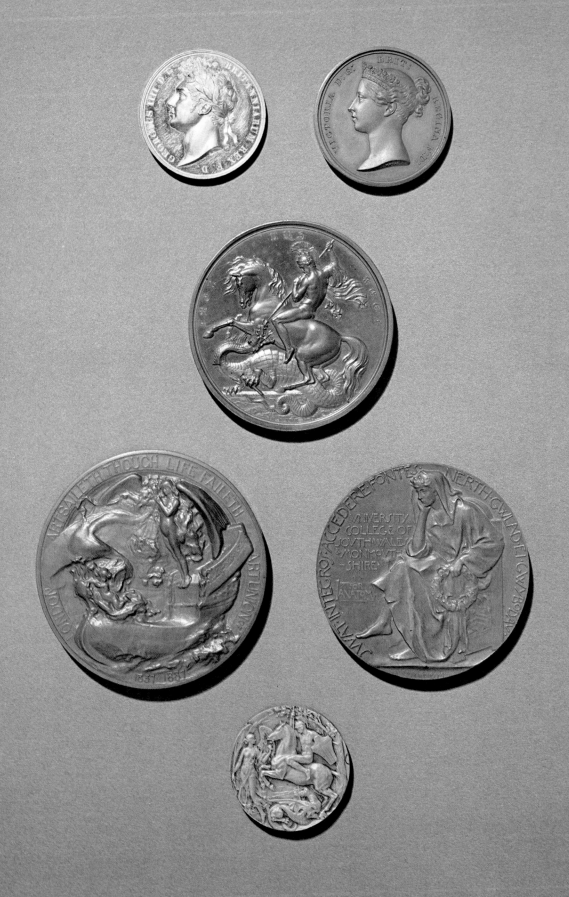

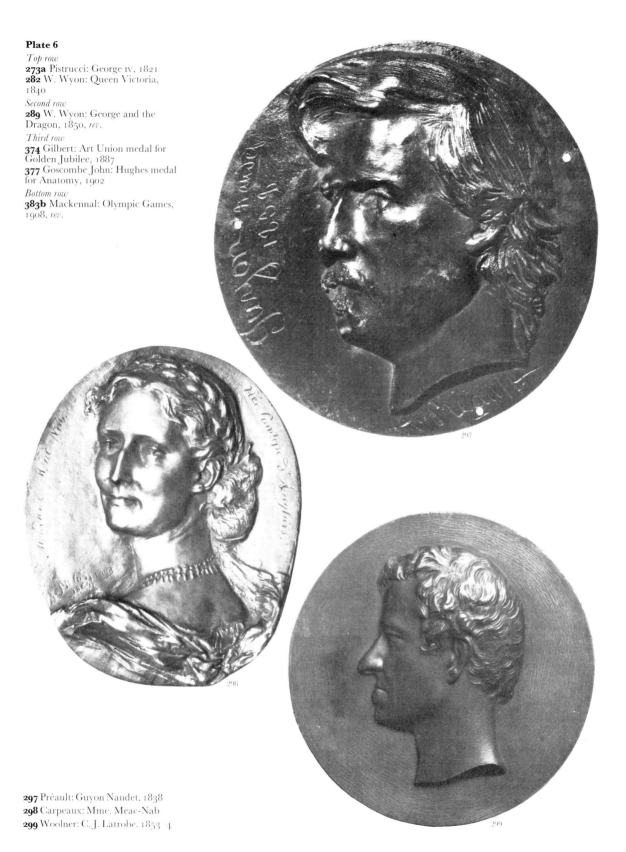

**Plate 6**

*Top row*
**273a** Pistrucci: George IV, 1821
**282** W. Wyon: Queen Victoria, 1840
*Second row*
**289** W. Wyon: George and the Dragon, 1850, *rev.*
*Third row*
**374** Gilbert: Art Union medal for Golden Jubilee, 1887
**377** Goscombe John: Hughes medal for Anatomy, 1902
*Bottom row*
**383b** Mackennal: Olympic Games, 1908, *rev.*

**297** Préault: Guyon Naudet, 1838
**298** Carpeaux: Mme. Meac-Nab
**299** Woolner: C. J. Latrobe, 1853–4

centuries, led the Romantics to regard the individual, at least in theory, as defined solely by his personal attributes and not in any way by his place in the 'natural order'.

David d'Angers had little or no influence on contemporary medal engravers. As late as the 1860s their productions seemed quite unaffected by the spirit of Romanticism. Among sculptors, however, the production of medallions became something of a vogue. Not only David's own pupils, like Auguste Préault (1810–79) – see, for example, his portrait of Guyon Naudet, 1838 (297) – and Étienne Maindron (1801–84), but also a wide range of other sculptors through-out Europe adopted the medallic portrait in the style of David as a useful extension to the possibilities of their métier. Distinguished sculptors like Jean Baptiste Carpeaux (1827–75) – see his portrait of Mme. Meac-Nab (298) – and Henri Chapu in France, and Joseph Ernst von Bandel in Germany, continued the tradition through the middle of the century; as late as the 1880s and 1890s Ringel d'Illzach, an Alsatian medallist, was busy producing his own version of David's gallery of contemporary portraits.

The revival of the cast medal in France also had a considerable effect in late nineteenth-century England. The decline of the struck medal had come later there than in France but was in its way quite as complete. Into this vacuum a Frenchman, Alphonse Legros (1837–1911), brought with him to London in 1867 the idea that the medal had possibilities of value to those primarily engaged in other arts. Legros was primarily an educator. He was Slade Professor for many years and he had a strong desire to spread the word among what the French tended to regard as the unenlightened English. The need for enlightenment about medals was clearly considerable since, although the marble medallion was a traditional form, the cast bronze medallion, with a few exceptions, such as Thomas Woolner's 'C. J. Latrobe' of 1853–4 (299), was almost unknown. In this field, at least, Legros had a considerable effect not only on his pupils but also on leading contemporary English artists.

Legros, unlike the majority of the French school of cast medal-makers was primarily a painter and based his approach to the medal on that of the greatest painter-medallist, Pisanello. The influence of the latter can be seen in the overall style, lettering and even technique of Legros' (300, 301, 302) medals but despite this the portraits of great Victorians who peer out from the soft textured bronze are quite different in spirit from those of the Renaissance princes portrayed by the earlier artist. The difference, which shows Legros to be essentially nineteenth century in his patterns of thought, is that Pisanello's finest portraits are inspired by those who, conscious of the possession of power, radiate that self-confidence which produces what is called presence (and his portraits of humanists are as a result among his least successful) while Legros' finest portraits are inspired by those whose faces betray, not unthinking self-confidence but a capacity for self-questioning, for doubt and so for creative thought. Alfred Tennyson (300), John Stuart Mill (301), Thomas Carlyle (302) were intellectual giants, yet it is their sunken and slightly haunted eyes that leave an impression on the mind. Only in his medal of Maria Valvona (303) made in 1881 does Legros come really close to Pisanello. This portrait shares with the latter artist's 'Cecilia Gonzaga' (46) an

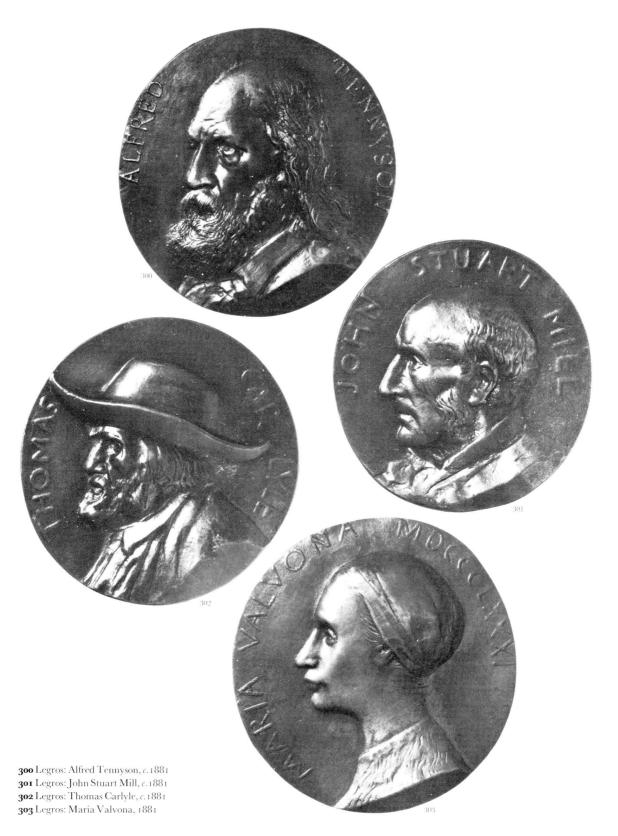

**300** Legros: Alfred Tennyson, *c.*1881
**301** Legros: John Stuart Mill, *c.*1881
**302** Legros: Thomas Carlyle, *c.*1881
**303** Legros: Maria Valvona, 1881

atmosphere which is curiously unworldly, inward and self-possessed and which may reflect a certain alienation from a society which in the nineteenth as in the fifteenth century had little place for women of intellect.

Among those who responded to Legros' call for a new approach to medal-making was Edouard Lantéri, another teacher at what was to become the Royal College of Art. His portrait of Julio Monticelli (304) shows him going even further than Legros toward endowing his sitters with a pseudo-Renaissance appearance. A number of Legros' pupils exhibited their work at the Royal Academy and a few settled down to careers as medallists. Among the most talented of these were Ethel Bower (later Lady Harris), a prolific portraitist of fashionable English society, and Maria Zambaco, Burne-Jones' model and lover, by whom we have a striking portrait dating from 1885 of Marie Stillman (305).

Another painter who dabbled in medal-making, Sir Edward Poynter, was Professor at University College London, Director of the South Kensington Art Schools, President of the Royal Academy and Director of the National Gallery, in short the establishment artist *par excellence*. In pursuit of his revival of neo-classicism he naturally turned toward that most neo-classical of forms, the medal. The result was a series of ravishingly beautiful portraits – among them 'A Capri Girl' (306), 'Clio' (307), a prize medal for Cambridge University, and 'Lily Langtry' (308) the great beauty, her bosom pierced by a miniature dagger. These strange pieces are quite unlike any contemporary medallic work and indeed stand quite alone in the history of the medal.

**304** Lantéri: Julio Monticelli, 1888
**305** Zambaco: Marie Stillman, 1885
**306** Poynter: Capri Girl, 1882
**307** Poynter: Clio, 1889
**308** Poynter: Lily Langtry, 1882

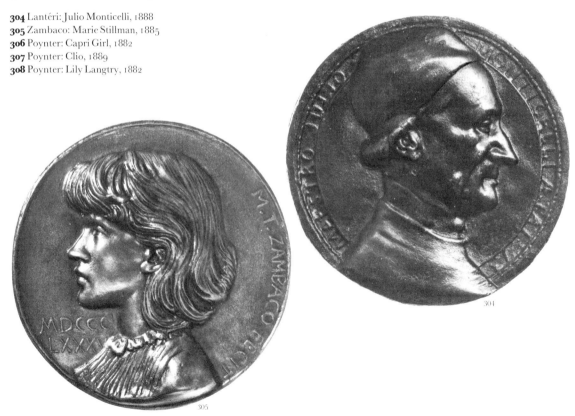

Members of the 'new school' of sculptors were also interested in making medals. Alfred Gilbert (373, **374**) and William Goscombe John (376, **377**), produced both cast and struck medals, Edgar Boehm, Charles Bell Birch and Thomas Brock produced models for struck medals and Yeames, Thorneycroft and Onslow Ford made cast medallions. Theodore Spicer-Simson, who combined in his work a strong feeling for the medals of the Italian Renaissance and the taste of the Aesthetic Movement, continued the English tradition of cast medal-making into the first decade of the twentieth century. His medals of Louise (309), dated 1906, and Elizabeth Strong Hammond and George Meredith (310), 1910, are good examples of his elegant and soulful but rather wishy-washy approach to portraiture.

Well before this, however, the distinction between cast and struck medals had ceased to have its traditional importance. Quite early in David's career, in the third decade of the nineteenth century, the reducing machine came into use in France and by the middle of the century it had spread to every medal mint. This machine allowed a reproduction of the artist's model to be engraved, at a reduced scale, directly into a steel die. It allowed a medallist like J. F. Domard (1792–1858), in his medal of Barnabé Brisson, the freedom to model on a large scale (311) thus achieving the effect of fine detail when the model was reduced (312) without the exacting and time-consuming labour of engraving directly into the metal. Domard was, himself, a skilled engraver but by the end of the century it had become common for both medals and coins to be designed by artists who had no knowledge of this skill.

As a result, the distinction between the modeller of cast medals and the engraver of struck medals which had in the past been clear became at first blurred and finally almost non-existent. Models for struck medals began to have an increasingly independent existence, and bronze casts from them were regarded as independent from and even superior to the final, struck medal. The distance between the artist's model and the end product, and his lack of comprehension of the techniques involved in the transition, could lead to a tendency to produce compositions more suitable to the scale of the model than that of the medal. On the other hand the technical freedom bestowed by the reducing machine allowed a wider range of artists to experiment with the medium and so led, at the end of the nineteenth century, to an enormous rise of interest in medallic art.

**309** Spicer-Simson: Louise Strong Hammond, 1906
**310** Spicer-Simson: George Meredith, 1910
**311** Domard: Barnabé Brisson, 1829
**312** Domard: Barnabé Brisson, 1829

# 14. The development of Art Nouveau in France

The first great artist to make use of the flexibility offered by the reducing machine was Jules-Clément Chaplain. He was born at Mortagne in 1839 and pursued an absolutely conventional artistic career, entering the École des Beaux-Arts in 1857, where he was pupil to the medallist Oudiné and the sculptor Jouffroy. Eventually he won the Prix de Rome with a classical medal and an engraved gem. He went on to win medals at the Official Salon, and to become a member of the Academy of Fine Arts and a Commander of the Légion d'Honneur. He demonstrated not only that it was possible for a medallist to be successful both in cast and struck medal-making but also that a single model, properly conceived, could be successful both as a cast plaque on a large scale and as a struck medal or plaquette on a small scale.

As his career would suggest, Chaplain took care to remain within the boundaries of accepted taste. His early medals are rather conservative in style and it was some time before he followed up Hubert Ponscarme's breakthrough in his medal of Naudet (1867) which abandoned the rim and beading which traditionally surrounded the struck medal. By 1879, however, in his official medal for the Exhibition of 1878 (313) these features appear only in vestigial form and Chaplain, like Ponscarme, has moved away from the convention of a composition in fairly high relief which rises abruptly from a completely flat and polished field. Instead, in this medal, and more so in succeeding medals, he allows the composition to merge into and emerge from the background transforming it from a flat backdrop into a space within which the action can occur. It is also noticeable in this medal that, while remaining within the acceptable bounds of classical allegory, Chaplain had begun to use vigorous movement and sinuous lines in a

**313** Chaplain: Exhibition of 1878, *rev.*

**314** Chaplain: Jules Simon, 1889

313

314

315

316

**315** Chaplain: Sarah, 1889
**316** Chaplain: Emmanuel Bibesco, 1891

way alien to the neo-classical ideal. In cast portraits, like that of Jules Simon (314), he developed an intimate and realistic portraiture of subjects in everyday dress that represented a synthesis between the Romantic radicalism of the followers of David and the cold formality of the official portrait. At its best, in 'Sarah' (315), 1889, or 'Emmanuel Bibeseo' in 1891 (316) this produced portraits that are startling in their clarity and force. Above all Chaplain excelled in the production of carefully composed reverses, as in, for example, that for the election of Casimir Périer as President from 1894 (317), in which the rigidity of the format is offset by the diaphanous drapery that falls from his classically profiled females. Even where, as in 'Cheap Homes' in 1891 (318), he represents an everyday interior, it is one in which not a fold of the worker's shirt is out of place and every stick of furniture contributes to the grid structure of the composition. Chaplain's solution to the problem of integrating 'modern' life to the allegorical world of academic art is wonderfully uncomplicated. In 'Chemical Synthesis, Science guides Humanity', struck in 1901 (319), he shows Marcellin Berthelot sitting in his laboratory staring at his elaborate equipment quite unaware that the spirit of France and Naked Truth have materialised behind his back. Chaplain had an unusual ability to produce work that was equally successful when reproduced in different sizes. Thus his portrait of Victor Hugo, while impressive as a bronze plaque (like that of Jules Simon; 314), was equally so as a small medal (320). The broad impressionistic approach of his large-scale portraits becomes, on reduction, crisply detailed and almost jewel-like, suited both to a different technique (striking produces an absolutely even surface) and metal (in this case silver).

Oscar Roty (1846–1911) was seen by contemporaries as responsible, with Chaplain, for what they described as an extraordinary renaissance in medallic art. Like Chaplain, he had an exemplary Establishment career, though unlike him he studied painting under Lecoq de Boisbaudron as well as sculpture under

Augustin Dumont. It was perhaps partly his training as a painter that led him, in 1880, to revive the rectangular format of the Renaissance plaquette which allowed him to give his compositions a more obviously pictorial treatment than was possible on a circular medal. He used this both for intimate portraits like that of his son (321) and for much more ambitious pieces, like that commemorating the death of Sadi Carnot, 1898 (322, 323a,b). In doing so he bridged the gap that had existed between Renaissance plaquettes and medals, for these objects, though plaquette-like in form, could be like medals both in technique (they were often struck) and in the fact that they were frequently two-sided. This extension of the possibilities open to medal-makers proved so widely popular that, by the end of the century, it had been universally accepted that the tradition that the medallist must confine himself to work in the round was defunct.

**317** Chaplain: Election of Casimir Périer as President, 1894

**318** Chaplain: French Society for Cheap Homes, 1891

**319** Chaplain: Science guides Humanity, 1901

**320** Chaplain: Victor Hugo, 1902

Roty was capable of producing medals like '*Inauguration des prisons de Fresnes*' in 1900 (324) showing the remorse and rehabilitation of a prisoner in the new prison system, which claimed almost epic significance. But he also liberated the medal from the utter seriousness to which it had been shackled by its official past. As early as 1881 in '*Diner de la Marmite*' or in '*Vin Mariani*' (325, 326a,b) he realised a medallic equivalent of that gay combination of classical nymphs and proprietary brands that graced the posters of the nineties. 'To the strong health, to the debilitated life' reads the plaquette on one side and on the other it drives the point home, warning the nymph that Vin Mariani will save the sick Cupid's life so that she had better be careful not to lose her heart to him. A pioneer of the frivolous, Roty was also a master of the decorative. He transformed the dreary inscriptions that had been a feature in the mid-nineteenth century not only, like Chaplain, by

**321** Roty: Maurice Roty

**322** Roty: Drawing for no. 323b

321

322

**323a,b** Roty: Funeral of Sadi Carnot, 1898

323a

323b

taking care over the design of the lettering and ensuring its integration into the composition, but also by breaking up large blocks of text with decorative foliage which were combined with it in a unified two-dimensional design (as in 326). Such foliage, which Roty first used in 1882, became, like the rectangular format, a standard part of the medallist's repertory. Carrying his exploitation of the decorative potential of the medal still further, Roty used medallic techniques to produce bracelets and brooches, which, however, lie outside the scope of this book. But the centre of his work remained the allegorical figure-composition of the type which, through pieces like his 'International Exhibition of 1900' (**327**) became known to tens and even hundreds of thousands of people as the epitome of the thoroughly modern medal.

**324a,b** Roty: Prisons of Frèsnes-les-Rungis, 1900

The extent to which medal making had become assimilated to the arts of sculpture and painting during this period is evident from the way in which medallists became caught up in the different currents of late nineteenth-century art. A number of medallists of the older generation were content with a slightly liberated academicism combined with pretty sentimentality and the mild eroticism of soft-edged nudes in silvan surroundings. Jean-Baptiste Daniel Dupuis' (1849–99) 'The Spring' (328a,b), Victor Peter's (1840–1918) 'The Happy Age' (329) and Frédéric-Charles Victor de Vernon's (1858–1912) 'Eve' (330a,b) are typical of this very popular genre. Naked bodies were felt to be acceptable only if they inhabited this safely imaginary world. As a result, artists like Abel la Fleur (b.1875), who wandered so far from the canons of good taste as to suggest that a bathing woman might end up wet (331a,b), were distinctly exceptional. Real women were expected to pose fully clothed for portraits like 'Jeanne' (332) by Louis-Eugène Mouchon (1843–1914) which, at their best, present a charming picture of contemporary fashion.

Symbolism in its various forms was a style that attracted a number of younger medallists. Ovide Yencesse (1869–1947), for example, fell under the spell of a leading symbolist painter, Eugène Carrière. With the aid of Liard's extraordinary mastery of the art of casting bronze and by paying minute attention to the exact tone of the patina of his medals, Yencesse was able, in works like 'Mother and Child' (333) to achieve something of the atmosphere of the painter's work and even the figures in his extravagantly sentimental struck works seem to inhabit a

**325** Roty: Drawing for 326b
**326a,b** Roty: Vin Mariani, 1895
**328a,b** J. B. D. Dupuis: The Spring
**329** Peter: The Happy Age, 1886
**330a,b** de Vernon: Eve

326b                                                          326a

325

328a                                                          328b

329

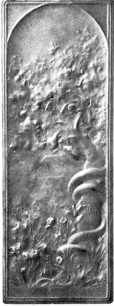
330a                                                          330b

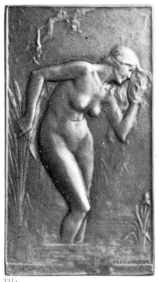

331a

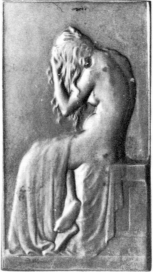

331b

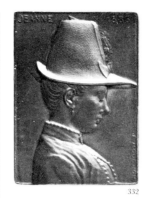

332

**331a,b** La Fleur: Woman bathing

**332** Eugène Mouchon: Jeanne

**333** Yencesse: Mother and child

**334a,b** Yencesse: Child; roses

**335** Georges Duprè: Meditation

**336** Georges Dupré: The Angelus: Dawn

333

334a

334b

335

336

**337a,b** Georges Dupré: *Salut au Soleil; quand tout change pour toi*

**338a,b** Prud'homme: The fisherman's wife

337a    337b

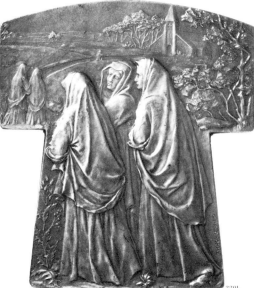

338a                                338b

strange, half-lit world (334a,b). Georges Dupré's (1869–1909) 'Meditation' (335), a veiled woman rapt in contemplation of the ruins of Rome, induces in the observer that bitter-sweet sense of irremediable loss that was so favoured by symbolist poets. The poetic impression is certainly intentional, for in this and other medals, like 'The Angelus' (336a,b) and '*Quand tout change pour toi*' (337a,b), he actually uses a combination of verse and nature to convey his emotions. Georges-Henri Prud'homme shares the obsession of writers like Pierre Lotti and painters of the Pont-Aven school with the fate of the fisherman's wife, staring with brave hopelessness out to the cruel sea (338a) and later a widow, among other widows, on her way to mass (338b).

The late nineteenth century was a period in which there was enormous interest in links between the arts. The theatre, as a vehicle for the synthesis of the arts of painting, writing, acting and music, exercised a particular fascination not only on

339

340

**339** Becker: Sarah Bernhardt
**340** Charpentier: Réjane, 1895
**341** Charpentier: Painting
**342** Charpentier: Sculpture

341

**Plate 7**
*Top*
**327** Roty: Universal Exhibition, 1900
**412** Von Esseö: *Pax*
*Bottom*
**411** May: Storm
**418** Lavrillier: Leda and the Swan

342

those directly involved but also on medallists. Pierre Roche, a pupil of Dalou and Rodin (who himself designed medals), produced a series of studies of Loie Fuller, while René Lalique and Edmond Becker made medals of Sarah Bernhardt (339). Alexandre Charpentier (1856–1909), though so far from being a literary medallist that he eschewed allegory entirely, spent his evenings at the Théatre Libre making portraits of the actors, writers, painters and journalists who were to be found there. These 'impressions', as, for example, of the actress, Réjane (340), were an attempt not, of course, to produce a counterpart of the impressionists' representations of light and colour in bronze, but to convey the likeness of an individual, not as his friends knew him to be but as he appeared at a particular instant. Charpentier was close to Rodin (who admired his work) in his feeling for the material in which he worked. In these cast plaques there is a constant struggle for the viewer's attention between what exists – the strangely hacked surface of the metal – and what is represented, so that the finished work is as much a record of a process as of a face.

Charpentier's commissioned work is naturally more conventional. He worked with Jules Chéret on interior design, made decorative metal door handles, finger

343

344

345

**343** Charpentier: Child
**344** Charpentier: Stone-masons
**345** Charpentier: Duval Janvier

plates and plaques to be set into furniture (341, 342, 343), and produced a large number of struck medals. Of these a few, like '*Baigneuse a la fleur*', are symbolist in the tradition of Gaugin, but the majority contributed to the birth in France of a quite different approach – that of social realism. Having banished the wispy allegorical females so dear to his contemporaries he filled medals like 'The Stone-Masons' (344) or 'Duval Janvier' (345) with workers, portrayed in striking compositions that emphasise the strain and effort which their occupations exact.

The period was one in which there was the greatest interest in the relationship not just between the various fine arts but also between the fine and applied arts. Medallists provided a natural link between the arts of painting and sculpture and those of workers in gold, silver and bronze. Their appreciation of the decorative and tactile qualities of sinuous form in metal led them to play an important part in the development of Art Nouveau. In 1892–3 Charpentier was one of the founders of '*Les Cinq*' the first group organised with the intention of propagating the new approach, and another medallist, Henry Nocq, joined them in 1897. The increasing popularity of their work led many other medallists to assimilate Art Nouveau forms to what was in most cases a basically unchanged, classical subject matter. Coudray's Orpheus (*back cover*) is one of the most successful examples of this approach. Soon, however, it developed into an increasingly deadening orthodoxy that was to dominate French medal-making until after the First World War.

Meanwhile, interest in the links between the fine and decorative arts, which had developed early in England with the Arts and Crafts movement and was a central theme in the development of the Secession movement in Austria and Germany, had a fruitful effect on the rest of Europe. Exhibitions of medals in Brussels (1897) and Vienna (1900) and the large section devoted to them at the Great Exhibition in Paris (1900) also spread the idea that medallic art was a worthwhile medium for those interested in 'advanced' trends in art. As a result, while the French school rested on the laurels awarded to Chaplain, Roty and Charpentier at the Exhibition of 1900, it was increasingly outside France, and in particular in Eastern and Central Europe that the most vital trends in medallic art emerged.

# 15. The Decorative and Decadent – medals at the turn of the century

For the Exhibition of 1900 Roger Max, art critic and Inspector General of the Ministry of Fine Arts, published a survey of the work exhibited in the section devoted to nineteenth-century medals. No less than six and a half of his thirteen plates devoted to non-French medals are taken up by the Austro-Hungarian Empire, whereas England and Germany share only one plate. This contrast reflects the revival of medallic art in Austria and the remarkable birth of national schools in Hungary and what was to become Czechoslovakia.

Heinrich Kautsch, who was born in Prague in 1859 and trained there and in Vienna, moved to Paris in 1889. The medals he made there, while influenced by the French example, reflected a knowledge of developments in decorative art in Austria-Hungary. For example, his medal of Heinrich Heine (346) shows particularly in its lettering an affinity with the Vienna Secession, a union of radical painters and sculptors founded in 1897, partly with the aim of reviving the applied arts. Another of Kautsch's works is a charming evocation both of the wonder and of the inconvenience of the early motor car (347).

Kautsch's example, and that of the sculptor J.-V. Myslbek, opened the way for

346

347

**346** Kautsch: Heinrich Heine
**347** Kautsch: Motor Car

349

350

351

352

Stanislas Sucharda (1866–1916), the first great medallist who both studied and worked in Prague. In his '*Urby*' of 1897 (348) he shows himself already conversant with the possibilities of the Art Nouveau plaquette. Yet his vigorous and impressionistic modelling sets him quite apart from the decorative delicacy favoured by Chaplain and Roty. In 'Spring' (349), 1904, Sucharda uses both figure and landscape to express, with different nuances, the single idea of dormant sensuality on the brink of being wakened by the rising sun. The cycle of seven plaquettes which relate the 'Story of the beautiful Princess Liliane', produced from 1903–9 (350, 351), shows that Sucharda shared the fascination of symbolist painters like Roerich in Russia or Klimt in Vienna with the atmosphere of mystery that could be created by the use of exotic costume and jewellery. The backgrounds of their plaquettes are no longer recognisable as conventional representations of landscape. Like Charpentier, whose influence is also visible in his portraits, for example, 'Madame Zintlova', 1911, Sucharda has become as interested in the texture of the surface of the medal as in what it represents. Unlike Charpentier, however, he is not concerned with recording the process leading to the final state. Instead he uses ill-defined and apparently random forms, as he used the landscape in 'Spring', to reinforce the strange and mysterious mood created by the figure. This approach is reminiscent less of the soft-edged vagueness of Carrière or Yencesse than of the positive use of the obscure in Redon's work. It is also to Redon's work that the later plaquette 'Always in Front' of 1912 (352) is closest.

Sucharda is not alone among Czech medallists of this period in producing work that shows close affinities with painting. His greatest pupil, Bohumil Kafka (1878–1942), like Sucharda himself, frequently used the narrow vertical format favoured by Gustav Klimt and shared with the members of the Secession an interest in relations between the senses. In his 'Perfume of Roses' of 1900 (353), the subject, the mixture of human and vegetable forms, the shape and lettering are typical of Austro-Hungarian Art Nouveau or Secession Style, as it was called. In later work like his portrait of Dr Mánes dating from 1904 (354) or his 'Peruvian Mummies' of 1905 (355), he completely broke with this decorative tradition in favour of a harsher and more personal style of his own.

Around Sucharda and Kafka a school of medallists grew up many of whom, like Bílek, Šaloun, Mára and Šejnost also had their roots in Art Nouveau. Links with Paris continued to be important. Kafka lived there from 1904–8, and Otakar Španiel, the third great figure in Czech medallic art of the period, followed him there to produce attractive plaquettes of bathing ladies (356), and athletes.

In Hungary, as in Czechoslovakia, a revival of national consciousness led to the growth of a national school, first of writers and then of artists. Hungarian medallists, like their counterparts in Czechoslovakia, turned to France for their example. Ferenc Szárnovski (1863–1903) studied there and produced medals in the new style, while Fülöp Ö. Beck (1873–1945) was, like Roty, a pupil of Ponscarme. His early medals are purely French in appearance, but by 1905, when he produced a medal of the radical Hungarian Romantic poet Petöfi (357a), Beck had evolved a style of his own. The reverse (357b), though still dependent in its lettering on the Secession Style, shows the beginnings of the muscular neo-

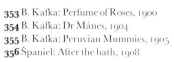

**353** B. Kafka: Perfume of Roses, 1900
**354** B. Kafka: Dr Mánes, 1904
**355** B. Kafka: Peruvian Mummies, 1905
**356** Španiel: After the bath, 1908

classicism which was to become the dominant style for the next generation of Hungarian medallists.

Jósef Róna, Robert Frangeš Mihanović and Ödön Moiret (1883–1932) in works like 'St George and the Dragon' of 1912 (358) remained faithful to a version of Art Nouveau. In the work of other medallists, however, like Reményi's 'Kalotaszeg', dated 1908 (359), a reaction from sinuous line and agitated compositions was already making itself felt. The most adventurous exponent of this reaction was Vilmos Fémes Beck (1885–1918). His pre-war medals, as for example his 'Woman' of 1911 (360), possess, in their static and angular compositions, an almost uncanny resemblance to Art Deco medals of the mid-1920s.

**357a,b** Beck: Petöfi; Freedom, 1905
**358** Moiret: St George and the Dragon, 1912
**359** Remenyi: Kalotaszeg, 1908, *rev.*

357a

357b

358

359

Beck goes beyond these, however, towards an awareness of the possibilities provided by the controlled distortion of the human form that sets him quite apart from his contemporaries. It was a setback for Hungarian medallic art that Beck's carly death opened the way for Ede Telcs (1872–1942) to dominate the scene between the wars. Although a talented portraitist, as the medal of his wife, made in 1910, shows (361), his work degenerated into a decorative version of Beck's neo-classicism, which had an unfortunate influence on his many pupils.

Though Vienna was the artistic and administrative centre not only of Austria but of the entire empire, its medallists were less original than those of Czechoslovakia and Hungary. Among the best known of them were Pawlik, Marschall and Scharff. Anton Scharff (1843–1903), in particular, was not only enormously prolific but also highly influential. His fluent talent, exemplified by his medallion of Professor Rudolf Virchow (362) which piles allegory on attribute with gay

abandon, was exercised for numerous patrons. Amongst these was the English Court, and works executed for Queen Victoria, like the official medal for the Golden Jubilee (1887), were instrumental in turning British taste toward the new continental style. In the pre-war years Viennese medallists like Arnold Hartig and Richard Placht, though still showing traces of the influence of the Secession, were, in medals like Hartig's 'Dr Arnold Ritter' (363) or Placht's dramatic nudes (364a,b), moving toward the neo-classicism that was to become orthodox between the wars.

In Germany, as in Austria, the impact of Art Nouveau was rather superficial. Becker and Bosselt, however, produced some pieces of interest while the Lauer firm, which had manufactured tokens since the early eighteenth century, bowed to fashion and produced attractive little plaquettes, including one of a Princess of Schaumburg-Lippe (365). The Low Countries, by contrast, provided, after France and Austria-Hungary, the most sympathetic response to the Art Nouveau medal. Brussels in particular produced not only the greatest architects, Horta and Van de Velde, but also in Philippe Wolfers, one of the greatest metal workers of

364a

364b

366

365

367

**364a,b** Placht: Man and Woman

**365** Lauer: Princess of Schaumburg-Lippe

**366** Wolfers: International Exhibition, 1897

**367** Rousseau: Disabled soldier's badge, c.1917

the movement. Born into a family of gold and silversmiths, Wolfers (1858–1929) was primarily a jeweller who found his own way to Art Nouveau through his early interest in imitating the rococo. His medal for the International Exhibition of 1897 (366) is one of the boldest and most vigorous pieces of the period. Other Belgian medallists like Victor Rousseau, perhaps influenced by Wolfers, adopted something of a jeweller's approach to the medal, working on a small scale and using enamel to introduce colour. His disabled soldiers' badge (367) shows the extent to which Art Nouveau remained the accepted style for the medal in Belgium even after the First World War. Other Belgian medallists, perhaps naturally in view of the strong cultural links between Brussels and Paris, remained dependent on the French approach to the medal. Godefroid Devreese, though very successful, suffers in works like the 'Liège Exhibition' (368) from the tendency of Art Nouveau medals to sink into decorative banality.

The movement in Holland produced more individual talents. Wienecke's extremely delicate modelling (his 'Inauguration of Queen Wilhelmina', 369, is almost entirely two-dimensional) is complemented by the bolder approach adopted by Toon Dupuis. The latter's medal for the Belgian-Dutch 'Friends of the Medal' of about 1907 (370) is a beautifully restrained and simple piece of design.

In England during this period the situation was rather confused. The Arts and Crafts movement, with its interest in the neglected applied arts from furniture to stained glass, was the prototype of movements in France and Central Europe which gave, as we have seen, an enormous impetus to the development of the medal. British painting, particularly in the work of Burne-Jones, and more so British sculpture, had pioneered both the ideas on which Symbolism was based and the sinuous forms typical of Art Nouveau (significantly called, among other things, Liberty Style in Italy, Modern Style in France and Studio style in Germany). Yet both these movements, which were so important to medallic art, were largely ignored in England, perhaps because they seemed rather dated there by the time they had reached their heyday on the Continent.

Some of those artists who, as we have already seen, made cast medallions also ventured into the field of the struck medal. E. J. Poynter's Ashanti War medal (371) of about 1874 for which we have a number of preparatory drawings (372), broke with the classical restraint favoured by the still dominant Wyon family. The doyen of the 'New School' of sculptors, Alfred Gilbert, was responsible both for cast portrait medallions (373) and for struck medals like the Art Union medal for the Golden Jubilee (**374**). This, with its misty forms and sinuously flowing lines, is the false harbinger of an English Art Nouveau that never fully developed.

Edouard Lantéri and George Frampton were among the other members of the school who produced models for struck medals such as Frampton's 'Physiology' (375) but only William Goscombe John (1860–1952) produced a really substantial number for works of this kind. These included important official commissions, like the medal for Edward VIII's investiture as Prince of Wales in 1911 (376), private commissions, like the 'Hughes Prize for Anatomy' in 1902 (**377**), and portraits of friends and family.

The impetus provided by these sculptors was insufficient, however, to produce a school of British medallists comparable to those in other major European

368

AMSTERDAM · 6 · SEPTEMBER · 1898
INHULDIGING · VAN · H.M. WILHELMINA
KONINGIN · DER · NEDERLANDEN ·

369

NEDERL...
BELGISCHE
VEREENIGING
DER
VRIENDEN
VAN DE
MEDAILLE

370

371

**368** Devreese: Liège
Exhibition, 1905

**369** Wienecke: Inauguration
of Queen Wilhelmina, 1898

**370** T. Dupuis: Belgian-
Dutch Friends of the Medal,
*c.*1907

**371** Poynter: Ashanti War
medal, *c.* 1874. *rev.*

**372** Poynter: Drawing for
no. 371

372

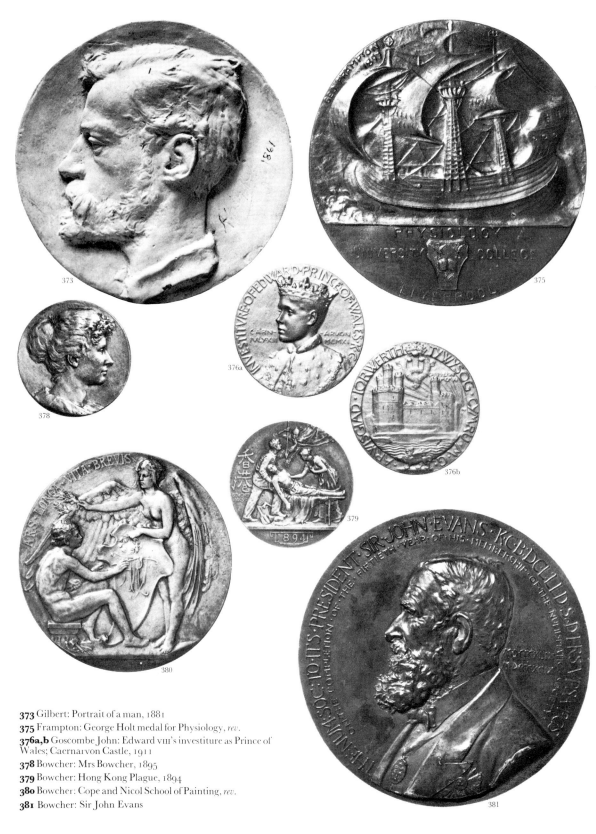

**373** Gilbert: Portrait of a man, 1881
**375** Frampton: George Holt medal for Physiology, *rev.*
**376a,b** Goscombe John: Edward VIII's investiture as Prince of Wales; Caernarvon Castle, 1911
**378** Bowcher: Mrs Bowcher, 1895
**379** Bowcher: Hong Kong Plague, 1894
**380** Bowcher: Cope and Nicol School of Painting, *rev.*
**381** Bowcher: Sir John Evans

countries. Indeed Frank Bowcher was almost the only British medallist of real talent who responded to the call of the International Style. He trained at the National Art Training School under Legros and Lantéri and later worked under Onslow Ford and in Paris, where he learned from the example of Chaplain and Roty. Early cast medals, which were done in France, were followed on his return to England by a series of struck pieces. These include a charming portrait of his wife from 1895 (378), the skilfully executed 'Hong Kong Plague' of 1894 (379) and the attractive 'Cope and Nicol School of Painting' (380). At the turn of the century he produced a fine portrait medallion of Sir John Evans (381) and an elegant plaquette of Parkes Weber. After 1903, however, when he succeeded De Saulles as Engraver at the Royal Mint, he produced little of real interest.

The Art Nouveau medal was otherwise represented in England only by an Austrian and an Australian. The former, Emil Fuchs, produced a medal in memory of those who died in the Boer War (382a,b). This is an interesting early example of the use of sentiment to shield the public from the real horrors of war that became so prevalent in France during the First World War. The latter, Bertram Mackennal (1863–1931), who studied at the Royal Academy and in Paris, provided in his compositions for medals for the Olympic Games in 1908 (**383a,**b) or the Union of South Africa in 1910 (384) a real basis for the optimism of his compatriot Dora Ohlfsen's 'Awakening of Australian Art' (385).

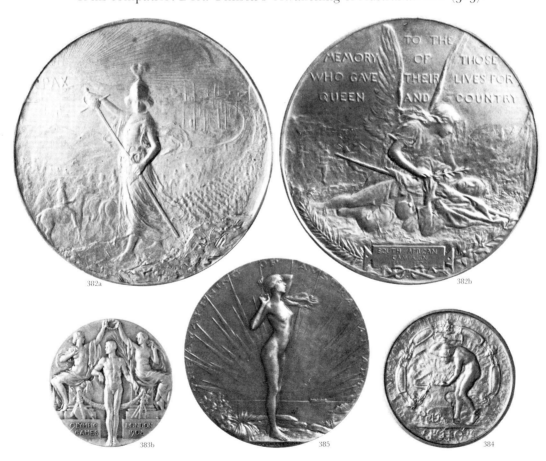

382a

382b

383b

385

384

**386** Gaudens: Child
**387** Brenner: Congress on Tuberculosis
**388** A. A. Wienemann: Louisiana Purchase, 1904
**389** Scudder: Three women

386

388

387

389

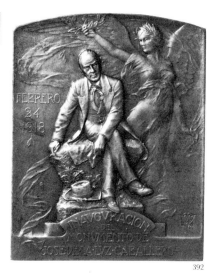

390 Lancelot-Croce:
Young woman, 1889
391 Lindberg: Nils
Forsberg, 1900
392 Tobon-Méjia:
José de la Luz
Caballero, 1918

In the United States, as in Eastern Europe, this period saw the birth of a national school of medallists, even though it was one that was fated to go into decline almost from the moment of its inception. Auguste Saint Gaudens (1848–1908), an Irish-French American, studied at the École des Beaux-Arts in Paris and produced a number of plaquettes in the French style (386). He had considerable influence as a sculptor, medallist and designer of coins, including the twenty dollar piece of 1907. His success opened the way for other medallists including Victor Brenner (1871–1924) from Russia, whose work includes the badge for a Congress on Tuberculosis in 1908 (387), and A. A. Wienemann who produced an inventive piece for the exhibition commemorating the Louisiana Purchase (388). Janet Scudder (389) and John Flanagan were among those who produced larger-scale cast works.

While there is insufficient space to discuss the medals of every European country at this period it is noticeable that from Russia to Portugal the style favoured by academic French medallists in the 1890s, established itself as the standard orthodoxy. In Italy, for example, one of the leading medallists, Lancelot Croce (390) was actually French by origin, and if the Swedish medallist Eric Lindberg's 'Nils Forsberg' (391) had been by an unknown hand it would have been almost impossible to say which part of Europe it came from. Even outside Europe a prominent politician like Caballero could expect to be immortalised in the correct style by a compatriot like Marco Tobon-Méjia (392). Although this uniformity eventually declined into uninspired banality it briefly produced a range and quality of work which has scarcely been equalled since. For the medallic art which, in the climate of the 1890s, had seemed secure in the esteem of the art establishment was to go out of favour in the English-speaking world and lose touch with the mainstream even in France. In the early twentieth century only Central Europe was to produce a new and vigorous school of medallists.

# 16. German Expressionism

The impact of the revival of medallic art in France and of the style that it popularised had, as we have seen, been relatively superficial and ephemeral in Germany. The rise of nationalism and the traditional enmity between the two countries made the importation of a French style seem doubly unpatriotic. Further, the militarist ethos of the new nation, reaching fever pitch towards the outbreak of the First World War, led to demands for the abandonment of the decorative representation of decadent allegory in favour of a heroic realism fit to glorify the young German soldier.

Josef Gangl's 'U-Bootmänner' is illustrative of the development of the German medal in these years. The reverse (393b) is a continuation of the decorative tradition in applied art during the pre-war years. Stylised fish are symmetrically placed against a decorative background of bubbles around an elegantly formed U. But the obverse has abandoned the purely decorative in favour of a representation (393a) of two very real and solid submariners peering into the distance in an effort to spot their prey. Typical of those who supplied the popular demand for such medals was Fritz Eue, whose work was produced in large editions by Ball's of Berlin. The reverse of his portrait of the Grand Duke of Baden (394a,b), one of a series of medals of generals, shows the flower of German soldierhood, imperturbable and invincible in their advance against the foes of the fatherland. Though superficially similar in appearance, Fritz Behn's portrait of Field Marshal von Hindenburg (395a), which emphasizes the monumental quality of the Marshal's massive skull, has strayed from realism on to the borders of expressionism. The reverse (395b), by concentrating on the victim rather than the victor, lessens our ability to appreciate the heroism of the act of thrusting a spear into its vitals. Similarly Richard Klein in his 'World War' (396), though remaining within the boundaries of realism, begins, in the set brutality of his soldier's expression and of the action of his distant comrade, as in the uncomfortable presence of the corpse at his feet, to show an awareness of the incompatibility of the heroic ideal and the reality of modern war.

As this incompatibility became increasingly apparent, many German medallists, in particular those living and working in Munich, found themselves unable or unwilling to react to the war in the uncomplicated manner of an Eue or a Gangl. Under the influence of nationalist critics who regarded Renaissance and post-Renaissance art as alien to the proper tradition of the Aryan peoples, and following the example of expressionist painting and sculpture, they tended increasingly to react, not just against the imposed French style of the 1900s, but against the whole classical tradition. They looked back instead to the expressive and spiritual elements of Gothic sculpture and to the recurrent Germanic pen-

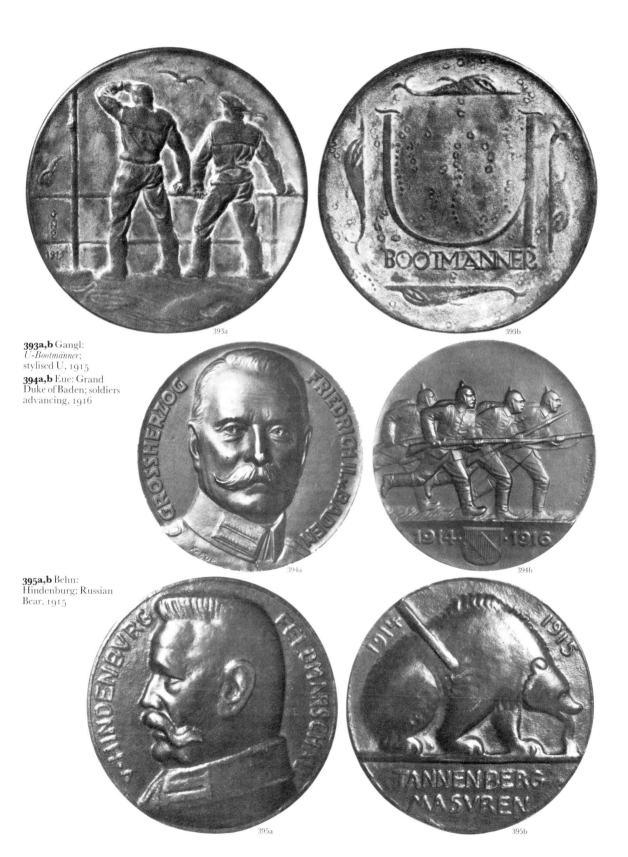

393a,b Gangl:
*U-Bootmänner*;
stylised U, 1915

394a,b Eue: Grand
Duke of Baden; soldiers
advancing, 1916

395a,b Behn:
Hindenburg; Russian
Bear, 1915

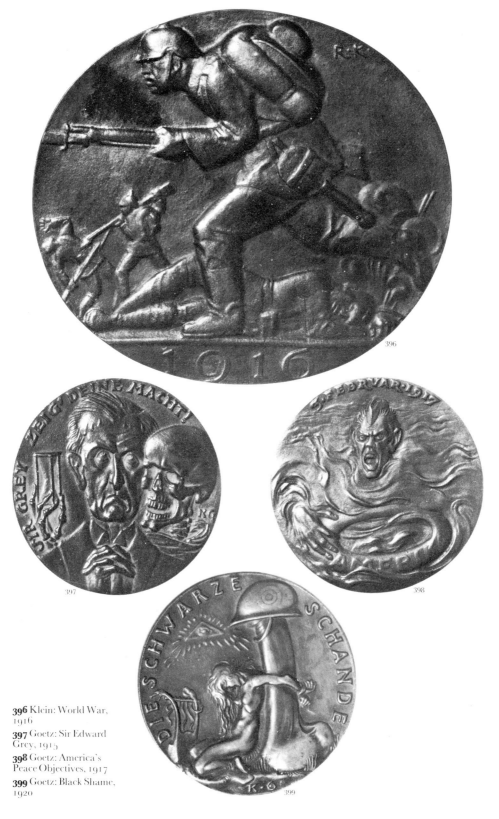

**396** Klein: World War,
1916
**397** Goetz: Sir Edward
Grey, 1915
**398** Goetz: America's
Peace Objectives, 1917
**399** Goetz: Black Shame,
1920

chant for brutal satire, for the fantastic, the bizarre and the macabre, as evident in the works of Bosch, Brueghel, Dürer or even Holbein and in popular woodcuts and engravings. Alienated by this approach from the channels through which official patronage – which continued to favour muscular classicism – was directed, a number of medallists felt free to experiment with new techniques. The adoption of a strange oval format (409, 410) and the use of iron and rough casting techniques to emphasize the brutality of the subject matter, set their work aside from that of traditional medallists. A more important innovation was their revival and reinterpretation of the tradition of the satirical medal. They used their work not only to express their feelings but also to convey precise and particular political and satirical messages.

The best known and most prolific of the medallists who adopted this approach and these themes was Karl Goetz (1875–1950). At the beginning of the war he tried to conform to the requirement for medals showing the heroism of Germany's leaders. He portrayed Crown Prince Wilhelm as the young Siegfried, which, given that individual's looks, was a considerable achievement and after which it must have seemed natural to turn to caricature. In this field he showed an unusual talent for the visual expression of a searing and bitter hatred first of Germany's enemies and later of her own leaders. His medal showing Sir Edward Grey menaced by imminent doom (397) as the result of his establishment of a protectorate over Egypt, or his 'America's Peace Objectives', the reverse of which (398) shows a drowning England reaching for the lifebuoy of American support, are remarkably devoid of human sympathy. In his later medals, for example 'The Black Shame' (399), the passions of war give way to those aroused by the humiliation of Versailles and the French occupation of the Rhineland.

An obsession with death and in particular with the 'Dance of Death', was evident in Goetz's work, as in that of almost all the Munich School of medallists. N.S. in his plaquettes of 1919 (400) presents the theme in its classic form – the

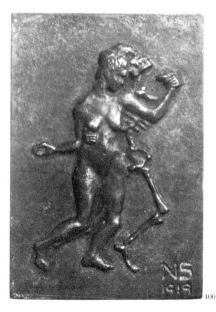

**400** N.S.: Dance of Death, 1919

**401** Eberbach: Britannia rules the waves though?, 1916

woman and the skeleton, flesh and dry bones, life and death, the erotic and the macabre. Walther Eberbach puts the traditional form to more directly contemporary use by particularising the lesson of the Dance of Death in a series populated by gigantic and horribly active skeletons. In a typical example 'Britannia rules the waves though?' (401), dedicated to 'The First Sea Lord Fisher', Death, presumably representing German U-Boats, crushes a British vessel in its bony hand.

The German Expressionists shared with the Italian Futurists and the English Vorticists a second obsession, with the machinery of war. The two are often combined. Zadikow's grinning figure of Death (402) sits happily astride the latest gun, smoking through his fashionably elongated cigarette-holder while May's skeleton (403) is equally delighted with the massive weapon which he contemplates, skull in hand. Ludwig Gies, another medallist working in Munich, was, like Zadikow and May, fascinated by modern weapons, but for him they

402

403

404

405

raised a larger issue of the relation of man to machine. In '42cm Mortars' (404), for example, the artillerymen have become quite insignificant beside the guns which they ceaselessly labour to service. Gies was fascinated by the effect of the mechanisation of war on the individual soldier and on the whole idea of war as a clash of individuals in which a particular man's courage could both mark him out and change the course of events. To some extent this produced in him a nostalgia for medieval warfare yet the initially archaic aspect of a medal like 'The Fort' (405) is deceptive. The ranks of men carrying lances and flags are accompanied by a mortar and the menacing outline of the massive fort is punctuated by factory chimneys. The theme of the destructive power of the machine is also present in 'Zeppelins over London' (406) in which the anonymous tower blocks are destroyed seemingly without human intervention, by the strange cigar-shaped objects in the sky above. Gies' feeling for the frailty and anonymity of the individual in the face of the modern world is also illustrated in his medals of workers streaming out of massive factories or seated, dwarfed by the towering bulk of a ship's hull (407).

406

**402** Zadikow: Death astride a gun, 1915
**403** May: *Nach der Schlacht*
**404** Gies: 42cm Mortars
**405** Gies: The Fort
**406** Gies: Zeppelins over London
**407** Gies: German Workers

407

**408** von Esseö: Bolshevism
**409** May: Hanging Sniper
**410** May: Russian Giant

408

409

410

Gies' pupil Erzsebert von Esseö shared his concern for the individual and his belief in the power of the medal as a medium through which to convey feelings about moral issues. She, like Gies, was horrified by the spread of revolution through Europe. In a medal inspired by Goya's 'War' she shows Bolshevism as a winged and horned devil of gigantic proportions grotesquely grinning as it erupts from the earth and prepares to destroy the helpless masses that cringe before it (408).

Such medals were far from the simple certainties propagated by an Eberbach or a Goetz. Other medallists, like Karl May, share Gies' ambiguous feelings about the war. The 'Hanging Sniper' (409) or the 'Russian Giant' (410) could officially be said to show a just satisfaction at the fate of a deadly enemy and a patriotic pride in the victories of the German army over the Russians. What they actually convey is pity for the vast yet helpless figure being hacked to pieces by a young German warrior and horror at the fate of the dead man. The only winner in May's war is the lithe young man, crowned with a victor's laurel wreath, who leads the troops into battle, gigantic banner waving in the wind (**411**). His identity is betrayed by the bony fingers beckoning to the legions behind; it is Death himself.

The end of the war and the increasing success of Expressionism as a popular style produced a reaction among the medallists with which we have been concerned. Some turned to the kind of muscular, clean-limbed classicism which was to be so popular under National Socialism. Others, like Ludwig Gies, turned to sentimental and religious themes or, like E. von Esseö in '*Pax*' (**412**), turned back to a decorative approach closer to *Jugendstil*. Nevertheless, during the war years they had demonstrated the powerful and individual contribution that their chosen medium could make to the development of twentieth-century art.

# 17. Art Deco

With the death of Daniel Dupuis in 1899, of Chaplain and Charpentier in 1909 and of Roty in 1911, much of the impetus behind the development of French medallic art disappeared. Though avant-garde painters like Picasso and Braque were working in Paris and experimenting with abstract modes of expression during the early years of the century, medallists remained wedded to increasingly sterile variations of a classicizing variety of Art Nouveau.

Even the First World War failed to jolt them out of their complacency. The majority, like Jules Prosper Legastelois in 'To the glory of the armies of Justice and Liberty' (413), or Pierre Alexandre Morlon in '*Merci*' (414), attempted to adapt a decorative and sentimental style to an ugly and brutal war. The problems with such an approach are indicated in Devignes' 'Homage to the Dead' (415), in which the lady from '*Merci*' is shown in uncomfortable proximity to a rather prosaic corpse which seems to be beyond the reach of her concern. Not only did it allow only the most inadequate of responses to the war but also resulted in inevitably incongruous juxtapositions between the sinuous lines of nineteenth-century drapery and the inelegant forms of modern weaponry in, for example, Morlon's medal of a tank (416). In reaction to this medallists moved towards the use of angular and geometric motifs, like the sun's rays in Bénard's 'Glory to the Unknown Soldier' (417), which were to become typical of Art Deco.

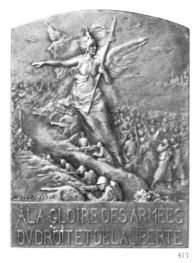

413

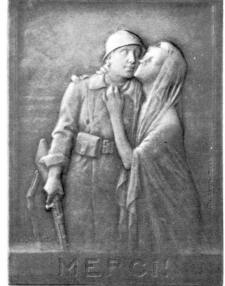

**413** Legastelois: The armies of Justice and Liberty
**414** Morlon: *Merci*

414

This, as its name suggests, was a style associated with the decorative arts. The term was first coined at the 1925 exhibition in Paris of '*Arts Decoratifs et Industriels Modernes*' which bore the abbreviated sub-title 'Art Deco'. It was seen as reconciling industry and art, as the Arts and Crafts or Secession movements had reconciled the fine and applied arts, and it marked a return of design to more functional forms. Though the concept of functionalism had no direct application to medals, medallists reacted to the atmosphere which produced it by abandoning the curvilinear forms of Art Nouveau in favour of straight, severe lines and by developing a preference for octagonal or rectangular rather than round or oval formats. Compositions moved away from clutter and complexity towards boldness and simplicity. The figures they contained possessed none of the fleeting diaphanous quality of their nineteenth-century predecessors and seem solid and monumental in comparison. It was as if, in reaction to the decorative excesses of Art Nouveau, the pendulum was swinging back towards classical restraint. André Lavrillier (1885–1958), for example, not only chose a classical theme, that of Leda and the Swan (**418**), but also robbed the tale of its usual overtones of violent

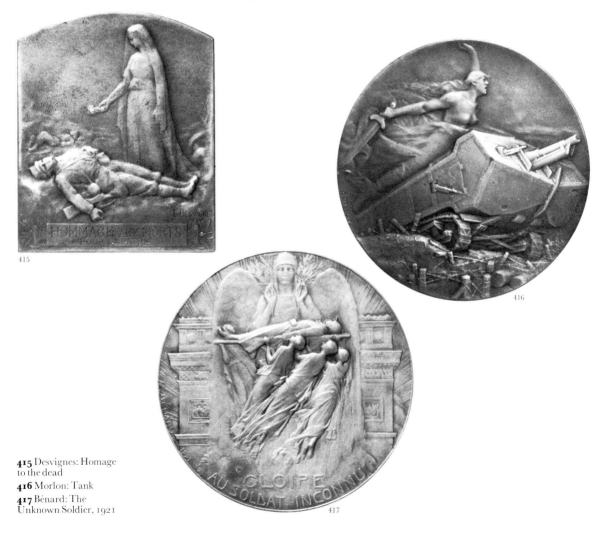

415

416

417

**415** Desvignes: Homage to the dead
**416** Morlon: Tank
**417** Bénard: The Unknown Soldier, 1921

eroticism in order to make the scene entirely static and the figures immobile. He has abandoned the psychological dimensions of the narrative, which had traditionally attracted artists, in favour of a purely decorative approach. Dammann was also attracted to the classical world. His 'Dance to the sound of the flute' shows a nymph providing the music to the sound of which a Bacchanalia takes place on the reverse (419) and uses Greek script on both the obverse and reverse to lend the subject an air of authenticity. The effects of this reaction from Art Nouveau are most apparent in the treatment of the vaguely allegorical females who continue to inhabit the majority of French medals of this period. A nude by Lavrillier or Lenoir is more wholesome looking and less delicate than a nude by the older generation of medallists such as Roty. The figure of Leda in 'Leda and the Swan' is positively muscular, and the draperies falling behind her are stiff and

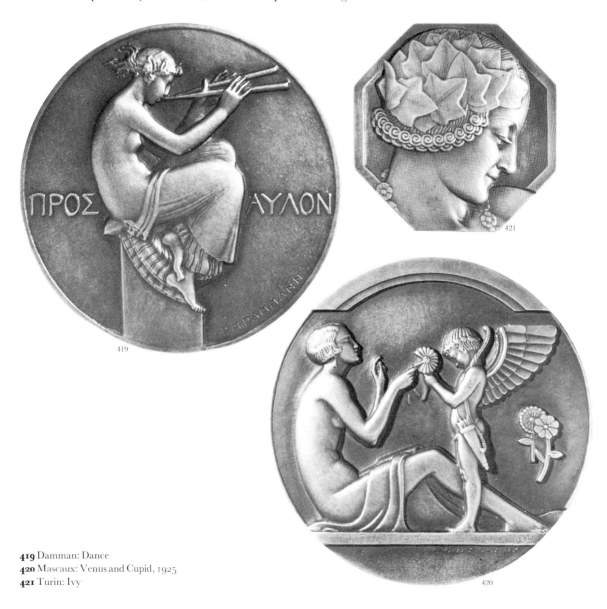

**419** Damman: Dance
**420** Mascaux: Venus and Cupid, 1925
**421** Turin: Ivy

clearly delineated in contrast to the diaphanous drapes of Art Nouveau. Similarly the faces on the medals by Morlon in his Art Deco phase have a fresh, sporty, Aryan look about them which is a far cry from the pallid, decadent, fin de siècle femme fatale. Morlon's women are surrounded by flowers and fruit, and embody visions of plenty in the twentieth century, for despite their classicism these medals are distinctly contemporary in their awareness of the 'look' of the moment. Mascaux's 'Venus' (420) playing 'he loves me, he loves me not' with Cupid has a definitely twenties bobbed haircut and long earrings, and Turin's 'Ivy' (421) looks uncompromisingly modern in her ivy leaf cap.

Hand in hand with this modernism went an interest in the achievements of technology. These medallists loved the wireless, telephone and cinema, the aeroplane and the motor car, whose development had shrunk the globe, speeded up the pace of life and created the cult of modernity reflected in the fashions which they depicted. To express their excitement at the novelty of such inventions they stretched the resources of classical allegory to the utmost. The massive power and speed of electricity are expressed far better by the contrasting figures on the obverse of Turin's 'Edison Continental Company' than in the tame reproduction of a pylon on the reverse (422a,b). Damman was able to glorify that most intangible of achievements, the radio, by taking a classical figure, Iris, who was traditionally a messenger of the gods, and adapting her symbolic significance to modern times (423). She is shown with the signs of the zodiac contained within

**422a,b** Turin: Edison Continental Company; pylon, 1932
**423** Damman: Wireless, 1927

the rainbow, with which she is generally associated, to indicate the speed with which radio waves move through the heavens. Turin's '*Scientia*' of 1930 (424) is concerned more with the general concept of progress than with a specific technological achievement. It celebrates the third centenary of the foundation of the Collège de France by showing Knowledge, unwavering in her determination to overcome the darkness of ignorance with the light that she carries before her. Delannoy's 'Cinema' (425) though strictly contemporary in subject matter, also uses a classical source. He has taken the traditional iconography of the birth of Venus and reused it in a marvellously inventive way to show her rising in triumph not from the sea but from light emitted by a film projector. Behind her the excitement and speed of the moving picture is conveyed in the jumble of images caught on the screen.

Such medals, despite, or perhaps in reaction to, the political and economic difficulties experienced by the society which produced them, convey an atmosphere of optimism, luxury and celebration, an image not dissimilar to that created by Hollywood in its heyday. Indeed the small, anonymous medal shown here, with its spiral of dancing girls descending a staircase, could come from a Busby Berkeley spectacular (426). The horrors and humiliation of defeat in the Second World War put an end to the easy optimism expressed in these medals. In the post-war years these medallists and their successors turned back to painting and sculpture in the search for modes of expression that would allow them to express different and more sombre preoccupations.

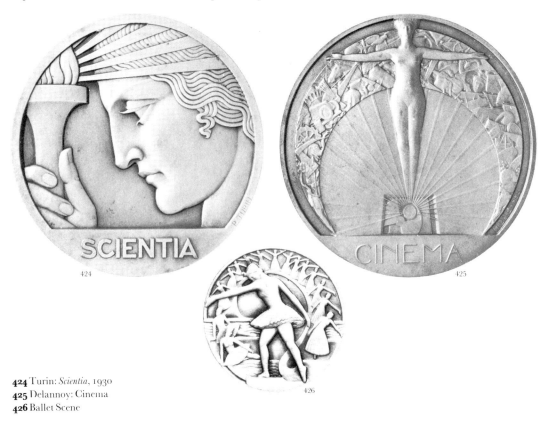

**424** Turin: *Scientia*, 1930
**425** Delannoy: Cinema
**426** Ballet Scene

# 18. What is it?–the contemporary medal

Any survey of the contemporary medal is bound to be partial in every sense. In the years following the Second World War official organisations in France and in Eastern Europe, especially Poland and Hungary, have done a great deal to support and encourage medallic art. Additionally, private medal societies in a number of countries and exhibitions like the biennale organised by the International Federation of Medal Editors (FIDEM) or the triennale held at Udine have attracted artists working in other fields towards experimenting with medal-making. As a result, even ignoring the so-called commemorative medals produced for those with a passion for hoarding precious metals, a much larger number of pieces are now made each year than has ever been the case in the past. Among the thousands of living artists who have produced medals it is possible to mention only a few, picked with difficulty from among their equally talented contemporaries.

Largely due to the enlightened patronage of Pierre Dehaye, director of the Paris Mint, France has continued to hold a central place in the development of medallic art. Typical of the distinguished artists attracted by this patronage are painters and sculptors like Henri-Georges Adam, Roger Bezombes, André Belo and Maurice de Bus. Adam (1904–67), engraver, monumental sculptor and, towards the end of his life, medallist shows the lingering influence of his early years among the surrealists in medals like '*Naissance des Mutations*', '*L'homme du Cosmos*' (427) or '*Angkor*'. Contained within the apparent chaos are a myriad of forms hovering on the brink of realisation, awaiting recognition. For Adam, as for many modern medallists, recording the appearance of contemporaries remains of central importance to the medallic tradition. In his medal of Pierre Boulez (428) he attempts to overcome the apparent contradiction between the abstract ten-

**427** Adam: *L'homme du Cosmos*, 1967
**428** Adam: Pierre Boulez, 1964

427

428

dencies of the majority of his work and the necessity for the possibility of recognition implied by the word 'portrait'. The observer is encouraged to believe that it is almost by accident that the striking features of the sitter loom up out of a maze of lines, each possessing a life of its own and having no immediately apparent relation to the ultimate result. Siv Holme, a Swedish medallist living in France, shows, in portraits like that of Anton Webern (429a) produced in 1967, the same ability to draw a face out of the bronze without apparently detracting from the independent and non-figurative composition which occupies the entire field of the medal. The reverse (429b) reverts to its Renaissance role as the expression of the personality of the individual whose features are represented on the obverse. A collection of forms, floating in space, are arranged so that they convey, with surprising clarity, the artist's perception of the nature of the sitter's music. Roger Courroy in his 'St Paul' of about 1976 (430) sets himself the apparently impossible task of producing a convincing portrait of a man whose appearance is unknown out of an imitation in bronze of piles of decomposing

429a

430

**429a,b** Holme: Anton Webern; abstract forms, 1967

**430** Courroy: St Paul, c.1976

429b

158

cotton wool. Yet the sheer unattractiveness of the portrait gives added strength to the impact of the subject's unwavering gaze. It is as if the medallist, though giving tangible expression to Paul's detestation of the things of the flesh, has caught the force of the spiritual impulse which moved him. Roger Bezombes (b.1913) goes further than Courroy towards abandoning the definition of a portrait as a recognisable likeness. The obverse of his 'César', dating from 1970 (431a), is based on a Carthaginian glass mask rather than on the features of his friend. Yet, he returns to the idea of recording an individual on the reverse, which portrays that part of the artist which is perhaps even more typical of a modeller than his face, namely his thumb.

Bezombes has extended the bounds of medallic art, both in technique and in approach. He uses materials which are new to the medal: enamel on the '*Vierge Noire*' and '*Fruits de la Terre*', imitation pearls for the eyes of 'Thétis' (432), 1971, and ball bearings for those of 'Rouletabille' (433), 1970. Through the juxtaposition of such unexpected materials and of disparate objects – his '*Poisson d'Avril*' dated 1968 (434), for example, is made up of a comb, a few small fish, some braille, scissors, a key-ring, a fish's head, a fish's skeleton and a button – he produces effects which can be comic, as in the '*Poisson d'Avril*', poetic, as in

431a        431b        432

433        434

**431a,b** Bezombes: César, 1970
**432** Bezombes: Thétis, 1971
**433** Bezombes: Rouletabille, 1970
**434** Bezombes: *Poisson d'Avril*, 1968

'Thétis', or disquieting, as in 'Rouletabille'. In his own words his intention is to 'invent forms which fuse the paradoxical with the serious and express serious things as if by a game'.

Siv Holme, perhaps influenced by Bezombes, has turned in his more recent work to the use of unexpected juxtapositions of banal images; in the case of '*De Profundis*', produced in about 1970 (435) a multitude of fingers, to express what can be disquieting emotions. Other medallists like René Quillivic, expanding on Bezombes' use of materials other than bronze, have started to make use of colour. His 'Jonah' of 1970 (436a,b) combines a decorative ensemble of enamel, silver and copper with the witty use of a new format – a medal which opens up – in this case to reveal the sinner in the belly of the whale.

435

436a

437

436b

**435** Holme: *De Profundis*, 1970
**436a,b** Quillivic: Jonah, 1970
**437** Lagowski: Recollection

In Eastern Europe the outburst of interest in medallic art which we have noted in the late nineteenth and early twentieth centuries coalesced, particularly in Hungary and Poland, into a solid and enduring part of their artistic tradition. During the Stalinist era, medallists were disciplined into a conservative and realist approach to their art. When the inevitable reaction to this came it was allowed, perhaps because of its small scale and relatively private nature, to go further at an earlier date in medallic art than in sculpture or painting. It is particularly noticeable that Russian medallists have felt free to use more or less abstract forms at a time when abstraction in the major arts was still proscribed.

Possibly as a result of their experience of restriction, the work of Eastern European medallists seems to possess a seriousness and even a passion that is

**438** Roller: The Memory, 1978
**439** Asszonyi: Torsos III
**440** Nowakowski: Cyprian Norwid
**441** Nowakowski: Champion Boxer

442 Asszonyi: *Ars Longa*
444 Mészáros: The Slide, 1976

lacking in much of the output of their Western contemporaries. Edward Lagowski's 'Recollection' (437) for example, is a disturbingly effective evocation of helpless and impossible longing for a happiness that can never be regained. Peter Roller, a Czech, expresses a calmer sense of nostalgia in 'The Memory', dated 1978 (438). His figure seems not to be desolated by what is lost but imprisoned by the inescapable sum of his own personal experience.

This theme of imprisonment is more explicitly present in the work of a Hungarian, Tamás Asszonyi. In his 'Three figures behind bars' (439) the psychological mutilation resulting from a loss of freedom is expressed in the physical amputation suffered by the helpless torsos. Jerzy Nowakowski (b.1947 in Poland) in a more directly physical expression of violence, experiments with the distortion of human features familiar from the work of Francis Bacon. In his portrait of Cyprian Norwid (440) the subject has been hideously disfigured by an axe blow that has split his face from skull to chin. The 'Champion Boxer' (441), a sinister featureless figure identifiable only by the great medal strung round his neck, seems, horrifyingly, to be unaware of the gaping hole in his head. The key to the intensity of such work may lie in the unspoken conclusion to Asszonyi's '*Ars Longa*' (442). The awareness of such medallists not only that life is short, but also that creative freedom must be grasped while it is available, has given some of them a passionate desire to communicate and a belief in the value of such communication which has often been lacking in the West. As a result many Eastern European medallists have felt that it was of primary importance that their work convey its message clearly, and so have tended to put experiment with form in second place. Though the subject matter has been contemporary, the method of presenting it has remained within the representational tradition.

Despite this formal conservatism the Eastern European school has had a remarkable effect on medallic art in the rest of the world. Half a dozen Hungarian medallists in Canada and the U.S.A., including Dora de Pédery-Hunt (b.1913)

and Imre Szebényi (b.1923) have created a real interest in medallic art in an area
without any native tradition on which to draw. Szebényi's 'Big Carnival' of 1968
is a macabre affair in which the features of Death haunt what should be a gay
occasion. In '*Ecce Imago*' (**443**), the third in the series, he grins out at us from a float
which is being carried in the procession.

In Australia, too, one of the leading medallists is, by origin, Hungarian.
Michael Mészáros (b.1945) relies on a simple representational approach com-
bined with a strong feeling for the possibilities of the circular format to produce
striking but interesting compositions. In 'The Slide' (444) the rim of the medal
itself provides the slope up which the children must climb, while in 'The Escape'
(445) a crushing sense of claustrophobia is induced by the way that the edge rises
each side of the escapee, threatening to trap him.

445

446

447

448

Eastern European medallists have also done a certain amount of work in France. The unaffected tranquillity of Stanislas Sikora's portrait of Chopin of 1967 (446), as of Andras Beck's portrait of Bela Bartok (447), provides an effective reaffirmation of traditional values, while Adolf Havelka's 'Variations on a Baroque Theme II *Misere Credo*' from 1969 (448) which, like the others, was produced for the *Club Français de la Médaille*, is a restatement of the lessons to be learned from the art of the past.

By no means do all Eastern European medals, however, rely on representation. Younger artists, without any direct experience of the 1950s, have concentrated an experiment with form and medium. The Czech Jan Wagner (b.1941), in his '21st Century Medal' series, seems to be playing with the idea of the medal as

**449** Jan Wagner: 21st Century Medal No. 7

**450** Jan Wagner: 21st Century Medal No. 1

**451** Lugossy: Microscopic Stratification IV, 1976

**452** (opposite) Adrin: Untitled

commemorator. Medals have been seen as a medium through which the memory of a person or an event can be saved from obliteration by the passage of time, but these pieces are concerned not to defeat but to celebrate the passing minutes. Strange bronze forms, studded with screwheads and resembling the backs of watches (449) lead up to his '21st Century Medal No 1' (450), a mobile, half-way between medal and timepiece, that, by changing over a period of time, extends the possibilities of the medal into the fourth dimension. Mária Lugossy, born in Hungary in 1950, takes up another variation of this theme with her abstract work in glass and steel. In her 'Microscopic Stratification IV' (451) of 1976, the medal consists not only of the fixed form of the object itself but also of the changing patterns of light shining through it and creating different patterns of reflection and shadow.

The severity of Lugossy's abstractions, however, removes her work from any specifically Eastern European context and places it firmly in an international one. One of the most gifted Swedish medallists, Olle Adrin, has also been working in translucent material (452). But in his case it is not so much reflections and shadows, but rather the light captured within his medals that gives them life. Bubbles and flaws in the plastic retain the light so that it appears to be the material itself which is glowing.

The most thriving school of Scandinavian medallists is not in Sweden but in Finland. There a 'Guild of Medallists' has succeeded, in a country without any real tradition of medal-making, in attracting and providing work for a large

**454** Räsänen: Finnish Savings Banks, 1972, *rev.*
**455** Räsänen: Wilhelm Moberg, 1973, *rev.*

455

454

number of talented artists. Enlightened government organisations and private companies have been persuaded to take every opportunity to commission medals without imposing their own views on subject matter or appearance. The Finnish Foundation for Economic Education, for example, received a medal from Kauko Räsänen (b.1926) that has no obvious relation to economics (**453**). It is, however, a masterly exploitation of the contrasting textures and colours of polished and corroded bronze. Räsänen's medal for the Finnish Savings Banks (454) is hardly more representational, although it does contain a witty reference to the hoarding instinct: the underside of the foot on which it rests and which is therefore never seen, is shiny gold while the visible surface is a dull bronze. His more recent works, like the medal of Wilhelm Moberg with its reverse of a woman in bondage (455), or his three-part Michelangelo and Leonardo medals, return to a representational idiom which he handles with an originality equal to that of his earlier, abstract pieces.

Other contemporary Finnish medallists have also tended to return to representationalism. The inchoate forms in Kari Juva's (b.1939) medal for the FIDEM conference in Helsinki of 1969 (456) are resolved into recognisable faces and figures in the Finnish Theatre Festival medal of 1977 (457). Raimo Heino's medal for the SALT conference in 1969 (458) is followed by the representational reverse of his medal of C. M. Bellman four years later (459). As early as 1971 Aimo Tukianen had begun to use representational elements, a suggestion of type on one side (460b) and layers of newspapers being excavated on the other (460a) to express the history of the Finnish Newspaper Association.

In Denmark and Sweden commercial medal editors have produced some of the most genuinely popular pieces made today. They continue to be popular because they have managed to remain within the limits imposed by the technique of striking medals and by the dictates of the market without allowing their output to decline into banality. This unfortunately has not always been the case in Britain where a number of medallists have been constrained to work on sets of medals in

**456** Juva: FIDEM Conference, 1969
**457** Juva: Theatre Festival, 1977

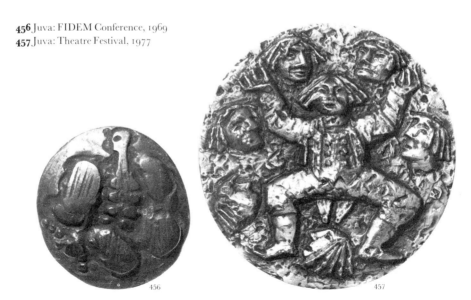

456

457

**458** Heino: SALT Conference, 1969
**459** Heino: C.M. Bellman, 1973, *rev.*
**460** Tukianen: Newspaper Association, 1971

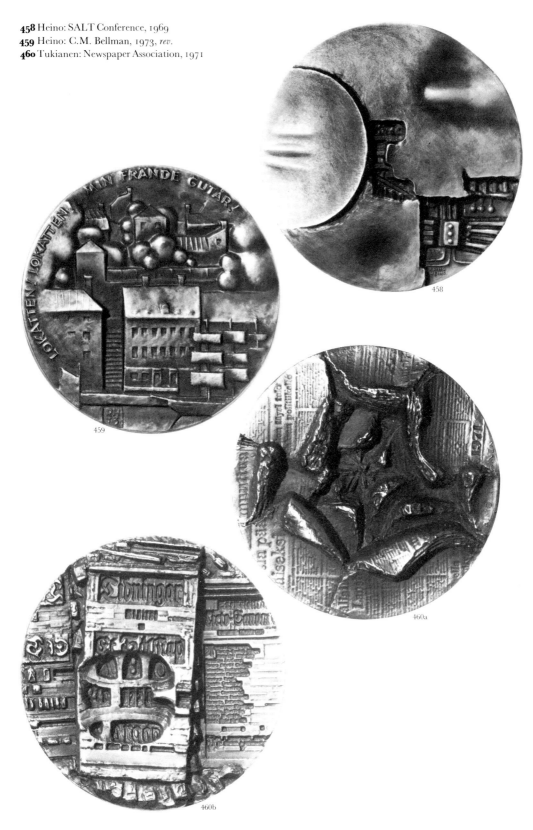

458

459

460a

460b

precious metal which have little but their intrinsic value to recommend them. Few artists have felt it worthwhile to try and break down the barrier of distaste that this perversion of the medal into a disguised and much overvalued ingot has erected. Amongst those who have, Malcolm Appleby, in a move extremely rare among modern medallists, has re-explored the possibilities of the engraver's art. In making medals like 'Bird of Destiny' (461), 'Owl' (462) and 'Sun' (463) he has bypassed the model and the reducing machine in favour of working directly on the die in the traditional manner. This has enabled him to produce medals which are satisfyingly true to the scale of the finished work and to the metal in which they are made. Further, by striking the medals himself he has been able to realise the interesting shapes obtainable without the use of a collar (which is normally used to prevent the blank from spreading when struck, so ensuring that the medal is perfectly round).

Other artists have made cast medals. Ron Dutton in medals like 'Wave breaks' (464) or 'Tree Rain' (465) treats a subject, landscape, which has seldom been tackled by medallists, perhaps because it is so difficult to render light and

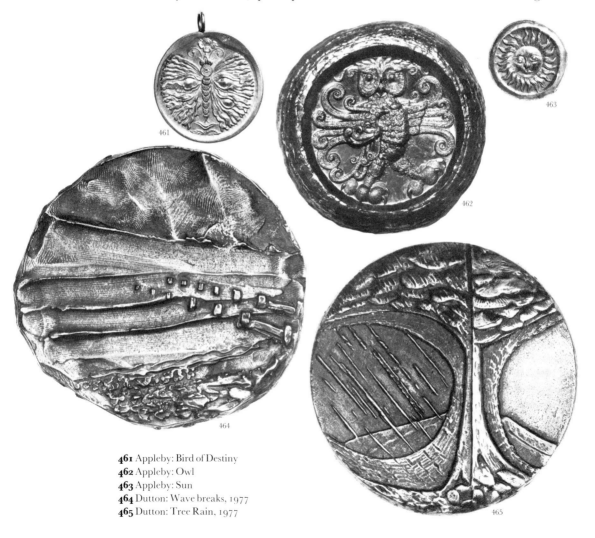

**461** Appleby: Bird of Destiny
**462** Appleby: Owl
**463** Appleby: Sun
**464** Dutton: Wave breaks, 1977
**465** Dutton: Tree Rain, 1977

atmosphere in bronze. In 'Wave breaks', through contrasting textures and an element of colour introduced by selective use of a blue-green patination, he manages to convey a sensation of space and place extraordinary in so small a work. Among other medallists working in England Fred Kormis has maintained, even in what were, from the point of view of medallic art, the rather desolate post-war years, the Central European tradition of regarding medals as a branch of sculpture. Since the Second World War he has produced a remarkable gallery of portraits of contemporaries, ranging from Laurence Olivier (466) and Alexander Fleming to Charlie Chaplin.

Elizabeth Frink is one among a number of other contemporary sculptors who have more recently experimented with medal-making. Her piece for the Royal Zoological Society stands out by virtue of the supressed energy of its subject, a massive buffalo (467), which seems about to burst out of the medal's frame. Ronald Searle has come to medals from a rather different background. The reverse of his 'Self-Portrait' of 1975 (468b), showing *La Gloire* about to crown the artist, is typical of his earlier medals which are purely linear – simply cartoons in metal. On the obverse (468a) he experiments with a raised line which is thrown into relief by the etched metal forming the background. In a more recent medal of Edward Lear (469), he has most successfully broken into relief.

**466** Kormis: Laurence Olivier, 1949
**467** Frink: Buffalo
**468a,b** Searle: Self-portrait; *La Gloire*, 1975
**469** Searle: Edward Lear, 1977

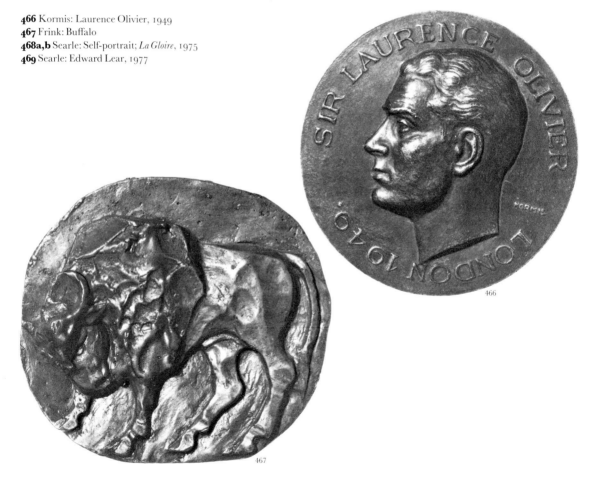

466

467

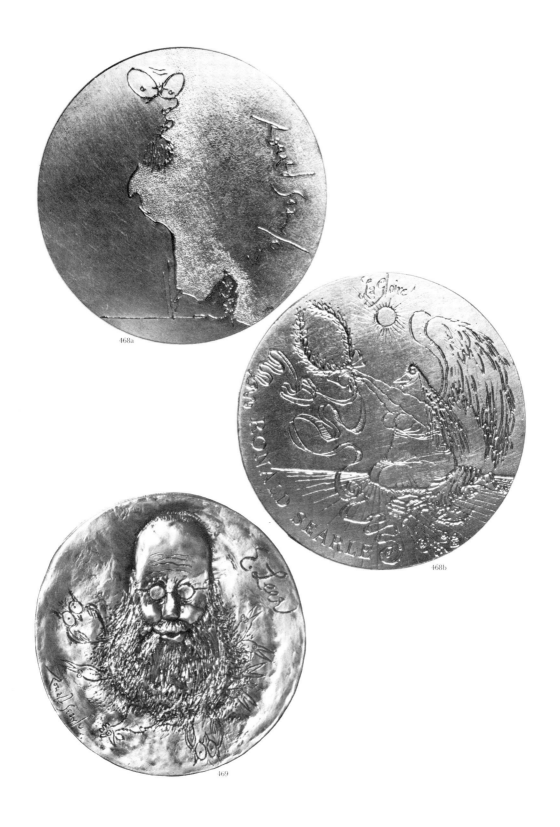

468a

468b

469

In Germany, particularly since the holding of a FIDEM Congress in Cologne in 1971 and the formation of a Medal Society, interest in medallic art has been increasing. Fritz Nuss (b.1907) is perhaps the most eminent German medallist working today. His earlier medals like '*Vogelseele*' from 1965 (470), which contain strange forms hovering in space, show a certain dependence on the work of painters like Klee. Nuss's strong feeling for antiquity, however, led him first to experiment with classical subject matter, in medals like 'The Sphinx' in 1969 (471) and later to the full-blooded classical approach to representing the human figure evident in his series 'Love Games', 1974 (472).

In Austria Helmut Zobl (b.1941), like a number of other modern medallists, is interested in the scope that the medium gives for creating series. In his case these involve both a text with illustrations and the medals themselves, small and delicately engraved works presenting strange figures in impossible landscapes – such as '*Die Macht, die Uns Verbindet*' of 1977 (473). In Switzerland Christl Seth-Hofner creates landscapes of a different kind – vague shadowy spaces out of which 'Indian Women' loom (474).

**470** Nuss: *Vogelseele*, 1965
**471** Nuss: Sphinx, 1969

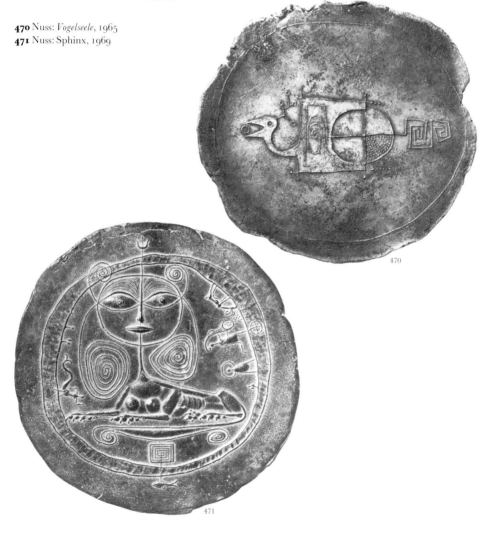

470

471

**472** Nuss: Love Games III, 1974
**473** Zobl: *Die Macht, die Uns Verbindet*, 1977
**474** Seth-Hofner: Indian Women

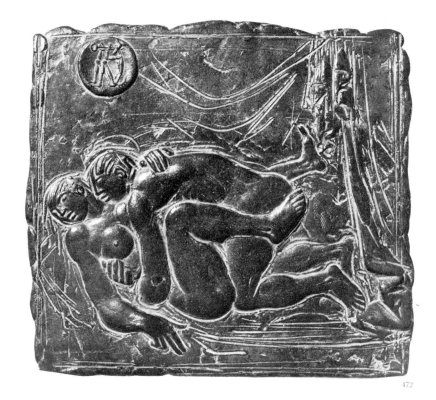

472

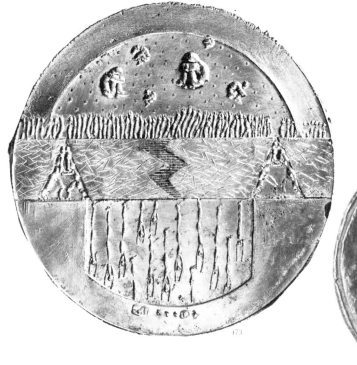

473

174

**475** Zanetti: *Composizione*
**476** Mucchuit: *Aggancio Rosso*
**477** Monti: Simplon Tunnel, 1956
**478** Grilli: *Giulio Natta*, 1976, *rev.*

475

476

477

478

479

480

**479** Kakuyama:
Sinking
**480** Kakuyama:
Impasse

Italian medallists are fortunate in having a school devoted to their training attached to the Papal Mint and a *triennale* at Udine. Their work ranges over the whole field from sentimental realism to abstraction. Among the best exponents of the latter are Gianfranco Zanetti whose rugged '*Composizione*' (475) has a strong tactile appeal and Pino Mucchuit. Mucchuit's '*Aggancio Rosso*' (476) is a self-confident reduction of the medal to a relation of simple forms carved out of the object rather than modelled on its surface. Good examples of the work of more traditional medallists, struck by private editors like Johnson's of Milan, are Emilio Monti's celebration of the fiftieth anniversary in 1956 of the completion of the Simplon tunnel (477) and Angelo Grilli's '*Giulio Natta*', 1976 (478). Such work demonstrates that it is possible to produce medals that are very cheap (a few pounds) and yet of considerable quality.

The traditionally European art form of the medal has even flourished in Japan. Ken Kakuyama, for example, has produced a series of medals of isolated, crushed, or trapped individuals (479, 480) that show an exceptional mastery of texture. He is typically Japanese in his use of the edge of the medal as an essential part of these exquisitely balanced compositions.

In the Iberian peninsular, too, the medal has been experiencing something of a boom. Among the more unusual medals made in Spain recently are Julio Hernandez' paean in praise of electric light (481) and Manolo Prieto's '*Campo*' (482). In Portugal the years since the death of Salazar have seen a revival of the

political medal. Each stage in the political evolution of the country over the last few years has led to the appearance of a new batch of medals. These, as is only suitable for pieces making instant comment on current events, are sold in news-agents alongside political pamphlets and magazines. A. Oliveira's double image of soldier and peasant (483) effectively emphasises the hoped-for unity between army and people, while J. Alves, with rather touching naivety, illustrates the building of socialism in terms of the important dates of the revolution (484).

These medals, precisely because they seem to us rather quaint and old fashioned, highlight the way in which the role of the medal has changed. Traditionally medals have served as metallic pamphlets, but now other, more immediate forms of comment are in fashion. Traditionally medals have provided an important portrait medium. Now the unconscious absorption of Marxist beliefs about the relative unimportance of the individual in the evolution of society and general acceptance of the egalitarian ideal have combined to reduce demand for the commemoration or glorification of the individual. In an era in which even conservative statesmen of the stature of Churchill and de Gaulle content themselves with simple tombs in country churchyards, the use of the medal as a memorial for lesser people has come to seem tasteless and egotistical, while its role as a medium for distributing gift portraits of heads of state has been rendered obsolete by the prevalence of the signed photograph. Then again the medal has traditionally been used as a medium for recording important events. Now the

**481** Hernandez: Electric Light
**482** Prieto: *El Campo*

mass of documentation surrounding every remarkable occurrence decreases the medal's potential importance as a historical record.

Not only the function but also the very existence of the medal as a distinct and separate art form is in question. When traditional barriers, not only between painting and sculpture or between both of these and the performing arts, but even between art and nature are being broken down it would be unrealistic to expect that a clear definition of the medal could be maintained. As this survey of contemporary work has shown, artists now use the term medal to cover objects which bear little resemblance to the traditional metal disc. The Paris Mint has gone further and produced 'natural medals' which are pieces of rock almost untouched by human hand. Yet this art, despite having lost both function and definition, is attracting an unprecedented number of artists.

The reason for this, I think, lies in certain advantages inherent in working on the scale and in the form of the medal which are as relevant to contemporary needs as they have ever been. Medals unite painting and modelling in an essentially pictorial format which yet has the tactile qualities of sculpture. They provide an opportunity to do work which is relatively inexpensive to realise and which can therefore, unlike large scale sculpture, be done without depending on subsidy or commission and which allows the exploration of a range of possibilities without the commitment implied by a public monument. Equally important, medals are private works which can be held and touched, with which the individual can establish an intimate relation quite impossible with work on a monumental scale. Finally they provide one of the best opportunities to do work which is genuinely available to ordinary people.

As a result of this the statement made in the introduction, that medals are a specifically European art form, may turn out to have been true only of the first half-millennium of their history. Medallic art may now be adopting forms and functions which will take it quite outside the tradition, established by humanist thought in the princely courts of Renaissance Italy, with which this book has been concerned.

**483** Oliveira: Armed Forces Movement
**484** Alves: Building Socialism, 1976, *rev.*

# List of Illustrations

The author and publishers are grateful to the following institutions for permission to reproduce the medals listed below.

## Abbreviations

### Collections

*Ashmolean*
Ashmolean Museum, Oxford

*Berlin*
Münzkabinett, Staatliche Museen zu Berlin, DDR

*BM*
Department of Coins and Medals, British Museum, London

*BM M&L*
Department of Medieval and Later Antiquities, British Museum, London

*BM P&D*
Department of Prints and Drawings, British Museum, London

*BN*
Cabinet des Médailles, Bibliothèque Nationale, Paris

*FM*
Fitzwilliam Museum, Cambridge

*Louvre*
Cabinet des Dessins, Musée du Louvre, Paris

*Tokyo*
Palais de Tokyo, Paris

*V&A*
Victoria and Albert Museum, London

### Works of Reference:

*Hill*
G. F. Hill, *A Corpus of the Italian Medals of the Renaissance before Cellini*, London, 1930

*BMC*
British Museum Catalogue

## Chapter 1

1a,b  Augustalis of Frederick II; *rev.* eagle. Struck *c.*1231 at Brindisi. BM. Struck Gold, 20mm.

2  Aureus of Caracalla (198–217) BM BMC Sept. & Car. 261. Struck Gold, 20mm.

3  Aureus of Trajan (98–117). BM BMC Trajan 351. Struck Gold, 20mm, *rev.*

4a,b  Billon denaro of Frederick II. Struck at Brindisi, 1239. BM. Struck billon, 18mm.

5a,b  Follar of Ragusa, *c.*1350. BM. Struck bronze, 15.5mm.

6  Constantius II, *c.*348. BM. Struck bronze, 18mm.

7  Follar of Ragusa, 1436. BM. Struck bronze, 15mm.

8  *Urbs Roma*, 330–335. BM. Struck billon, 20mm.

9  Francesco II da Carrara, Novello, 1390. Hill 4. Paris. Cast silver, 33mm.

10  Sestertius of Vitellius, 69. BM BMC Vitellius 57. Struck brass, 35mm.

11a,b  Carrarino of Francesco II da Carrara (1390–1405). Struck at Padua. BM. Struck silver, 19mm.

12a,b  Francesco I da Carrara; *rev.* the *carro*, or cart of Carrara, 1390. Hill 2. Berlin. Struck bronze, 34mm.

13a,b  Mural medal of Francesco I da Carrara. Hill 5. BM. Struck bronze, 29mm.

14a,b  Marco Sesto: Galba/Venetia, 1393. Hill 11(a). Florence. 33mm.

15a,b  Lorenzo Sesto: Galba/Venetia, *c.*1393. Hill 10. Berlin. Cast bronze, 24mm.
From an example destroyed during the Second World War.

16  Dupondius of Galba, 68–69. BM BMC Galba 122. Struck brass, 30mm.

17a,b  Alessandro Sesto: Alexander the Great, 1417. Hill 12. Berlin. Struck bronze, 21mm.
From an example destroyed during the Second World War.

18a,b  Constantine the Great; *rev.* Old and New Churches, 1402. After a medal by the Limbourg brothers (?). BM. Two silver plates joined, 89mm.

19a,b  Heraclius; *rev.* Heraclius at the gates of Jerusalem, 1402. After a medal by the Limbourg brothers (?). BM. Cast bronze, 98mm.

20  Sestertius of Tiberius. Carpentum. BM PCR 365. Struck brass, 34mm, *rev.*

21  Justinian (527–565). Electrotype copy (original destroyed after Paris robbery of 1831). BM. 83mm. *rev.*

22 Limbourg brothers: Heraclius taking the True Cross to Jerusalem, c.1408. (*Belles Heures*, fol. 156). The Metropolitan Museum of Art, The Cloisters Collection. 107 × 88mm.

23 Limbourg brothers: Meeting of the Three Magi, c.1411–16. (*Très Riches Heures*, f. 51v). Musée Condé, Chantilly. 147 × 217mm.

## Chapter 2

24 Antonio Marescotti (?): Pisanello c.1440–3. Hill 87. BM. Bronze, 58mm.

25 (detail) St George freeing the Princess of Trebizond. Fresco, c.1433–8. Pellegrini Chapel, Church of St Anastasia, Verona. 2230 × 6200mm.

26a,b Pisanello: John VIII Palaeologus; *rev*: John VIII on horseback with a page, 1438–9. Hill 19(h). V&A. Cast bronze, 104mm.

27 Pisanello, or circle of Pisanello: Architectural study. Rotterdam, Boymans Museum. Drawing No. 1, 526r.

28 Copy after the Limbourg brothers: St Jerome in his study. BN Fr. Ms. 166, fol. A.

29 Pisanello: Madonna and Child with Saints Anthony and George. National Gallery, London. 470 × 290mm.

30 Drawing after the Limbourg brothers. Madonna and Child. Louvre, No. 2623v.

31 Pisanello: John VIII Palaeologus riding. Louvre 1062. 199 × 290mm.

32 Pisanello: Two horses. Louvre 2468. Related to no. 26. 200 × 165mm.

33 Pisanello: Horse, three-quarters right. Louvre 2378. Related to no. 35. 200 × 165mm.

34 Pisanello: Horse from behind. Louvre 2444. Related to no. 44. 192 × 118mm.

35a,b Pisanello: Filippo Maria Visconti, Duke of Milan; *rev*. the Duke on horseback with a page and an armed horseman, c.1441. Hill 21. BM. Cast bronze, 101mm.

36a,b Pisanello: Niccolò Piccinino; *rev*. griffin suckling Braccio da Montone and Piccinino, c.1441. Hill 22(j). V&A. Cast bronze, 89mm.

37a,b Pisanello: Leonello d'Este; *rev*. old and young man by a mast, c.1443. Hill 26(b). BM. Cast bronze, 68.5mm.

38 Pisanello: Blindfold Lynx, c.1443. Hill 28(b). BM. Cast bronze, 68.5mm. *rev*.

39 Pisanello: Triple faced child, c.1443. Hill 24(d). BM. Cast bronze, 68mm. *rev*.

40 Pisanello: Man and vase, c.1443. Hill 30(b). BM. Cast bronze, 68.5mm. *rev*.

41a,b Pisanello: Leonello d'Este: Marriage medal; *rev*. Leonello as lion singing from a scroll held by a cupid, 1444. Hill 32(e). V&A. Cast bronze, 102mm. *(colour plate facing page 48)*

42 Pisanello: Sigismondo Malatesta, c.1445. Hill 33(f). BM. Cast lead, 91mm.

43a,b Pisanello: Domenico Novello Malatesta, Lord of Cesena; *rev*. Malatesta on his knees before a crucifix, c.1445. Hill 35(g). V&A. Cast bronze, 85mm.

44a,b Pisanello: Gianfrancesco I Gonzaga, Marquess of Mantua; *rev*. Gianfrancesco with a page, c.1447. Hill 20(e). BM. Cast lead, 100mm.

45 Pisanello: Drawing of cavalcade. Louvre 2595. 256 × 190mm.

46a,b Pisanello: Cecilia Gonzaga; *rev*. Innocence with a unicorn, 1447. Hill 37. BM. Cast lead. 87mm.

47 Pisanello: Goat. The Devonshire Collections, Chatsworth. 97 × 125mm.

48a,b Pisanello: Vittorino Rambaldoni da Feltre (d.1446); *rev*. a pelican drawing blood from her own breast to feed her young, symbol of Vittorino's devotion to his pupils, c.1447. Hill 38. V&A 504–1864. Cast bronze, 67mm.

49 Pisanello: Study for '*Liberalitas*' medal. Louvre, Vallardi 2307, f. 61. 109 × 143mm.

50a,b Pisanello: Alfonso v of Aragon and Sicily; *rev*. eagle surrounded by lesser birds of prey, 1449. Hill 41(e). BM. Cast lead, 110mm.

51 Pisanello: Alfonso v boar hunting, 1449. Hill 42(c). BM. Cast lead, 108.5mm, *rev*.

52 Pisanello: Boar. Fitzwilliam PD 124–1961. 97 × 167mm.

53a,b Pisanello: Don Inigo d'Avalos; *rev*. terrestrial sphere, Hill 44(c). BM. Bank Ital. Med. 9. Cast bronze, 77mm.

54 Pisanello: Drawing for no. 53b. Louvre, Vallardi 2280, 195 × 260mm.

55 Pisanello: Study for a medal of Alfonso v of Aragon. Louvre, Vallardi 2486, pl. 249. 168 × 45mm.

## Chapter 3

56a,b Matteo de' Pasti: Sigismondo Malatesta; *rev*. Rocca Malatestiana, the Castle of Rimini, 1446. Hill 174(d). BM. Cast bronze, 83mm.

57 Matteo de' Pasti: Leon Battista Alberti, c.1446–50. Hill 161(c). V&A. Cast bronze, 93mm.

58 Matteo de' Pasti: Tempio Malatestiano, 1450. Hill 183(j). BM. Cast bronze, 40mm, *rev*.

59a,b Matteo de' Pasti: Isotta degli Atti; *rev*. elephant, 1446. Hill 167(e). BM. Cast bronze, 85.4mm. *(colour plate facing page 48)*

60a,b Matteo de' Pasti: Benedetto de' Pasti; *rev*. youth shooting arrows at a rock, probably before 1446. Hill 160(c). BM. Cast lead, 90mm.

61a,b Pier Jacopo di Antonio Alari Bonacolsi, called L'Antico (attr. to): Giulia Astallia; *rev*. phoenix on a burning pyre. Hill 218(e). BM. Cast bronze, 64mm. *(colour plate facing page 48)*

62 Giancristoforo Romano (attr. to): Lucrezia Borgia, c.1502. Hill 232(b). BM. Cast bronze, 59mm.

63 Sperandio: Drawing of two men. BM P&D. 65 × 105mm.

64 Sperandio: Sarzanella de' Manfredi, c.1463. Hill 358(d). BM. Cast bronze, 70mm.

65a,b Sperandio: Federigo da Montefeltro, Duke of Urbino; *rev*. the Duke on horseback, c.1482. Hill 389(f). BM. Cast bronze, 90mm.

66a,b Giovanni Boldù: Caracalla; *rev*. the artist with Death, 1466. Hill 423(g). BM. Cast bronze, 93mm.

67 Fra Antonio da Brescia: Dea Contarina, after 1500. Hill 471(c). BM. Cast bronze, 72mm.

68a,b Giulio della Torre: Antonio de Giulio della Torre; *rev*. Antonio with a dragon. Hill 563(a). BM. Cast bronze, 66.5mm.

69a,b Giovanni Candida: Maximilian of Austria; *rev*. Maria of Burgundy, *c*.1477. Hill 831(h). BM. Cast silver, 48mm.

70 Sandro Botticelli: Bertoldo di Giovanni (?) holding a medal of Cosimo de' Medici. 575 × 440mm.

71 Bertoldo di Giovanni (attr. to): Cosimo de' Medici, il Vecchio. Hill 909(g). V&A. Cast bronze, 77mm.

72a,b Niccolò Fiorentino: Giovanna Albizzi; *rev*. Three Graces, *c*.1486. Hill 1021(c). BM. Cast bronze 78mm.

73 Niccolò Fiorentino: Pico della Mirandola, *c*.1490. Hill 998B(d). BM. Cast bronze, 82mm.

74a,b Andrea Guacialoti: Alfonso of Aragon; *rev*. triumphal entry into Otranto, 1481. Hill 745(d). BM. Cast bronze, 61mm.

75 Lysippus the Younger: Self-portrait(?). Hill 796(a). BM. Cast bronze, 82.5mm.

## Chapter 4

76 Albrecht Dürer: Willibald Pirckheymer, V&A. Cast lead, 79mm.

77 Albrecht Dürer: Ideal Head (Agnes Frei), 1508. V&A. Cast lead, 53.5mm.

78 Albrecht Dürer: Old Man, 1508. BM. Cast lead, 53mm.
*(colour plate facing page 49)*

79 Albrecht Dürer: Young Man, 1514. BM. Cast lead, 82mm.

80 Mathes Gebel: Albrecht Dürer, 1527. BM. Cast lead, 39mm.

81a,b Mathes Gebel: Hieronymus Holzschuher; *rev*. coat of arms, 1529. BM. Cast bronze, 41mm.
*(colour plate facing page 49)*

82 Joachim Deschler: Hieronymus Paumgartner, 1553. BM. Cast bronze, 65.5mm.

83 Hans Schwarz: Lucia Doerrer, 1522. BM. Cast lead, 74mm.

84 Hans Schwarz: Young Man, 1514. V&A. Boxwood, 59mm.

85 Christoph Weiditz: Lienhard Meringer, 1526. V&A. Boxwood, 46mm.

86 Christoph Weiditz: Fernando Cortez, 1529. BM. Cast lead, 54mm.

87 Christoph Weiditz: Joachim Rehle, 1529. V&A. Boxwood, 59mm.

88 Friedrich Hagenauer: Hans Wolf Otmar, 1537. BM. Cast lead, 41mm.

89 Friedrich Hagenauer: Philip Melanchthon, 1543. BM. Cast lead, 46mm.

90 Friedrich Hagenauer: Margaret von Freundsberg. V&A. Pearwood and coloured gesso, 54.5mm.

91 Friedrich Hagenauer: Ulrich Fugger of Augsburg. V&A. Pearwood & coloured gesso, 54mm.

92 Hans Reinhardt: Trinity, 1544. BM. Cast and worked silver, 103mm.

93 Hans Reinhardt: Adam and Eve. BM. Cast silver gilt, 56mm.

94 Hans Reinhardt: Johann-Friedrich of Saxony. BM. Cast silver, 65.5mm.

## Chapter 5

95 Quentin Matsys: William Schevez, Archbishop of St Andrews, 1491. BM. Cast bronze, 78mm.

96a,b Quentin Matsys: Erasmus; *rev*. Terminus the Roman god of boundaries, 1519. Historisches Museum, Basel. Cast Lead, 103mm.

97 Jean Second: Nicholas Perrenot. BM. Cast lead, 87.5mm.

98a,b Jacob Jonghelinck: Antonis van Stralen; Fortune 1565. BM. Cast silver, 53.5mm.

99 Jacob Jonghelinck: Walbourg de Neunar, *c*.1566. BM. Coloured lead, 62.5mm.
*(colour plate facing page 49)*

100a,b Steven van Herwijck: Maria Dimock; *rev*. 'As the hart panteth after the water brooks' Psalms 42 v.1, 1562. BM. Cast silver, 40mm.

101 Steven van Herwijck: Engelken Tols, 1588. BM. Cast lead, 87mm.

102 Jan Symons: Margarita de Calslagen, 1567. BM. Cast lead, 71mm.

103a,b Coenrad Bloc: Pomponne de Bellièvre, 1598. BM. Cast silver gilt, 44.5mm.

104 Nicholas-Gabriel Jacquet: Pomponne de Bellièvre, 1601. BM. Cast lead, 55mm.

105a,b Anon: The Defeat of the Spanish Armada, 1588. BM. Struck silver, 51mm.

106 Anon: The Battle of Nieuport, 1600. BM. Struck silver, 55mm.

107 Jacob II de Gheyn: Drawing for no. 106. BM P&D. 61mm.

108 Peter van Abeele: William II Prince of Orange, 1650. BM. Repoussé silver, 64.5mm.

109 Peter van Abeele: William III as a child, 1654. Repoussé silver, 64.5mm, *rev*.

110a,b O. Müller: Cromwell; *rev*. Masaniello, 1658. BM. Repoussé silver, 71mm.

## Chapter 6

111 Anon: The Expulsion of the English, *c*.1454. BM. Struck silver, 61.5mm.

112 Francesco Laurana: Louis XII, *c*.1465. Hill 65. BM. Cast lead, 84.5mm.

113 Fiorentino (?): Jean Matharon de Salignac, *c*.1494. Hill 952. BM. Cast lead, 86mm.

114a,b Louis Lepère, Nicholas de Florence and Jean Lepère: Charles VIII; *rev*. Anne of Brittany, 1494. BM. Struck silver, 40.5mm.

115a,b Nicholas Le Clerc, Jean de Saint-Priest and Jean Lepère: Louis XII and Anne of Brittany, 1500. BM. Cast bronze, 114mm.

116 Candida (attr. to): François de Valois, afterwards François I, 1512. Hill 851b. BM. Cast lead, 96mm.

117a,b Benvenuto Cellini: François I; *rev.* François about to strike Fortune. V&A. Struck lead, 41mm.

118a,b Regnault Danet: Self-portrait; *rev.* Danet's wife. BM. Cast lead, 43.5mm.

119 Jacques Gauvain: Jean Clouet. BM. Cast lead, 58mm.

120a,b Étienne de Laune: Antoine de Bourbon; *rev.* Prudence. BM. Struck silver, 37.5mm.

121 Claude de Hery: Creation of the Order of the Holy Ghost. 1579. BM. Struck silver, 41mm.

122 The Danfries: Peasant ploughing in a sunlit landscape; *rev.* of medal of Henry IV. BM. Struck silver, 48mm.

123a,b Philippe II Danfrie: Henry IV: conquest of Savoy; *rev.* Henry IV as Hercules about to strike a centaur, 1602. BM. Cast and chased silver, 48.5mm.

124 Germain Pillon: Catherine de Médicis. BM. Cast lead, 165mm.

125 Germain Pillon: Charles IX, 1573. BM. Cast lead, 158mm.

126 Germain Pillon: René de Birague, *c.*1576. BM. Cast bronze, 162mm.
*(colour plate facing page 64)*

## Chapter 7

127a,b Benvenuto Cellini: Clement VII; *rev.* Peace burning a pile of arms, 1534. BM. Struck silver, 39mm.

128 Giovanni Cavino: Cavino and Bassiano. BM. Struck bronze, 37.5mm.

129 Cavino: Restoration of Roman Catholicism in England, 1554. BM. Struck bronze, 46.5mm. *rev.*

130 '*Roma Resurges*', Sestertius of Vespasian, 71, BM BMC Vesp 566. Struck brass, 34mm, *rev.*

131 Alessandro Cesati: Ganymede watering Farnese lilies, *c.*1545. BM. Struck silver, 42mm, *rev.*

132 Leone Leoni: Andrea Doria, 1541. Drawing for 133. Pierpoint Morgan Library, New York.

133a,b Leone Leoni: Andrea Doria; *rev.* Leone Leoni surrounded by leg irons, 1541. BM. Cast silver, 41.5mm.

134 Leone Leoni: Leoni rowing away from galley; *rev.* of medal of Andrea Doria, 1541. BM. Cast bronze, 42mm.

135 Leone Leoni: Michelangelo Buonarotti. BM M&L. Wax, 49 × 43mm.

136 Leone Leoni: Michelangelo Buonarotti. BM. Cast lead, 59mm.

137 Leone Leoni: Ippolita Gonzaga. BM. Cast silver, 70mm.

138 Leone Leoni: Charles V as Jupiter striking down the giants. BM. Cast lead, 75mm, *rev.*

139 Leone Leoni: Charles V as Hercules. BM. Cast silver, 69.5mm, *rev.*

140 Jacopo da Trezzo: Fountain of the Sciences. BM. Cast bronze, 80mm. *rev.*

141 Antonio Abondio: Portrait medallion of Archduke Ernest of Austria. Wallace Collection. Wax, 82 × 64mm.

142 Antonio Abondio: Caterina Riva. BM. Cast lead, 68.5mm.

143 Ludovico Leoni (attr. to): '*Tertia Iam Vivitur Aetas*'. BM. Cast lead, 65mm. *obv.*
*(colour plate facing page 49)*

144 Pastorino de' Pastorini: Cassan Ciaussi, 1556. BM. Cast lead, 58.5mm.

145 Pastorino de' Pastorini: Isabella Manfro de' Pepoli, 1551. BM. Cast lead, 67mm.

146 Alfonso Ruspagiari: Ercole II d'Este. BM. Cast lead, 65mm.

147 Alfonso Ruspagiari: Unknown woman. BM. Cast lead, 67mm.
*(colour plate facing page 49)*

148 Bombarda: Giulio Vitriani. BM. Cast lead, 68mm.

149 Bombarda: Leonora Cambi, wife of the artist. BM. Cast bronze, 68mm.

## Chapter 8

150 School of Fiorentino: John Kendal, 1480. BM. Cast bronze, 57.5mm.

151 Hans Schwarz: Henry VIII. BM. Cast lead, 59mm.

152 Henry Basse (attr. to): Edward VI, 1547. BM. Cast gold, 61mm.

153a,b Jacopo da Trezzo: Mary Tudor; *rev.* The happy state of England, 1555. BM. Cast silver, 65.5mm.
*(colour plate facing page 65)*

154 Ludovico Leoni: John Cheke. BM. Cast bronze, 53.5mm.

155 Pastorino: Edward Courtenay, 1556. BM. Cast lead, 58mm.

156 Steven van Herwijck: Edmund Withipoll, 1562. BM. Silver, 54mm.
*(colour plate facing page 49)*

157a,b Steven van Herwijck: Richard Martin; *rev.* Dorcas Eglestone, 1562. BM. Silver, 58mm.

158a,b Michael Mercator: Drake's Voyage. BM. Engraved silver, 68mm.

159 Nicholas Hilliard: Drawing for Elizabeth's Great Seal of Ireland. BM P&D. 127mm.

160 Nicholas Hilliard (attr. to): Dangers Averted, *c.*1588. BM. Cast and chased gold, 61 × 53mm.

161a,b Nicholas Hilliard (attr. to): Dangers Averted; *rev.* bay tree on an island, *c.*1588. BM. Cast gold, 56 × 44mm.
*(colour plate facing page 65)*

162a,b Nicholas Hilliard (attr. to): James I; peace with Spain, 1604. BM. Struck gold, 37.5m.
*(colour plate facing page 65)*

163a,b Charles Anthony (attr. to): Henry Prince of Wales; *rev.* coat of arms, 1612. BM. Struck gold, 28mm.

164a,b Simon van de Passe: Counter – James I; *rev.* Charles I as Prince of Wales. BM. Engraved silver, 27.5mm.

165 Hendrick Goltzius: The Earl of Leicester, 1586. The City Art Gallery and Museum, Birmingham. Engraved gold, 62 × 52mm.

166a,b Simon van de Passe: James I; *rev.* coat of arms. BM. Engraved gold, 60mm.

167a,b Nicholas Briot: Charles I; *rev.* dominion over the seas, 1630. BM. Cast gold, 61.5mm.

168 Briot: Charles I return to London, 1637. BM. Struck silver, 43mm, *rev.*

169 Abraham Simon: Self-portrait. BM M&L. Wax, 45mm.

170 Thomas Simon: John Thurloe. BM. Cast and chased gold, 34.5mm.
*(colour plate facing page 65)*

171 Thomas Simon: George Monk, 1660. BM. Cast and chased gold, 35mm.

172 Thomas Simon: The Earl of Southampton, 1664. BM. Cast and chased gold, 42mm.

173 Thomas Simon: The Earl of Southampton, 1663. BM. Cast and chased gold, 43mm.

174 Thomas Simon: Drawing for a portrait of the Earl of Strafford. Private Collection. 192 × 158mm.

175 Thomas Simon: Drawing for a medal. Private Collection. 98.5 × 69mm.

176 Abraham Simon: Elizabeth Cleypole. BM. Cast silver, 38.5mm.

177 Samuel Cooper (?): Miniature of Elizabeth Cleypole. *c.* 64mm.

178a,b Thomas Simon: Dunbar medal; *rev.* the Long Parliament in session. BM. Struck silver, 34mm.

179 Thomas Simon: Drawing for the Great Seal, 1649. Private Collection. *c.*150mm.

180a,b Thomas Simon: Naval Reward; *rev.* naval battle, 1653. National Maritime Museum, Greenwich. Struck gold.

181a,b Thomas Simon: Cromwell as Lord Protector; *rev.* arms of the Protectorate, 1653. BM. Struck gold, 39mm.
*(colour plate facing page 65)*

**Chapter 9**

182a,b Guillaume Dupré: Lavallette; *rev.* lion, fox and Fury in Landscape, 1607. BM. Cast silver, 54.5mm.

183 Guillaume Dupré: Apollo; *rev.* of medal of Brulart de Sillery, 1613. BM. Cast bronze, 70mm.

184 Jacopo da Trezzo: Apollo; *rev.* of medal of Philip II of Spain, 1555. BM. Cast silver, 66mm.

185a,b Guillaume Dupré: Louis XIII and Marie de Médicis; *rev.* Louis as Apollo and Marie as Minerva, 1611. BM. Cast silver, 50mm.

186 Guillaume Dupré: Cosimo II de' Medici, Ashmolean. Polychrome wax, 100mm.

187 Guillaume Dupré: Marcantonio Memmo, 1612. BM. Cast and chased silver, 91.5mm.
*(colour plate facing page 112)*

188 Guillaume Dupré: Francesco IV of Mantua, 1612. BM. Cast silver, 165mm.

189 Guillaume Dupré: Pierre Jeannin, 1618. BM. Cast bronze, 192mm.

190a,b Guillaume Dupré: Maréschal de Toyras; *rev.* sun over landscape, 1634. BM. Cast silver, 58.5mm.

191 Claude Warin: Thomas Carey, 1633. BM. Cast silver, 93.5mm.

192 Claude Warin: Alphonse de Richelieu, 1647. BM. Cast silver, 97mm.

193a,b Jean Warin: Cardinal Richelieu; *rev.* France in triumph, 1630. BM. Cast and chased silver, 76mm.

194 Jean Warin: Hercules taking the world from Atlas; *rev.* of medal of Antoine de Ruzé, 1629. BM. Cast and chased silver, 66.5mm.

195a,b Jean Warin: Louis XIV and Anne of Austria; *rev.* Val-de-Grace, *c.*1645. BM. Cast silver, 96mm.

196a,b Jean Warin: Louis XIV; *rev.* Bernini's design for the Louvre, *c.*1665. BM. Cast bronze, 108mm.
*(colour plate facing page 112)*

197 Jean Warin: Canal joining the two seas, 1667. BM. Struck silver, 50.5mm, *rev.*

198 Jean Warin: Conquest of the Franche-Comté, 1668. BM. Struck silver, 50mm, *rev.*

199 Conquest of the Franche-Comté, *c.*1688. BM. Struck bronze, 69mm, *rev.*

200 Jean Mauger: Conquest of the Franche-Comté, *c.*1695. BM. Struck silver, 41mm, *rev.*

201 Conquest of the Franche-Comté, *c.*1705. BM. Struck silver, 41mm, *rev.*

202 Peter van Abeele: Charles II, 1660. BM. Repoussé silver, 70mm.

203 Jean Warin: Louis XIV, 1660. BM. Struck silver, 53.5mm.

204 Johann Höhn: John III Sobieski, 1683. BM. Struck silver, 58mm.

205a,b Jan Boskam: William III; *rev.* capture of Namur, 1695. BM. Struck silver, 60mm.

206a,b Jean Mauger: Louis XIV; *rev.* capture of Namur, *c.*1692. BM. Struck silver, 71mm.

207 Antonio Mengin: John V of Portugal, 1717. BM. Struck silver, 50mm.

208a,b Anon: Louis XIV; *rev.* William III, 1691. BM. Struck silver, 52.5mm.

209 Anon: Louis XIV's concessions to the Pope and to the Moors, 1689. BM. Struck silver, 49.5mm.

210 François Chéron: Bombardment of Algiers, *c.*1684. BM. Struck silver, 69mm.

211a,b Anon: French alliance with the Turks. BM. Struck silver, 38mm.

212 Jean Dollin: Battle of Palermo, *c.*1676. BM. Struck silver, 50mm, *rev.*

213 Philipp Heinrich Müller: Battle of La Hogue, *c.*1692. BM. Struck bronze, 49.5mm, *rev.*

214 Martin Brunner: Louis XIV as Phaethon, 1709. BM. Struck silver, 43mm.

215 Jan Luder: Capture of Namur, 1695. BM. Struck silver, 49.5mm, *rev.*

216 John Croker: Capture of Lille, 1708. BM. Struck silver, 44mm, *rev.*

217 Jean Mauger: Capture of Thionville, *c.*1695. BM. Struck bronze, 41mm, *rev.*

218 John Croker: Drawing for medal. Department of Manuscripts, British Library, London.

219 John Croker: Drawing for medal. Department of Manuscripts, British Library, London.

220 John Croker: Queen Anne, 1707. BM. Struck silver, 70mm.

221 John Croker: Second Treaty of Vienna, 1731. BM. Struck gold, 47mm, *rev.* (*colour plate facing page 65*)

## Chapter 10

222 Gaspare Mola: Cosimo II, Duke of Tuscany. BM. Struck silver, 40mm.

223 Gian Lorenzo Bernini: Drawing for medal of Cathedra, *c.*1662, BM. 78 × 75mm.

224 Gaspare Morone Mola: Cathedra, *c.*1662. BM. Wax on slate, 43.5mm.

225 Gaspare Morone Mola: Cathedra, 1662. BM. Struck silver, 41.5mm.

226 Massimiliano Soldani-Benzi: Painting and Architecture, *rev.* of medal of Cyro Ferri, 1680. BM. Cast bronze, 67mm.

227 Massimiliano Soldani-Benzi: Bacchic orgy; *rev.* of medal of Francesco Reddi, 1684. BM. Cast bronze, 88mm.

228 Massimiliano Soldani-Benzi: Serristori Patriti, 1711. BM. Cast bronze, 89mm.

229 Antonio Selvi: *rev.* of medal of Giuseppe Martelli, Archbishop of Florence, 1722. BM. Cast bronze, 89mm.

230 Antonio Montauti: Count Lorenzo Magalotti, 1712. BM. Cast bronze, 93mm.

231 Lorenzo Maria Weber: Gaietano Berenstadt. BM. Cast bronze, 92mm, *rev.*

## Chapter 11

232 Michel Molart: Pyramid raised in Rome, *c.*1688. BM. Struck bronze, 70mm, *rev.*

233 Jean Mauger: Pyramid raised in Rome, *c.*1695. BM. Struck bronze, 41mm, *rev.*

234 Apartments at Versailles opened to the public, *c.*1690. BM. Struck bronze, 72mm, *rev.*

235 Jean Mauger: Apartments at Versailles opened to the public, *c.*1695. BM. Struck silver, 41mm, *rev.*

236 Jean Mauger: Relief of Arras, *c.*1692–1701. BM. Struck bronze, 41mm, *rev.*

237 Jean Le Blanc: Relief of Arras, *c.*1702–1723. BM. Struck silver, 41mm, *rev.*

238 Jean Duvivier: Louis XV, 1717. BM. Struck silver, 59.5mm.

239a François Marteau: Louis XV, 1746. BM. Struck silver, 41mm.

239b Joseph Charles Roettiers: Battle of Racoux. BM. Struck silver, 41.5mm.

240 Jean Duvivier: Drawing for medal for the Chamber of Commerce, Rouen, 228mm.

241 Edmé Bouchardon: Drawing for no. 242. V&A.

242 François Marteau: Jetton for Trésor Royal, 1749. BM. Struck silver, 28.5mm.

243 Jean-Baptiste Nini: Catherine the Great of Russia, 1771. BM. Terracotta, 163mm.

244 Jean-Baptiste Nini: Voltaire, 1781. BM. Terracotta, 139mm.

245 Benjamin Duvivier: Drawing for no. 251. BN. 190 × 230mm.

246 Augustin Dupré: American Liberty, 1783. BM. Struck silver, 48mm.

247 Augustin Dupré: Subterranean junction of the Escaut and the Somme, 1785. BM. Struck bronze, 55.5mm, *rev.*

248a,b Augustin Dupré: John Paul Jones; *rev.* battle between the Bon Homme Richard and the Serapis, 1789. BM. Struck bronze, 56mm.

249a,b Benjamin Duvivier: Washington before Boston, 1786–9. BM. Struck bronze, 69mm.

250 Benjamin Duvivier: Abandonment of Privilege, 1789. BM. Struck bronze, 63mm.

251 Benjamin Duvivier: Storming of the Tuilleries, 1792. BM. Struck bronze, 55.5mm.

252 Benjamin Duvivier: Bonaparte, 1798. BM. Struck bronze, 57mm.

253 Bertrand Andrieu: Storming of the Bastille, 1789. BM. Lead, 85.5mm.

254 Augustin Dupré: Confederation, 1790. BM. Struck bronze, 35 × 28.5mm.

## Chapter 12

255a,b André Galle: Bonaparte's arrival at Fréjus; *rev.* the god of good fortune. BM. Struck silver, 33mm.

256 Rambert Dumarest: Athena, 1803. BM. Struck silver, 49mm.

257a,b Jean-Pierre Droz: Bonaparte: Peace of Amiens, 1802. *rev.* return of Astraea. BM. Struck gilt silver, 49mm.

258 Nicholas Brenet after Chaudet: *Fortuna, c.*1804. BM. Struck bronze, 33mm, *rev.*

259 Bertrand Andrieu: Passage of the Great St Bernard. BM. Lead, 68mm.

260 Nicholas Brenet: Conquest of Naples, *c.*1806. BM. Struck bronze, 40mm, *rev.*

261 Coin of Naples: Bull and Victory, *c.*300 BC BMC Neapolis 61. Struck silver, 22mm.

262 Alexis Joseph Depaulis: Conquest of Illyria, *c.*1809. BM. Struck bronze, 40mm, *rev.*

263 Coin of Illyria: Cow and Calf, 4th century BC. BMC Dyrrhachium 16. Struck silver, 21mm.

264a Bertrand Andrieu: Napoleon, *c.*1806. BM. Struck bronze, 40.5mm.

264b André Galle: Battle of Jena, *rev.*

265 André Galle: Elisa Bonaparte, 1811. BM. Struck bronze, 36mm.

266 André Galle: Retreat from Moscow, 1812. BM. Struck bronze, 40mm, *rev.*

267 Nicholas Brenet: Mont Blanc School of Mining, *c.*1805. BM. Struck bronze, 40mm, *rev.*

268 Nicholas Brenet: *Fortune Adverse, c.*1814. BM. Struck bronze, 41mm, *rev.*

269a Bertrand Andrieu: Louis XVIII, 1814. BM. Struck bronze, 50mm.

269b Jacques Edward Gatteaux: Allied Sovereigns, *rev.*

270a Hieronymous Vassallo: Napoleon, Battle of Ratisbon, 1809. BM. Struck bronze, 42.5mm.

270b Ludovico Manfredini: Typhon crushed by Etna, *rev.*

271 Aureus of Augustus, *c*.20–15 BC, BM BMC 395. Struck gold, 20mm.

272 Benedetto Pistrucci: Model for George and the Dragon. BM. Wax on glass, *c*. 94mm.

273a,b Benedetto Pistrucci: George IV; *rev*. George IV crowned by Victory in front of England, Scotland and Ireland, 1821. Struck gold, 35mm.
*(colour plate facing page 113)*

274a,b Benedetto Pistrucci: Waterloo medal; *rev*. Victory, horsemen and tritons, 1817–1850. BM. Electrotype, 133mm.

275a,b William Wyon: Earl Howe; *rev*. Battle of Ushant, *c*.1818. BM. Struck gilt bronze, 41mm.

276 William Wyon: Defeat of the Pindaree and Mahratta Confederacy, 1818. BM. Struck silver, 41mm. *rev*.

277 G. F. Pidgeon after John Flaxman: Medal for the Royal Society of Arts, Minerva and Mercury. BM. Struck silver, 43mm.

278 William Wyon: Medal for Royal Society of Arts – Minerva and Mercury, 1820. BM. Struck silver, 43mm.

279 William Wyon: Ireland, England and Scotland, Pattern Crown. BM. Struck silver, 40mm, *rev*.

280 William Wyon: Five pound piece, Una and the Lion, 1839. BM. Struck gold, 38mm, *rev*.

281 William Wyon: 'Bun penny', 1839. BM. Struck bronze, 34mm.

282 William Wyon: Queen Victoria, 1840. BM. Struck bronze, 38mm.
*(colour plate facing page 113)*

283a,b William Wyon: George IV: medal for the Royal National Institution for the Preservation of Life from Shipwreck; *rev*. a rescue: the rescuer is W. Wyon himself, 1824. BM. Struck silver, 35mm.

284 William Wyon: Cheselden medal; a body awaiting dissection, 1839. BM. Struck silver, 72mm, *rev*.

285 William Wyon: Apothecaries' Company, Linnaeus medal, a youth being instructed in the art of botany, 1830. BM. Struck bronze, 46.5mm, *rev*.

286 William Wyon: Newcastle to Carlisle Railway, 1840. BM. Struck silver, 50mm, *rev*.

287 William Wyon: Lloyd's Lifesaving medal, Leucothöe rescuing Ulysses, 1839. BM. Struck bronze, 73mm, *rev*.

288 William Wyon: Royal Humane Society medal. BM. Struck gold, 72mm, *rev*.

289 William Wyon: George and the Dragon, 1850. BM. Struck bronze, *rev*. of medal of Prince Albert, 76mm. *(colour plate facing page 113)*

290 Leonard Wyon: William Wyon, 1854. BM. Struck silver, 56mm.

291 Leonard Wyon: International Exhibition of 1862. BM. Struck bronze, 76.5mm, *rev*.

292 Daniel Maclise: Drawing for no. 291. V&A.

**Chapter 13**

293 David d'Angers: Bonaparte, 1837. City Museum and Art Gallery, Birmingham. Cast bronze, 141mm.

294 David d'Angers: Juliette Récamier, 1838. FM. Cast bronze, 133mm.

295 David d'Angers: Jean Pierre Boyer, 1845. BM. Cast bronze, 180mm.

296 David d'Angers: Blumenbach, 1834. BM. Cast bronze, 155mm.

297 Auguste Préault: Guyon Naudet, 1838. BM. Cast bronze, 185mm.

298 Jean Baptiste Carpeaux: Mme. Meac-Nab, BN. Cast bronze.

299 Thomas Woolner: C. J. Latrobe, 1853–4. National Portrait Gallery, London. Cast bronze, 89mm.

300 Alphonse Legros: Alfred Tennyson, *c*.1881. BM. Cast bronze, 119mm.

301 Alphonse Legros: John Stuart Mill, *c*.1881. BM. Cast bronze, 101mm.

302 Alphonse Legros: Thomas Carlyle, *c*.1881. BM. Cast bronze, 109mm.

303 Alphonse Legros: Maria Valvona, 1881. BM. Cast bronze, 97mm.

304 Edouard Lantéri: Julio Monticelli, 1888. BM. Cast bronze, 93mm.

305 Maria Zambaco: Marie Stillman, 1885. BM. Cast bronze, 118mm.

306 Edward Poynter: Capri Girl, 1882. BM. Cast bronze, 146mm.

307 Edward Poynter: Clio, Cambridge Prize Medal, 1889. BM. Cast silver, 113mm.

308 Edward Poynter: Lily Langtry, 1882. BM. Cast bronze, 145mm.

309 Thomas Spicer-Simson: Louise Strong Hammond, 1906. BM. Cast bronze, 117mm.

310 Thomas Spicer-Simson: George Meredith, 1910, Ashmolean. Cast bronze, 110mm.

311 Joseph-François Domard: Barnabé Brisson, 1829. BM. Cast bronze, 129mm.

312 Joseph-François Domard: Barnabé Brisson, 1829. BM. Struck bronze, 51.5mm.

**Chapter 14**

313 Jules-Clément Chaplain: Exhibition of 1878. BM. Struck bronze, 68mm, *rev*.

314 J. C. Chaplain: Jules Simon, 1889. BM. Cast bronze, 99mm.

315 J.C. Chaplain: Sarah, 1889. BN. Cast bronze, 230mm.

316 J. C. Chaplain: Emmanuel Bibesco, 1891. V&A. Cast bronze, 100 × 77mm.

317 J. C. Chaplain: Election of Casimir Périer as President, 1894. BM. Struck bronze, 68mm, *rev*.

318 J. C. Chaplain: French Society for Cheap Homes, 1891. BN. Cast bronze, 250mm.

319 J. C. Chaplain: Marcellin Berthelot – Chemical Synthesis, Science Guides Humanity, 1901. BM. Struck bronze, 71 × 57.5mm, *rev*.

320 J. C. Chaplain: Victor Hugo, 1902. BM. Struck silver, 32mm.

321 Oscar Roty: Maurice Roty. BM. Cast bronze, 66 × 49.5mm.

322 O. Roty: Drawing for no. 323b. 299 × 221mm.

323a,b O. Roty: Death of Sadi Carnot; *rev*. State Funeral, 1898. BM. Struck bronze, 80.5 × 57mm.

324a,b O. Roty: Prisons of Frèsnes-les-Rungis; *rev.* remorse, work and family visits, 1900. BM. Struck bronze, 59 × 80.5mm.

325 O. Roty: Drawing for no. 326b. 248 × 209mm.

326a,b O. Roty: Vin Mariani; *rev.* nymph with sick Cupid, 1895. BM. Struck, silver plated bronze, 52.5 × 38mm.

327 O. Roty: Universal International Exhibition, 1900. Struck, silver plated bronze, 51 × 36mm. (*colour plate facing page 128*)

328 Jean-Baptiste Daniel Dupuis: The Spring. BM Struck bronze, 66 × 36mm.

329 Victor Peter: The Happy Age, 1886. BM. Cast bronze, 148mm.

330a,b Frédéric-Charles Victor de Vernon: Eve; *rev.* Tree of Knowledge. BM. Struck bronze, 79 × 30mm.

331a,b Abel La Fleur: Woman bathing. FM. Struck bronze, 72 × 41mm.

332 Eugène Mouchon: Jeanne. BM. Silvered electrotype, 45.5 × 34mm.

333 Ovide Yencesse: Mother and child. FM. Cast bronze, *c.*86mm.

334a,b Ovide Yencesse: Child; *rev.* roses. FM. Struck silvered bronze, 55 × 34mm.

335 Georges Dupré: Meditation. BM. Struck bronze, 62 × 49mm.

336 G. Dupré: The Angelus: Dawn. FM. Struck silver, 71 × 52mm.

337a,b G. Dupré: *Salut au Soleil; rev. Quand tout change pour toi.* FM. Struck bronze, 64 × 50mm.

338a,b Georges Prud'homme: The fisherman's wife. BM. Struck bronze, 76 × 69mm.

339 Edmond Becker: Sarah Bernhardt. Tokyo. Cast bronze.

340 Alexandre Charpentier: Réjane, 1895. Musée de la Monnaie, Administration des Monnaies et Médailles, Paris. Cast bronze, 220 × 120mm.

341 A. Charpentier: Painting. FM. Cast bronze, 154 × 84mm.

342 A. Charpentier: Sculpture. V&A. Cast bronze, 148 × 79mm.

343 A. Charpentier: Child. V&A. Cast bronze.

344 A. Charpentier: Stone-Masons. FM. Struck bronze, 75.5 × 62.5mm.

345 A. Charpentier: Duval Janvier. BM. Struck bronze, 53 × 60mm.

(*Back cover*) Marie-Alexandre-Lucien Coudray: Orpheus, 1900. BM. Struck bronze, 68mm.

## Chapter 15

346 Heinrich Kautsch: Heinrich Heine. BM. Struck bronze, 76 × 44.5mm.

347 Heinrich Kautsch: Motor Car. BM. Struck, silvered bronze, 80.5 × 58mm.

348 Stanislas Sucharda: *Urby* (Willow Tree), 1897. National Gallery, Prague. Cast bronze, 115 × 28mm.

349 Stanislas Sucharda: Spring, 1904. National Gallery, Prague. Struck, silvered bronze, 65 × 90mm.

350 Stanislas Sucharda: Story of the beautiful Princess Liliane I, 1903–09. National Gallery, Prague. Silvered bronze.

351 Stanislas Sucharda: Princess Liliane VI. National Gallery, Prague.

352 Stanislas Sucharda: Always in front, 1912. National Gallery, Prague. Cast bronze, 150 × 140mm.

353 Bohumil Kafka: Perfume of Roses, 1900. National Gallery, Prague. Cast bronze, 310 × 130mm.

354 Bohumil Kafka: Dr Mánes, 1904. National Gallery, Prague. Cast tin, 85 × 100mm.

355 Bohumil Kafka: Peruvian Mummies, 1905. National Gallery, Prague. Cast bronze, 310 × 455mm.

356 Otakar Španiel: After the bath, 1908. National Gallery, Prague. 210 × 160mm.

357a,b Fülöp Ö Beck: Petöfi; *rev.* Freedom, 1905. BM. Struck bronze, 71 × 49mm.

358 Ödön Moiret: St George and the Dragon, 1912. BM. 79.5 × 59mm.

359 Josef Reményi: Kalotaszeg, 1908. BM. Struck bronze, 70.5 × 48mm, *rev.*

360 Vilmos Fémes Beck: Woman, 1911. BM. Struck bronze, 53mm.

361 Ede Telcs: Anna Geröfi, 1910. BM. Struck silver, 51 × 46mm.

362 Anton Scharff: Professor Rudolf Virchow. BM. Two bronze plates joined, 175mm.

363 Arnold Hartig: Dr Arnold Ritter. BM. Struck bronze, 65mm, *rev.*

364a,b Richard Placht: Man; *rev.* Woman. FM. Struck bronze, 81 × 29mm.

365 Lauer: Princess of Schaumburg-Lippe. BM. 45 × 37mm.

366 Philippe Wolfers: International Exhibition, 1897. Collection of Mr John Physick. Cast silver, 73 × 85mm.

367 Victor Rousseau: Disabled soldier's badge, *c.*1917. BM. Bronze, 45 × 39mm.

368 Godefroid Devreese: Liège Exhibition, 1905. BM. Struck bronze, 75mm.

369 Johann Wienecke: Inauguration of Queen Wilhemina, 1898. BM. Struck silver, 100.5 × 75mm.

370 Toon Dupuis: Belgian-Dutch Friends of the Medal, *c.*1907. BM. Struck bronze, 67mm.

371 Edward Poynter: Ashanti War Medal, *c.*1874. BM. Struck silver, 36.5mm, *rev.*

372 Edward Poynter: Drawing for no. 371, (detail). BM. P&D. 431 × 283mm.

373 Alfred Gilbert: Portrait of a man, 1881. Identified by Mr T. Stainton as representing Matthew Ridley Corbet. BM. Plaster model for bronze medallion, 99mm.

374 Alfred Gilbert: Art Union medal for Queen Victoria's Golden Jubilee, 1887. BM. Struck bronze, 64mm.

(*colour plate facing page 113*)

375 George Frampton: George Holt medal for Physiology, University College Liverpool. BM. Struck bronze, 89mm, *rev*.

376a,b William Goscombe John: Edward VIII's investiture as Prince of Wales; *rev*. Caernarvon Castle, 1911. BM. Struck gold, 35mm.

377 William Goscombe John: Hughes medal for Anatomy, University College of South Wales and Monmouthshire, 1902. BM. Struck bronze, 58mm, *rev*.

*(colour plate facing page 113)*

378 Frank Bowcher: Mrs Bowcher, 1895. BM. Electrotype.

379 Frank Bowcher: Hong Kong Plague, 1894. BM. Electrotype.

380 Frank Bowcher: Cope and Nicol School of Painting. BM. Struck bronze, 57mm, *rev*.

381 Frank Bowcher: Sir John Evans. BM. Cast bronze.

382a,b Emil Fuchs: The Boer War, 1900. BM. Struck silver, 70mm.

383a,b Bertram Mackennal: Olympic Games, 1908. BM. Struck silver, 33.5mm.

*(colour plate facing page 113)*

384 Bertram Mackennal: Union of South Africa, 1910. BM. Struck silver, 36mm, *rev*.

385 Dora Ohlfsen: Awakening of Australian Art, 1907. BM. Struck bronze, 50mm.

386 Auguste Saint Gaudens: Child. Tokyo. Cast bronze.

387 Victor Brenner: Congress on Tuberculosis. BM. Struck bronze, 39.5 × 31mm.

388 A. A. Wienemann: Louisiana Purchase, 1904. BM. Struck bronze, 71mm.

389 Janet Scudder: Three women. Tokyo. Cast gilt bronze.

390 Marcelle Lancelot-Croce: Young woman, 1889, Tokyo. Cast bronze.

391 Eric Lindberg: Nils Forsberg, 1900, Tokyo. Cast bronze.

392 Marco Tobon-Méjia: José de la Luz Caballero, 1918. BM. Struck bronze, 70 × 56mm.

**Chapter 16**

393a,b Josef Gangl: U-Bootmänner; *rev*. stylised U, 1915. BM. Cast bronze, 81mm.

394a,b Fritz Euc: Grand Duke of Baden; *rev*. soldiers advancing, 1916. BM. Cast iron, 107mm.

395a,b Fritz Behn: Field Marshal von Hindenburg; *rev*. Wounded Russian Bear, 1915. BM. Cast bronze, 87mm.

396 Richard Klein: World War, 1916. BM. Cast iron, 104 × 120mm.

397 Karl Goetz: Sir Edward Grey; awakening of Egypt, 1915. BM. Cast iron, 58mm.

398 Karl Goetz: America's Peace Objectives, 1917. BM. Cast bronze, 58mm.

399 Karl Goetz: Black Shame, 1920. BM. Cast bronze, 59.5mm.

400 N.S.: Dance of Death, 1919. BM. Cast bronze, 75 × 52mm.

401 Walther Eberbach: Britannia rules the waves though?, 1916. BM. Cast iron, 69mm.

402 A. Zadikow: Death astride a gun, 1915. BM. Cast iron, 73.5mm.

403 Karl May: *Nach der Schlacht*. BM. Cast bronze, 67.5mm.

404 Ludwig Gies: 42cm Mortars. BM. Cast bronze, 62.5mm.

405 Ludwig Gies: The Fort. BM. Cast bronze, 66mm.

406 Ludwig Gies: Zeppelins over London. BM. Cast iron, 62mm.

407 Ludwig Gies: German workers. BM. Cast bronze, 120mm.

408 Erzsebet von Esseö: Bolshevism. BM. Cast bronze, 69mm.

409 Karl May: Hanging Sniper. BM. Cast bronze, 116 × 42mm.

410 Karl May: Russian Giant. BM. Cast bronze, 81 × 152mm.

411 Karl May: 'Sturm'. BM. Cast bronze, 125 × 66mm.

*(colour plate facing page 128)*

412 Erzsebet von Esseö: *Pax*. BM. Cast bronze, 68.5mm.

*(colour plate facing page 128)*

**Chapter 17**

413 Jules Prosper Legastelois: To the glory of the armies of Justice and Liberty. BM. Struck bronze, 62 × 47mm.

414 Pierre-Alexandre Morlon: *Merci*. BM. Struck bronze, 77 × 58mm.

415 Louis Desvignes: Homage to the dead. BM. Struck bronze, 63 × 53mm.

416 P.A.Morlon: Tank. BM. Struck bronze, 68mm.

417 Raoul René Alphonse Bénard: Glory to the unknown soldier, 1921. BM. Struck copper, 68mm.

418 André Lavrillier: Leda and the Swan. BM. Struck bronze, 101 × 61mm.

*(colour plate facing page 128)*

419 Paul Marcel Dammann: Dance to the sound of the flute. BM. Struck bronze, 98mm.

420 Léon Claude Mascaux: Venus and Cupid, 1925. BM. Struck bronze, 109mm.

421 Pierre Turin: Ivy. BM. Struck bronze, 54mm.

422a,b Pierre Turin: Edison Continental Company; *rev*. pylon, 1932. BM. Struck bronze, 72.5 × 52mm.

423 P. M. Dammann: Wireless, 1927. BM. Struck bronze, 68mm.

424 Pierre Turin: *Scientia*, Fourth Centenary of the Collège de France, 1930. BM. Struck bronze, 68mm.

425 Maurice Delannoy: Cinema. BM. Struck bronze, 68mm.

426 Anon: Ballet scene. BM. Struck silver, 38mm.

**Chapter 18**

427 Henri-Georges Adam: *L'homme du Cosmos*, 1967. BM. Struck, silvered copper, 85 × 92mm.

428 H-G Adam: Pierre Boulez, 1964. BM. Struck bronze, 68mm.

429a,b  Siv Holme: Anton Webern; *rev.* abstract forms, 1967. BM. Struck bronze, 67mm.

430  Roger Courroy: St Paul, *c.*1976. BM. Cast bronze, 124mm.

431a,b  Roger Bezombes: César, 1970. BM. Cast tin, 113 × 86mm.

432  Roger Bezombes: Thétis, 1971. BM. Cast bronze and imitation pearls, 148mm.

433  Roger Bezombes: Rouletabille, 1970. BM. Cast bronze, 75mm.

434  Roger Bezombes: *Poisson d'Avril*, 1968. BM. Cast bronze, 81mm.

435  Siv Holme: *De Profundis*, 1970. BM. Cast bronze, 224mm.

436a,b  René Quillivic: Jonah, 1970. BM. Struck copper enriched with enamel, 85mm.

437  Edward Lagowski: Recollection. BM. Cast bronze, 173 × 120mm.

438  Peter Roller: The Memory, 1978. Collection of the artist. Cast bronze.

439  Tamás Asszonyi: Torsos III. Collection of the artist. Cast bronze, 100mm.

440  Jerzy Nowakowski: Tribute to Cyprian Norwid. Collection of the artist. Cast bronze, 90mm.

441  Jerzy Nowakowski: Champion Boxer. Collection of the artist. Cast bronze, 158mm.

442  Tamás Asszonyi: *Ars Longa*. Collection of the artist. Cast bronze. 100mm.

443  Imre Szebényi: *Ecce Imago*, No. 3 in the 'Big Carnival' Series. BM. Cast bronze, 115mm.
*(colour plate facing page 129)*

444  Michael Mészáros: The Slide, 1976. BM. Cast bronze, 126mm.

445  Michael Mészáros: The Escape, 1970. BM. Cast bronze, 116mm.

446  Stanislas Sikora: Chopin. BM. Cast bronze, 120mm.

447  Andras Beck: Bela Bartok. BM. Cast bronze, 135mm.

448  Adolf Havelka: Variations on a baroque theme II '*Misere Credo*', 1969. BM. Cast bronze, 142mm.

449  Jan Wagner: 21st Century Medal, No. 7. Collection of the artist. Bronze, 70mm.

450  Jan Wagner: 21st Century Medal, No. 1. Collection of the artist. 105mm.

451  Maria Lugossy: Microscopic Stratification IV, 1976. Glass, 120mm.

452  Olle Adrin: Untitled. Collection of the artist.

453  Kauko Räsänen: Medal for Finnish Foundation for Economic Education, 1969. BM. Struck bronze, 70mm.
*(colour plate facing page 129)*

454  Kauko Räsänen: Medal for Finnish Savings Banks, 1972. BM. Struck bronze, 72mm.

455  Kauko Räsänen: Wilhelm Moberg, 1973. BM. Struck bronze, 56mm.

456  Kari Juva: FIDEM Conference, Helsinki, 1969. BM. Cast bronze, 44mm.

457  Kari Juva: Finnish Theatre Festival, 1977. BM. Struck bronze, 70mm.

458  Raimo Heino: SALT Conference, 1969. BM. Struck bronze, 70mm.

459  Raimo Heino: C. M. Bellman, 1973. BM. Struck bronze, 70mm.

460a,b  Aimo Tukianen: Fiftieth anniversary of the Finnish Newspaper Association, 1971. BM. Struck bronze, 72mm.

461  Malcolm Appleby: Bird of Destiny. BM. Struck silver, 29mm.

462  Malcolm Appleby: Owl. BM. Struck lead – trial impression, 57mm.

463  Malcolm Appleby: Sun. BM. Struck silver, 21mm.

464  Ron Dutton: Wave breaks, 1977. BM. Cast bronze, 81.5mm.

465  Ron Dutton: Tree Rain, 1977. BM. Cast bronze, 78mm.

466  Fred Kormis: Laurence Olivier, 1949. BM. Cast bronze, 115m.

467  Elizabeth Frink: Buffalo, medal for the Royal Zoological Society, 1975. BM. Cast bronze, 84mm.

468a,b  Ronald Searle: Self-portrait; *rev. La Gloire*, 1975. BM. Struck bronze, 77mm.

469  Ronald Searle: Edward Lear, 1977. BM. Struck bronze, 80mm.

470  Fritz Nuss: *Vogelseele*, 1965. BM. Cast bronze, 100 × 118mm.

471  Fritz Nuss: Sphinx, 1969. BM. Cast bronze, 112mm.

472  Fritz Nuss: Love Games III, 1974. BM. Cast bronze, 120 × 133mm.

473  Helmut Zobl: *Die Macht, die Uns Verbindet*, 1977. Collection of the artist. Struck silver.

474  Christl Seth-Hofner: Indian Women. BM. Cast bronze, 66mm.

475  Gianfranco Zanetti: *Composizione*. Collection of the artist. Cast bronze, 83 × 80mm.

476  Pino Mucchuit: *Aggancio Rosso*. Collection of the artist. Cast bronze, 118mm.

477  Emilio Monti: Fiftieth anniversary of the completion of the Simplon Tunnel, 1956. BM. Struck bronze, 60mm.

478  Angelo Grilli: *Giulio Natta*, 1976. BM. Struck bronze, 59mm, *rev.*

479  Ken Kakuyama: Sinking. Collection of the artist. 130 × 89mm.

480  Ken Kakuyama: Impasse. Collection of the artist. 119mm.

481  Julio Hernandez: Electric Light. BM. Cast bronze, 124mm.

482  Manolo Prieto: *El Campo*. Collection of the artist. Cast bronze.

483  Antonio Oliveira: Soldier and Peasant, the Armed Forces Movement. BM. Struck bronze, 30mm.

484  J. Alves: Building Socialism, 1976. BM. Struck bronze, 68mm, *rev.*

# Index

# Bibliography

This bibliography contains only a small selection of the useful works on medals. It concentrates on recent works and those dealing with nineteenth and twentieth century medals, since these have not often been recorded elsewhere. Graham Pollard's revision of Hill's *Renaissance Medals* contains a good and up-to-date bibliography. Works on post-Renaissance medals are included in Philip Grierson's *Bibliographie Numismatique*, Brussels 1966 and Elvira Clain-Stefanelli's *Select Numismatic Bibliography*, New York, 1965.

### General

BABELON, Jean, *La Médaille et les médailleurs*, Paris, 1927.

BABELON, Jean, *La Médaille en France*, Paris, 1948.

BROOKE, George Cyril, & Hill, George Francis, *Guide to the exhibition of historical medals in the British Museum*, London, 1924.

*Česká a Slovenská medaile 1508–1968*, Exh. Cat. Prague and Bratislava, 1969-70

FORRER, Leonard, *Biographical dictionary of medallists*, 8 vols, London, 1902-1930

HAWKINS, Edward, *Medallic Illustrations of the History of Great Britain and Ireland to the death of George II*, (ed. A. W. Franks and H. A. Grueber) 2 vols. London, 1885. Plates published separately, London, 1904–11.

HUSZAR, Louis and PROCOPIUS, Bela von, *Medaillen- und Plaketten-kunst in Ungarn*, Budapest, 1932.

JULIAN, R. W., *Medals of the United States Mint. The First Century 1792–1892*, El Cajon, California, 1977.

*La Médaille Tchecoslovaque*, Exh. Cat. Paris Mint, 1973.

NORRIS, Andrea S. and WEBER, Ingrid, *Medals and Plaquettes from the Molinari Collection at Bowdoin College*, Brunswick, 1976.

SIMONIS, Julien, *L'art du médailleur en Belgique*, 2 vols., Brussels and Jemeppe, 1900, 1904.

*Trésor du Numismatique et de Glyptique*, (ed. P. Delaroche, H. Dupont, C. Lenormont), 20 vols., Paris, 1834–1858.

VAN LOON, Gerard, *Histoire métallique des XVII provinces des Pays Bas depuis l'abdication de Charles-Quint jusqu'à la paix de Bade en MDCCXVI*, The Hague, 1732–7.

VAN MIERIS, Frans, *Historie der nederlandische vorsten*, 3 vols., The Hague, 1732–5 (down to 1555).

## Periodicals

*Archiv für Medaillen- und Plankettenkunde*, 5 vols, 1913–14, 1920–26.

*Gazette Numismatique Française*, 1897–1914.

*Medaglia* 1971– . Stephano Johnson, Milan. A periodical devoted entirely to medals.

## Renaissance

ARMAND, Alfred, *Les Médailleurs italiens des XV$^e$ et XVI$^e$ siècles*. 2nd rev. ed. 3 vols. Paris, 1883–1887.

BABELON, Ernest, 'Les Origines de l'art du Médailleur', *Histoire de l'art d'André Michel*, III, Paris, 1908.

BABELON, Jean, *Germain Pillon*, Paris, 1927.

DELL'ACQUA, Gian Alberto and CHIARELLI, Renzo, *L'opera completa del Pisanello*, Milan, 1972.

HABICH, Georg, *Die Medaillen der italienishen Renaissance*, Stuttgart and Berlin, 1924.

—— *Die deutschen Schaumünzen des XVI Jahrhunderts*. 5 vols, Munich, 1929–34.

HILL, George Francis, *A guide to the exhibition of medals of the Renaissance in the British Museum*, London, 1923.

—— *A Corpus of the Italian Medals of the Renaissance before Cellini*, 2 vols, London, 1930.

HILL, George Francis and POLLARD, Graham, *Medals of the Renaissance*, London, 1978. (Pollard's revision of Hill's work of 1920).

—— *Renaissance Medals from the Samuel H. Kress Collection at the National Gallery of Art*, New York, London, 1967. (Pollard's revision of Hill's catalogue of the Drefus Collection 1930).

MAZEROLLE, Fernand, *Les Médailleurs français du XV$^e$ siècle au mileu du XVII$^e$ siècle*. 3 vols, Paris, 1902–1904.

PACCAGNINI, Giovanni, *Pisanello*, London, 1973.

WEISS, Roberto, *Pisanello's Medallion of the Emperor John VIII Paleologus*, London, 1966.

## Seventeenth and Eighteenth Centuries

BETTS, Charles Wyllys, *American Colonial History illustrated by contemporary medals*, New York, 1894.

HENIN, *Histoire Numismatique de la Révolution Française*, Paris, 1826.

JACQUIOT, Josèphe, *Médailles et Jetons de Louis XIV*, Paris, 1968.

—— and others, *La Médaille au temps de Louis XIV*, Catalogue for an exhibition held at the Paris Mint, 1970.

JONES, Mark, *Medals of the French Revolution*, London, 1977

—— *Medals of the Sun King*, London, 1979.

*Louis XV, Un Moment de Perfection de l'art Français*, Exhibition Catalogue, Paris, 1974.

MAZEROLLE, François, *Jean Varin*, Paris 1932.

*Médailles sur les principaux événements du règne de Louis le Grand*, Paris, 1702. A revised edition published in 1723.

SAUNIER, Charles, *Augustin Dupré*, Paris 1894.

WEIL, Alan, *Histoire et Numismatique du Patriote Palloy*, Paris and Lyon, 1976.

## Nineteenth Century

BERGOT, François, *David d'Angers*, Catalogue for Exhibition at Paris Mint, 1966.

BRAMSEN, Ludwig Ernst, *Médailleur Napolean le Grand*, Paris and Copenhagen, 1904.

DOMPIERRE DE CHAUFEPIE, Henri Jean de, *Les Médailles et Plaquettes modernes*, 3 vols. Haarlem, 1899–1907.

EVARD DE FAYOLLE, A, *Bertrand Andrieu*, Chalon-s-Saône and Paris, 1902.

GOLDENBERG, Yvonne, *La Médaille en France de Ponscarme à la fin de la Belle Epoque*, Exh. at the Paris Mint, 1967.

JOUIN, Henry, *David d'Angers, sa vie, son oeuvre, ses ecrits et ses contemporains*, 2 vols, Paris, 1878.

MARX, Roger, *Les Médailleurs Français depuis 1789*, Paris, 1897.

—— *Les Médailleurs modernes à l'Exposition Universelle de 1900*, Paris, 1901.

—— *Les Médailleurs Français contemporains*, Paris.

MAZEROLLE, Fernand, Articles on contemporary medallists in the *Gazette Numismatique Française*, Paris, 1897–1914.

NOCQ, Henri, *Les Duvivier, Jean Duvivier, 1687–1761, Benjamin Duvivier, 1730–1819*, Paris, 1911.

## Twentieth Century

Catalogues of the FIDEM exhibitions.

Catalogues of the Italian Art Medal Triennale held at Udine.

GOLDENBERG, Yvonne, *Vignt Ans de Médailles à la Monnaie de Paris*, Exh. Cat. Paris Mint, 1965.

—— *Raymond Joly*, Exh. Cat. Paris Mint, 1967.

—— *À la rencontre d'Adam*, Exh. Cat. Paris Mint, 1968–69.

—— *Roger Bezombes*, Exh. Cat. Paris Mint, 1972.

JONES, Mark, *The Dance of Death*, London, 1979.

*La Médaille Italienne*, Exh. Cat. Paris Mint, 1965.